THE CHANGING FACE
OF PORTRAIT PHOTOGRAPHY

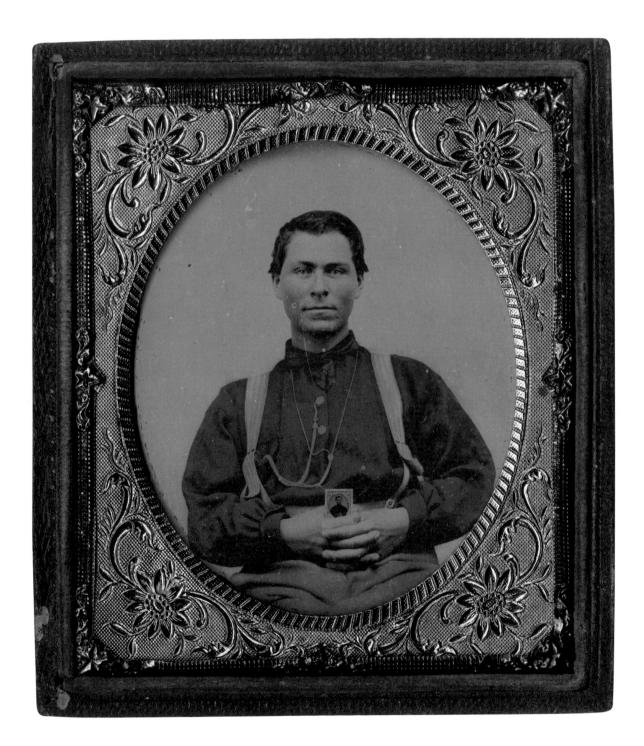

THE CHANGING FACE
OF PORTRAIT PHOTOGRAPHY
From Daguerreotype to Digital

Shannon Thomas Perich

National Museum of American History
Washington, DC

For Thomas and Maeve,
who taught me to see portraiture in new ways as your dad
and I lovingly photographed you during the first years of your lives.

Published by the National Museum of American History
in association with the Smithsonian Institution Scholarly Press

This publication was prepared by Smithsonian Institution Scholarly Press and Smithsonian Books.

Smithsonian Institution Scholarly Press
Ginger Strader, Scholarly Publications Manager
Edited by Jane McAllister
Designed by HK Creative Inc., Carrie Hunt and Pace Kaminsky

Smithsonian Books
Carolyn Gleason, Director
Christina Wiginton, Acquisitions Editor

Distributed through Smithsonian Books
This book may be purchased for educational, business, or sales promotional use.
For information, please write:
Smithsonian Books
Special Markets Department
P.O. Box 37012, MRC 513
Washington, D.C. 20013-7012

Meridel Rubenstein, Sante Fe, New Mexico (p. xiii) © Charles Rushton
Portrait of Jerry Uelsmann (p. xiv) © John Paul Caponigro
Horenstein photographs (pp. 104, 109–119) © Henry Horenstein
Greenfield photographs (pp. 120, 126–137) © Lauren Greenfield/INSTITUTE
Weingarten photographs (pp. 138, 144–149) © Robert Weingarten
The Man That Jan Sees (p. 150) © Graham Nash

Library of Congress Cataloging-in-Publication Data

Perich, Shannon Thomas.
The changing face of portrait photography : from daguerreotype to digital / Shannon Perich. -- 1st ed.
p. cm.
Includes bibliographical references and index.
ISBN 978-1-58834-274-4 (hardback)
1. Portrait photography--History. I. Title.

TR575.P463 2011
778.9'209--dc23

2011014666

First Edition
16 15 14 13 12 11 5 4 3 2 1

Printed in China through Oceanic Graphic Printing, Inc.

Frontispiece: *Man Holding a Portrait*, unidentified photographer (c. 1865), catalog number 77.79.03

CONTENTS

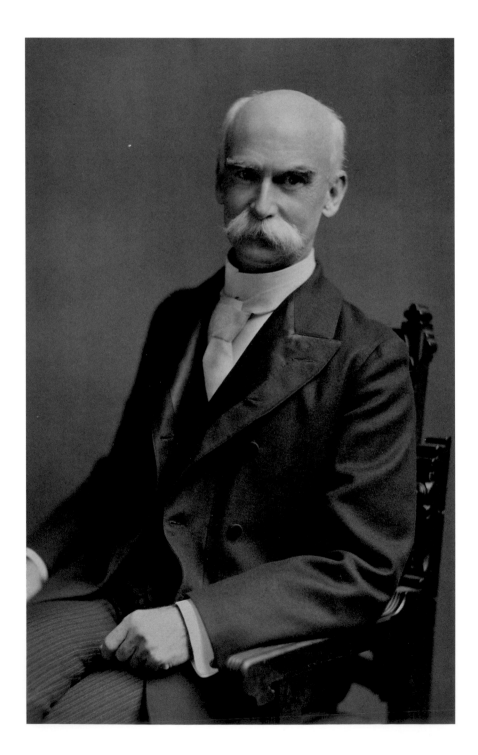

FOREWORD

The core mission of the National Museum of American History is to tell the story of America through our research, collections, exhibitions, public programs, websites, and publications. Each year, more than four million people from across the country and around the world visit the Museum seeking a deeper understanding of our national experience and what it means to be an American.

In support of its mission, the Museum offers audiences access to an extraordinary collection notable for its breadth and its depth. One of the oldest and most unique among these collections is the Photographic History Collection. In 1887, Thomas Smillie—an appropriate name for the Smithsonian's first photographer and curator of photography—initiated this collection when he paid twenty-five dollars for a hand-built daguerreotype camera and accessories once owned by artist–inventor Samuel F. B. Morse, better known as the inventor of the telegraph. Today, the Photographic History Collection consists of nearly a quarter million photographic images and ten thousand pieces of equipment representing the work of over two thousand photographers.

This book of portrait photography is important on several levels. It represents the special interest of the National Museum of American History in understanding photographic process and technique, from those of the first formal studio portraits to the complex images created by digital technology. This volume also reflects a strong collaboration between Smithsonian Books, the Smithsonian Institution Scholarly Press, and one of the Museum's many productive and dedicated curators, Shannon Perich.

For me, this rich and rewarding publication derives its greatest significance by reminding us that history is about people. The 130 images collected in this volume show famous and ordinary Americans in various poses. Even as technology has evolved and become more sophisticated over time, the human element—proud, shy, flawed, and flamboyant—remains constant. I cannot think of a better way to explore American identity than through the stories of the ten photographers presented here and the subjects they chose to capture.

— Brent D. Glass
The Elizabeth MacMillan Director
National Museum of American History

Portrait of Thomas Smillie
Harris & Ewing, c. 1910s
Gelatin silver print, 9¼ × 6¼ in.
Catalog number 2092.A

Smillie, the Smithsonian's first official photographer, established the first historic photography collection in an American museum.

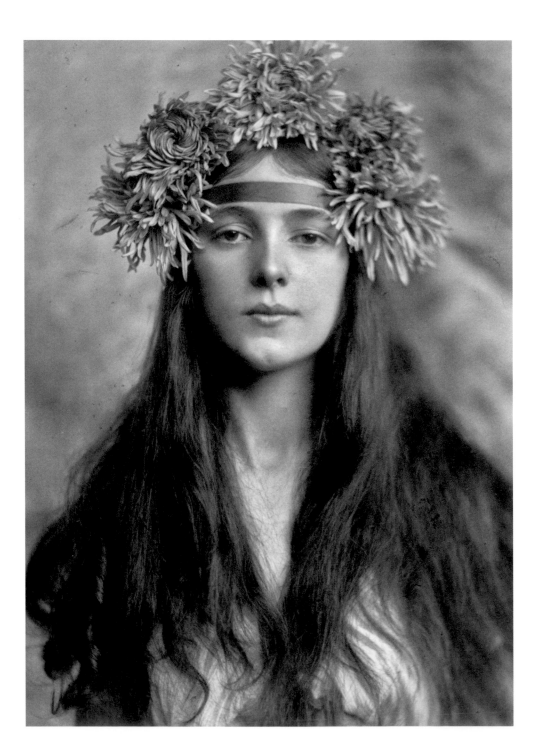

INTRODUCTION

"You are unique, like everyone else." I walked by these words posted on a colleague's door for several years, chuckling at the wordplay. But as I began to think about how I might explore the photographs and apparatus in the Photographic History Collection at the Smithsonian's National Museum of American History, it occurred to me that perhaps this funny little quip played out in portraiture. Portraiture—broadly defined as a visual representation of a person—implies a certain sameness, that is, an image of people with two eyes, two ears, a nose, a mouth, and various hairstyles, all mostly presenting their best selves to the camera. In addition to the obvious and nuanced physical differences among us are a mind-boggling number of influential variables, including the limitations and opportunities related to the technology, photographers' skills, and sitters' desires. I became interested in exploring how, over time, photographic portraiture remains the same and changes, and how the approaches by individual photographers figure into the equation that produces the final images.

The Smithsonian's Photographic History Collection was the first collection of photography in an American museum; it focuses on the art, technology, and history of photography. About two hundred thousand photographic objects and more than ten thousand pieces of apparatus represent the work of more than two thousand amateur and professional photographers, distributors, inventors, and experimenters. The apparatus and images together tell rich national and international stories about how Americans have imagined, produced, and used photography.

As I surveyed the expansive holdings of the Photographic History Collection with an eye on portraiture, it became clear to me that the portrayal of sitters has changed since it first came into vogue in the 1840s. What objects in the collection help tell the story of photographic portraiture? Which variables have modified the genre? How did the application of new technologies influence how and which people were photographed and how photographs were used? Given the advent of fast-paced, open access of digital photography, how is this history relevant?

To answer these questions I combed the collection for photographers whose works represent familiar and extraordinary photographic portraiture in the history of photography, that is, from the nineteenth into the twenty-first century. Nine photographers and one photography studio emerged. Their work offers multiple original approaches to portraiture that remain informed by conventions and innovations. This photography provides a context for thinking about changes in the medium and the ways in which photographers present their subjects as shaped by their aesthetic intentions, intellectual explorations, and commercial desires.

Many other photographers are undoubtedly worthy of inclusion in this project, and others would introduce additional questions to explore. To bring a diverse group of images together in a reasonable manner and manage the multiple variables, however, some limitations were set. First, all the images are drawn from the Photographic History Collection at the National Museum of American History. For ease of comparison of the images across time, formats, and processes, only images of single sitters were selected. The few examples with additional figures serve to enhance either the author's or the photographer's messages about the main subject of the portrait. Self-portraiture is excluded, as it is a separate topic with its own set of conversations. Given such parameters, the works included here merely hint at the breadth and depth of this particularly rich Smithsonian collection that holds many photographic treasures.

Portrait of Evelyn Nesbit
Rudolf Eickemeyer, Jr., c. 1901
Platinum print, 9 × 6½ in.
Catalog number 4135.B5.8

This luscious portrait played a part in what was called the "crime of the century." Eickemeyer photographed Nesbit for architect Stanford White, who was killed by Nesbit's husband in a fit of jealousy.

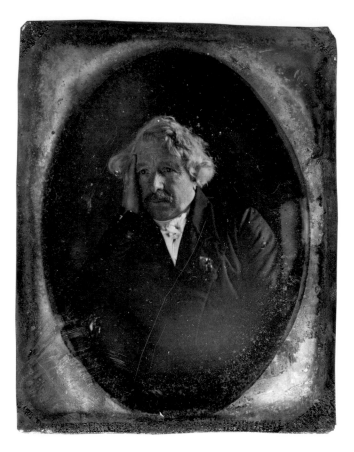

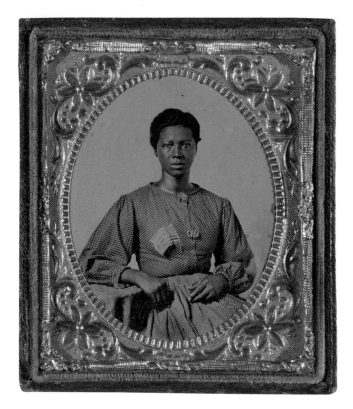

The purpose of this project is not to conduct an exhaustive survey of the Smithsonian's collections, nor to outline the history of portraiture. Rather, it is to suggest a variety of ways in which photographers make choices about how to photograph people; what motivates them to do so, whether it is business, artistic, and intellectual concerns or the influences of cultural norms and popular media; what the tensions are between the photographer's goals and the sitter's ego; and what limitations and opportunities specific technology provides. Aside from economic access to the portrait studio, the sitters' motivations have not changed much over time, but our understanding of them is nuanced by the cultural environment in which a portrait is produced. *The Changing Face of Portrait Photography* examines some ways in which photographic portraiture is used: as sentimental markers with personal significance, as promotions of well-known people, as documents recording the story of a historic moment, as explorations of the interior, emotional life, and even for questioning the definition of portraiture itself. All of these explorations drive home the truism that there is no "right" way to make or read a portrait; the creation of a portrait is a confluence of shifting variables, and it is up to the viewer to decide how to interpret an image.

The first four chapters in the book explore how technology factored into early photographers' approaches to portraiture. The subject of chapter 1 is Boston-area photographer George K. Warren, who began as a studio daguerreotypist in 1851 and made the transition to the wet-plate collodion negative process. By maximizing the reproducibility of the negative, he capitalized on the concept of yearbook photography and remained active until 1882.

(top)
Portrait of Woman with Glasses
William Henry Fox Talbot, c. 1840s
Calotype print, 4⅜ × 4¾ in.
Catalog number 3864F

Talbot patented his innovations in the photographic negative process in 1839, but the Talbotype, or calotype, was initially less popular than the daguerreotype in part because the soft edges of the paper negative rendered less detail. Once the issues of quality and fading were resolved, the ability to use a negative to make reproductions became central to photography's commercial success.

(bottom)
Multiple Portrait of a Man
Unknown photographer, c. 1850s–1860s
Tintype, 4 × 3⅖ in.
Catalog number 77.74.14

Multiple-lens cameras allowed photographers to create inexpensive portraits by taking several exposures on a single plate that could then be divided and shared.

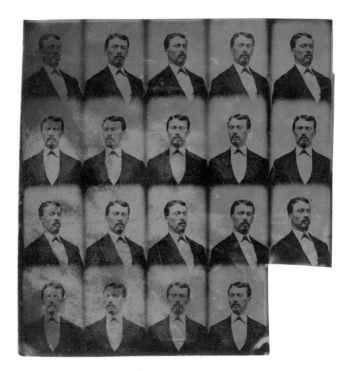

Julia Margaret Cameron, the focus of chapter 2, was an upper middle-class English woman who, from 1863 to 1875, also used the wet-plate collodion process. She deviated from traditional studio portraiture by creating images of her close friends, family, those in her social circle, and anyone else whose demeanor reflected ideals shaped by her rich literary repertoire, deep religious beliefs, and life in colonial-era Victorian England. Cameron was learned about other arts but embraced the photographic process and did not demand that it perform in the same way as painting or sculpture. Although she created her portraits in a highly personal style, she expected to sell the images to augment her family's finances.

The style of portraiture that Cameron eschewed is represented by the work David P. Barr and Charles J. Wright produced in their studio in Houston, Texas, during the 1870s, as seen in chapter 3. The work of Barr & Wright represents the most common portrait experience of their day, the carte de visite. This business-card-size photograph became available to a wide consumer audience beginning in the 1850s, in part owing to the mass distribution of supplies and instruction manuals. Their affordability and small size fueled their popularity, and their collectability was made possible by the reproducibility of individual negatives.

Chapter 4 marks a change in the history of photography, a time when the dialogues about photography as art were primed to explode. By 1897, when Gertrude Käsebier's work entered the scene, the mass production and availability of fairly consistent commercially produced gelatin dry plates removed the laborious process of preparing one's own negatives, freeing up

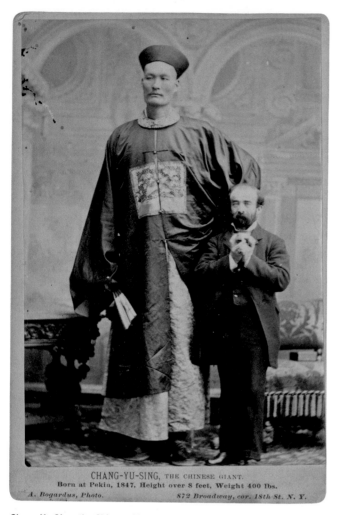

Chang-Yu-Sing, the Chinese Giant
A. Bogardus & Co., late 19th century
Cabinet card, 6½ × 4¼ in.
Catalog number 87.564.28

Gertrude Käsebier's sensitive photographs of Native
Americans stand in stark contrast to the collectable
cabinet cards showing the curious and exotic people who
participated in popular shows and circuses, essentially
offering humans as commodities.

Woman in Green Dress
William H. Towles, 1908
Autochrome, 8½ × 6½ in.
Catalog number 3900

Photographers eager to render the world in color made
autochromes, introduced by the Lumière brothers in 1907,
the first commercially successful color photography process.

access to photography and subject matter. Taking advantage of
that possibility, Käsebier focused on the end product, that is, her
prints and how well they sold. She straddled the art and com-
mercial worlds of photography, which, for some, would become
separate modes of working.

Chapters 5, 6, and 7 address photographers whose work
shaped the ways in which modern photographers approach por-
traiture. As photography became more accessible and available
to consumers, its role in American culture also expanded; as the
development of photographic technology plateaued, the subject
matter and function of photographs became the primary focuses, at
least until the advent of digital imaging in the 1990s. The idea that

portraiture represents the specificity of an individual is debunked
in chapter 5 through an exploration of Dorothea Lange's photo-
graph of 1936 known as *Migrant Mother*. In that iconic work the
individual is suppressed in order to represent the plight of many
Dust Bowl–era victims. The sustained relevance and perpetuated
meanings of the image continue to inspire photographers looking
to create meaningful photographs, either by reference to the work
or attempts to understand its cultural construction.

Nickolas Muray's work, the topic of chapter 6, shows a
transition in celebrity portraiture between 1921 and 1965. His
beautiful, lush gelatin silver prints of the 1920s give way to
brash, bold color carbro prints. A technically skilled commercial

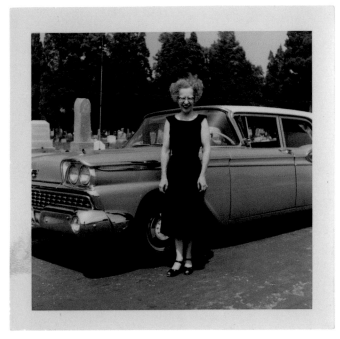

Woman with Car in Graveyard
Unknown photographer, 1959
Color snapshot, 3½ × 3½ in.
Catalog number 2006.0108.008

The snapshot's ability to capture a relaxed and personal experience opened the door for photographers such as Richard Avedon to incorporate informal compositional elements into their photography.

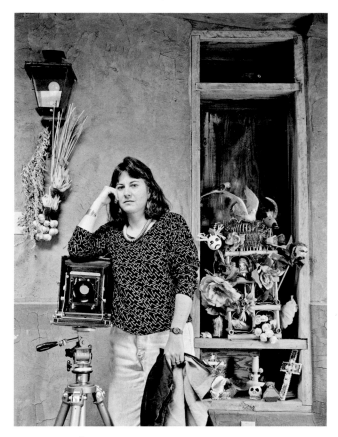

Meridel Rubenstein, Santa Fe, New Mexico
Charles Rushton, 1989
Ink-jet print, 8½ × 11 in.
Catalog number 2008.0178.31

Placing a subject within his or her personal environment, community, or culture provides the viewer with cues to understand the sitter in context.

photographer, Muray worked for magazines, creating portraits of the famous to sell not only the periodicals but also other products. Print media has continued to use celebrity portraiture, formal and informal, to hawk goods and publications themselves.

Chapter 7 looks at Richard Avedon, another photographer employed by a magazine selling fashions. He was moved by the humanity under the stylish fabrics and make-up of his famous sitters and strove to create photographic works acknowledging the life beneath the surface. His black-and-white gelatin silver photographs of the 1950s and 1960s, which explore what some deem the unflattering landscape of aging bodies and brought the psychological portrait to the fore, set a new benchmark for documentary photography. Avedon opened the door for other photographers to tamp down the sitter's ego in favor of responding to their less-than-attractive physical attributes and recording their internal psychological and emotional moments as seen through the camera lens.

The final chapters examine the work of three contemporary photographers who approach portraiture with a conscious nod to the photographers who have preceded them and an eye to the future, all the while recording subjects of the present. The three photographers began with grounding in the darkroom and photographic film and now generally work in a digital mode.

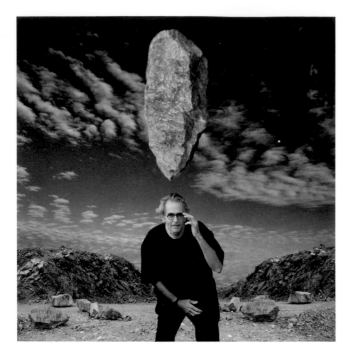

Chapter 8 explores the work of Boston-area photographer Henry Horenstein, a historian with a camera who began placing his subjects in historical social contexts in 1970. He is the author of the first darkroom textbook for the generation that first earned fine art photography degrees from universities and colleges. Horenstein simultaneously balances film photography and digital imaging while retaining a consistent vision and remaining open to new photographic opportunities.

Lauren Greenfield, the subject of chapter 9, brings an individual face to women caught in the swirl of popular culture, consumerism, and materialism in her explorations of identity, the search for self-esteem, and the struggle with negative body image. A photojournalist and documentary and commercial photographer working predominately in color, Greenfield began taking photographs in the mid-1980s. She has built on the practices of long-term in-the-field reporting like that of *Life* photographer W. Eugene Smith and self-determined, meaningful projects that drove the founders of the news agency Magnum. Through still photography, book projects, and films, she is able to represent the specific lives of individuals to draw attention to nationally significant stories.

Robert Weingarten's work, discussed in chapter 10, reveals that digital technology has brought a new kind of image, especially to color photography. Weingarten's portraits remove the human likeness and instead bring into a single photograph the objects and locations specified by his iconic subjects as central to their definition of self. The ability to digitally control

elements of color, translucency, opacity, and image placement expand the options of photocollage to create works with a depth and complexity not seen before in color photography. Public figures have personas they project to suggest who they are. When the human is physically removed from the photograph, what is left and how does one photograph convey what made them who they are? Weingarten's work asks, ultimately, "Where is the line between portraiture and biography?"

The photographers and photographs explored here each represent a variety of shifting variables, the most important being the photographers' economic and artistic concerns and the sitters' contributions and expectations. As the physical producer of the image, a photographer's parameters are established by his or her understanding of the photographic technology he or she employs. Warren, for example, saw economic opportunity in technology that allowed him to produce many prints from one negative, which could mean a minimum investment with the hope of a high return. Muray's expertise in the difficult color carbro process made him a sought-after photographer by publishers eager to utilize color photographs on and in their magazines to increase magazine and advertising sales. Weingarten's technological savvy provides endless artistic possibilities that are limited only by his imagination and skills.

The sitter's contribution and participation must not be minimized. In many instances they have provided payment for their portraits. Even when not proffering money, sitters have an interest in how they are recorded. Barr & Wright's sitters, who came to the studio of their own accord, willingly took part in an activity that signified their membership in the broader American middle-class culture of the time, and so they put their best faces forward to document the moment. Cameron's sitters, too, were invested in their place in society—in their case Victorian England—and submitted to the frozen tableaux of a leisured class. Muray's celebrities were selling products and their famous selves, often under contract.

Dynamic possibilities occur when there is potential conflict between the photographer's goals and the sitter's aspirations. Florence Thompson, Dorothea Lange's unnamed "migrant mother," was simultaneously embarrassed by being destitute yet proud to represent the federal cause for which it stood. Avedon's sitters had to let go of concerns over their physical imperfections in lieu of discovering a revelation of the inner self. Horenstein's subjects are typically not used to being the focus of a documentary project but generally comply in hopes of being represented in fair light and leaving a record for

posterity. Greenfield's subjects, some of whom are in physical, emotional, and psychological distress, have to trust that the photographer is conveying their stories for a greater good.

The users and viewers of photographs are also important factors related to understanding portraiture or really any image. Each individual brings his or her own experiences, knowledge, biases, thoughts, and beliefs to each visual encounter that may be outside of what the photographer or sitter intends. As members of a rich visual culture, each of us shares the responsibility to be educated about the photographs that surround us and how they work in nonverbal ways. This book aims to tease out and examine those variables so that we become savvy consumers of images and can better question and understand pictures that confront us daily. We can also produce more meaningful photographs for ourselves when we are thoughtful about the complex balance of culture, technology, artistic intention, personal and consumer use, and historical context that surround our choices.

So we are back to being unique, like everyone else. Portraiture, loosely defined as a representation of the human likeness of two eyes, a nose, and a mouth, is a vast genre. As we examine the work of photographers from across the history of photography, we discover that photographing the sitters' faces and attributes is a complex confluence of variables that can broaden our understanding about the sitters, the makers, and the time in which they lived, giving their portraits a deeper meaning. As you peruse this book and look at other photographs beyond these pages, I hope you have an expanded experience that draws on your intellect and your emotions to create personally significant visual experiences.

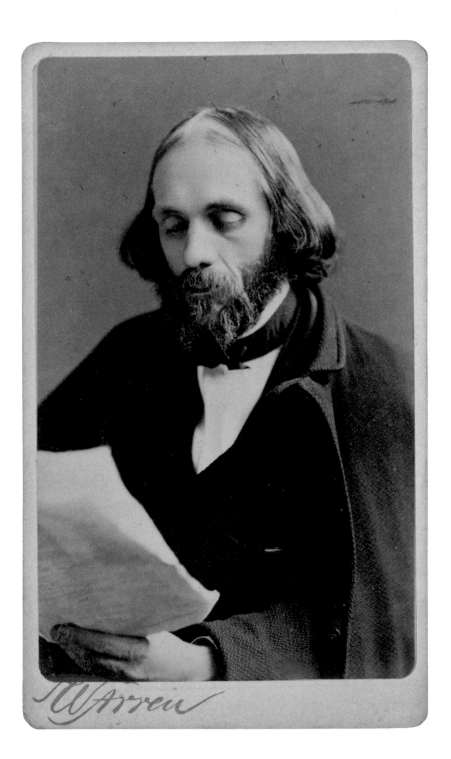

GEORGE K. WARREN

(1832–1884)

The Yearbook Photographer— A Perfect Brick

Boston-area photographer George Kendall Warren made a name for himself as one of the earliest and most prolific producers of photographic yearbooks. Working in a time when early photographic processes were under development, he successfully made the transition from the metal daguerreotype to glass-negative and paper-print processes. The Photographic History Collection has a range of materials reflecting Warren's photography and studio business, as well as family scrapbooks, autograph books, and P. T. Barnum's autobiography with his portrait by Warren. Most important is a yearbook containing Warren's photographs of the graduating class from Rutgers College, New Brunswick, New Jersey, in 1860.

The Daguerreotype and Wet Collodion Processes

When Frenchman Louis-Jacques-Mandé Daguerre (see Introduction, p. x) introduced the daguerreotype process in 1839, the predominate form of portraiture was the hand-painted rendering on ivory called ivorytype. With its relatively slow exposure time, the daguerreotype was used to record landscapes, architecture, and still lifes. But it was not long until the daguerreotype process was refined enough to photographically capture a human likeness. The ability to make photographic portraits helped drive improvements in the quality of daguerreotype images and lessen the exposure time, which in turn fueled the emerging business of photographic portrait studios. Daguerreotype studios remained strong in the United States until the 1850s, when the wet-plate collodion process was introduced.

Edward Everett Hale
George K. Warren, c. 1860
Carte de visite, 4¼ × 2½ in.
Catalog number 1995.0231.058

Clergyman and author Edward Everett Hale, nephew of Revolutionary War hero Nathan Hale, was important to the cultural, literary, and political life of New England.

Making a daguerreotype centered on a copper plate with a highly polished silver surface made light-sensitive when exposed to iodine and bromine fumes. The camera operator would place the plate in the camera and expose it by uncapping the lens. When he determined that enough time had passed, he would replace the lens cap, remove the plate from the camera, and develop the image over mercury vapors. He may have gilded the plate, giving the cold metal a slightly warm tone and offering the silver some protection from tarnish. To enliven the portrait, an assistant might apply pink pigment to cheeks and lips or add gold paint to a brooch, watch, ring, or necklace. They would then seal the unique plate under its brass mat and glass cover, edge it with a foil preserver, and place it in a velvet- or silk-lined case. The daguerreotype could be given to the purchaser the day of the sitting.

Englishman William Henry Fox Talbot announced and patented the Talbotype, or calotype, a paper negative and positive process, at the same time Daguerre introduced his invention. The calotype's softly focused image (Introduction, p. xi *top*), however, could not compare to the highly detailed daguerreotype. A rival process did not appear until Frederick Scott Archer's discovery in 1851 of the wet-plate collodion process, which produced glass negatives that required printing. The method entailed mixing a suspension of collodion (guncotton dissolved in ether) and silver nitrate then coating, exposing, and developing a glass plate at each use. It could be very messy. The paper to receive the negative was also hand-coated with a mixture of egg whites and silver nitrate known as albumen. The glass-plate negative was usually treated as a contact print (placed directly on the paper and exposed in the sun). Introduction of the solar enlarger in 1857 expanded the possibilities, enabling prints of different sizes. Using salted paper instead of albumen paper sped up production.[1] Sensitized canvases intended to be overpainted were also exposed under the enlarger. The enlarged photographic image created the basis for the painted portrait,

which became a more detailed, accurate rendering of the sitter than if the portrait were painted freehand.

The clarity of the daguerreotype portrait reigned until the desire for reproducibility encouraged photographers to convert to using glass plate negatives to make multiple photographs. The change from daguerreotype to the negative-to-positive process was not an easy transition for all photographers; it is comparable to the twenty-first-century shift from film photography to digital imaging. Some photographers were early adapters; some held out for improved, less-expensive, better-tested technology; and some never adapted.

Becoming a Photographer

George K. Warren successfully employed both of these techniques during his long career as a portrait photographer. In 1851, at age nineteen, Warren boldly opened a daguerreotype studio in Lowell, Massachusetts, not far from the long-established galleries of John Adams Whipple and Southworth & Hawes in nearby Boston. Whipple made his first daguerreotype in 1840, shortly after Daguerre had patented the process in 1839. Southworth & Hawes, known for some of the most exquisite daguerreotypes ever made, had been in business since 1843.

Despite the odds and the existing competition, Warren's studio was a success, and he began submitting work to photography journals in hopes of garnering positive feedback and to competitions to win awards that would help establish the quality of his work. In 1852 the *Photographic Art Journal* editors commented that Warren's early daguerreotypes were satisfactory: "The tone is good and the outline perfect, the lights and shades being very harmonious, with uniform graduation. Mr. Warren is a young operator, but he bids fair to stand at the head of his profession. We trust the good people of Lowell will bestow upon him that support he so richly deserves."[2] In 1856 he received a medal for work that was "remarkably pure and apparently free from touches with brushes or pencil." Moreover, the critic wrote, "The best daguerreotypes in this collection have unusual spontaneous expressions, thanks to careful arrangement of pose and lighting."[3] For several years Warren made sensitively rendered daguerreotypes, such as one of his wife, Mary (p. 9).

During the Daguerrean era, photographers invited celebrities of all sorts to their studios; it proved a good marketing technique for both parties. It behooved a potential sitter to take advantage of these offers, as he or she often gained publicity and received free photographs. The images from the sitting might hang on the walls in a prestigious photographer's studio, such as Mathew Brady's National Portrait Gallery in New York. Being viewed among other well-known individuals gave the sitter additional cachet. The photographer benefited by taking an image that might serve as the basis for an engraving to be used as an illustration, as this was how photographs made their way into publications. Some of the celebrity's status might transfer to the photographer. When the carte de visite arrived on the scene in the 1850s, photographers continued to invite celebrities to sit, only now the resulting portraits of famous people could be reproduced en masse and sold to anyone.

George K. Warren knew many notables. He befriended a number of New England's elite, including the eloquent author and clergyman Edward Everett Hale (p. xvi). He was related to President Franklin Pierce on his mother's side of the family. Having been on college campuses for so many years, he met prominent professors. In 1875 abolitionist Henry Ward Beecher ordered sixty prints in three different sizes from him.[4] And P. T. Barnum (p. 5) used Warren's portrait as the basis of the engraving in his autobiography, *Struggles and Triumphs, or Forty Years' Recollections of P. T. Barnum* (1873).[5] While building a reputation for his cartes de visite portraits, Warren also developed and maintained a steady college photography business.

The Yearbook Craze

Warren was an early adapter of the wet-plate collodion process and quickly identified the commercial potential of producing multiple prints from a single negative. The most long-lasting idea that Warren hit on was providing portraits and campus views for graduation albums, or yearbooks, as we would call them today. Yearbooks, then and today, serve to capture memories and written sentiments from friends and educators as the albums' owners transition away from an educational institution.

The first schools to use Warren's services, in 1858, were Brown University, Providence, Rhode Island; Dartmouth College, Andover, New Hampshire; and Andover Theological Seminary. In his second year practicing in this new area of photography, Warren made more than $1,000 at Union College in Schenectady, New York.[6] Most of the class pictures were taken in the northeastern United States, but Warren ventured in 1869 as far as the University of Michigan, Ann Arbor, where students were eager to sit for his camera despite the expense.[7] With its wealth of universities and colleges, Boston proved a rich resource where Warren created class pictures for Harvard for the

better part of the 1860s and 1870s; so rich in fact that Warren opened studios in Cambridge and Boston to be able to better access this population.

By all accounts his services were in high demand. In the *Yale Literary Magazine* of October 1861, Warren advertised that he had worked with twenty graduating classes.[8] In the *Yale Lit. Advertiser* of November 1868 he claimed to have made more than five hundred thousand college photographs.[9] Half-a-million images—quite a lot! The tools and processes, though cumbersome and labor-intensive, were in place, allowing Warren to reach such numbers; in a *Harvard Magazine* of 1862, an editor speculated that Warren produced fifteen thousand photographs for that year's class alone.[10]

The business of creating student portraits emerges from the letters in the Smithsonian's Warren collection. Warren was quick to identify a student who served as a sort of chairman to an ad hoc committee set up to engage Warren's services for class pictures. The young man (the students of the time were mostly men) would help recruit others to participate, locate a suitable temporary studio for the portrait sittings, collect money, and organize and distribute orders. One such man was John Walter Beardslee (p. 13), a member of the Rutgers graduating class of 1860. His letter to Warren outlines the contract and the beginning of negotiations.

Dear Sir,

At a class meeting held the day you were here it was decided to employ you on the terms you proposed + that there may be no misunderstanding we wish things settled beforehand. They like the pictures well, <u>but will expect them to equal the specimens you left.</u> They will take at least 1000 of the $15 kind + 160 of the 30$ kind + perhaps more. There are 28 members of the class. When do you wish your pay? How long before you will come? How long will it take? + will you take them here? [These] are questions we desire to have answered. We greatly prefer them here as we wish some of the Profs. + can not well ask them to go so far [into Lowell] to accommodate us. If possible we must have them before the 20th Dec, as our term closes then + most of them wish them before that. They wished me to propose your taking the faculty + selling the pictures to the students. I think it would pay well as most of them would take them. Should you wish to see me I will be in College from 9 A.M. till 1 P.M. at other times

at No 47 Schureman St. Saturdays home all day. Please let us hear from or see you as soon as convenient.
Yours truly, J. W. Beardslee[11]

Beardslee helped arrange a rented room for the sittings, and in mid-November, after Warren was delayed at Princeton during stormy weather, the portrait sessions at Rutgers commenced. A Mr. Lutkers was Warren's traveling partner and assistant.[12] His job likely entailed helping set up the camera, preparing the emulsion and plates, and ensuring that the sitter's name matched the corresponding negative. After processing the negatives, Warren sent them to his parents, who managed the studio. He then sent proofs to the students so they could select the versions of themselves they preferred. By November 29 the orders started arriving at Rutgers.[13] Warren also photographed the faculty, fraternities, and other social and academic groups, staff members, and people such as Henrietta Verteake (p. 13), who may have been the woman who ran the boardinghouse where student George McNeel (p. 13) lived (see North and South below).

Beardslee repeatedly praises Warren's photographs as "giving universal satisfaction."[14] Letters from other students reflect the personal connections he made with them. A student at Williams College wrote, "In college parlance I should pronounce you a 'perfect brick' as I have heard other fellows do repeatedly."[15] Another friendly young man who signed his letter "R" appreciated Warren's advice to him to be careful how he spoke to women, but the young man claimed he loved to flirt with married and unmarried women and had no intention of stopping. He went on to complain about the two or three students who did not participate in having their portraits made and "spoil the whole thing."[16] Though most liked their portraits, not everyone was happy. Some wrote wanting Warren to make their eyes more expressive or felt they were not captured at their most handsome. Students ordered individualized sets from the "Photograph List" that indicated the names of sitters as well as campus landscapes and buildings.[17] Students often ordered additional prints in multiple sizes. Josiah Plumpelly, for example, wanted extras "for lady friends."[18] After the students received their photographs, they would have them bound by professional bookbinders, often with personalized decorations.

North and South

Fewer Americans attended college then compared to today. Admission required one to have read Virgil's *Aeneid, Caesar's*

Commentaries, and texts by Roman philosopher Cicero, forming the basis of a classical education in which Greek and Latin were core classes. The erudite nature and high-mindedness of the Rutgers graduating class of 1860 supposes that the messages they left in the yearbook created with Warren's portraits were politically strong and poignant. The yearbook belonging to George Washington McNeel is a powerful example of where private life and public discourse intertwine.[19] McNeel was born in 1837 at Ellerslie Plantation in Brazoria County, Texas; his younger brother and a cousin also attended Rutgers.[20] It is not clear why the McNeel Texans chose the college in New Jersey. In parting yearbook messages to McNeel, several writers acknowledge the political tensions building between the North and South on the eve of the Civil War. McNeel's friend William Brownlee Voorhees, who became a clergyman, echoed much of what mathematics professor and Rutgers vice-president Theodore Strong (p. 13) had written.

My Southern Friend,

When we have finished our College course, and you have gone to your Southern home, remember that you are a citizen of a great republic. As such, be loyal, and countenance no schemes of personal or sectional aggrandizement. Tell your friends and neighbors that from your certain knowledge there is a great, conservative, Union-loving people at the North; that they look upon our country as one country, and never will consent to its dissolution. Tell them how a Frelinghuysen [the president of Rutgers] pleads their rights, and teaches his students to uphold the Constitution and the laws.
W. B. Voorhees [21]

These words must have held much meaning for McNeel. He was well-received at Rutgers, a member of Zeta Psi fraternity, and worked on a student magazine. At the commencement ceremony held June 20, 1860, for which special music, the "Lone Star Quickstep," was written for him, McNeel gave a speech titled "Success, the Offspring of Effort." *The New York Times* noted it as being short, sensible, and eloquent.[22] After graduation, McNeel remained in New Jersey, where he attended Princeton University. He married Maria Pell Brower from New York, thus mixing his familial allegiances to North and South. Whatever his political positions, the call of war beckoned him home. In September 1861 he joined the Confederate cavalry unit known as Terry's Texas Rangers. He died in battle in

Louisiana on May 7, 1864, as a major and assistant inspector general.[23]

Warren's own life was touched by the Civil War. His father was related to General Nathaniel Banks, who eventually became a Massachusetts governor. Banks and his two brothers were in the Union army; one brother went missing on the battlefield and was never found.[24] Warren photographed the brothers and others, including George Fox (p. 11), before they set off for war.

George Warren's college photography business eventually declined. By the end of the 1870s he was finished making portraits for yearbooks. It seems the quality of his services was no longer satisfactory; perhaps the quick rapport he previously had with young college men waned as he aged. When Warren's father died in 1882, his business continued to suffer.[25] In 1884, thirty-two years after opening his first studio and soon after closing his last, Warren was killed in a train accident at the College Hill station in Medford, Massachusetts.

———————————————

Within the history of photography, Warren stands as a photographer with excellent technical skills, artistic sensibility, and business savvy whose legacy is quietly found among many family albums and elegantly bound yearbooks. He was a commercial portrait photographer who successfully transitioned from the daguerreotype to the wet-plate collodion processes and generated a successful commercial niche in the college photography business. Although his yearbook portraits recorded the faces of New England, its college students, and significant personalities who shaped an era, he could not have known that the artifacts he created marked the intersection of private lives in the midst of a national crisis. From his record, we can look to the past to glean who were important in their time and who remained significant. After nearly a half-century, we are still discovering that some of those individuals whose visages Warren recorded hold new meanings and opportunities for us. In the fall of 2010, *Smithsonian in Your Classroom,* a magazine geared to bring primary source materials to educators, explored the McNeel yearbook in great detail by following the lives of several members of the class of 1860 and of former slaves owned by the McNeel family. This yearbook, once a personal memento, reverberates with meaning and provides insight into how one man and his classmates figured into a larger, national story.

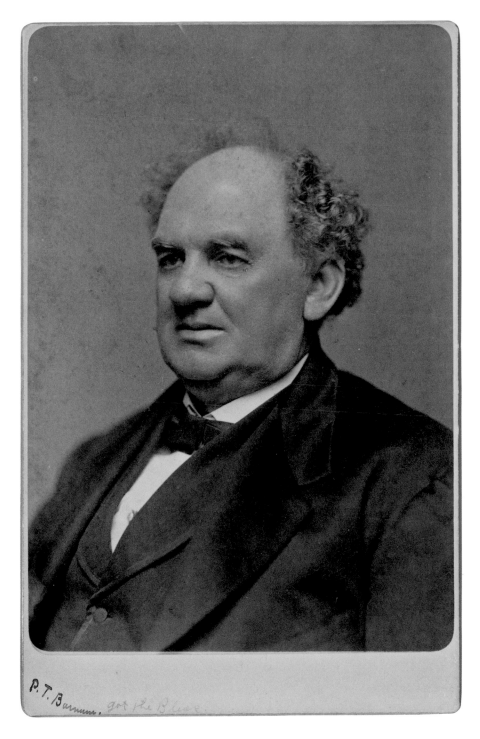

P. T. Barnum got the Blues.

P. T. Barnum
George K. Warren, c. 1855
Cabinet card, 6½ × 4¼ in.
Catalog number 1995.0231.115

The entrepreneur, businessman, and circus founder
understood how to use the power of photography to
promote himself and others.

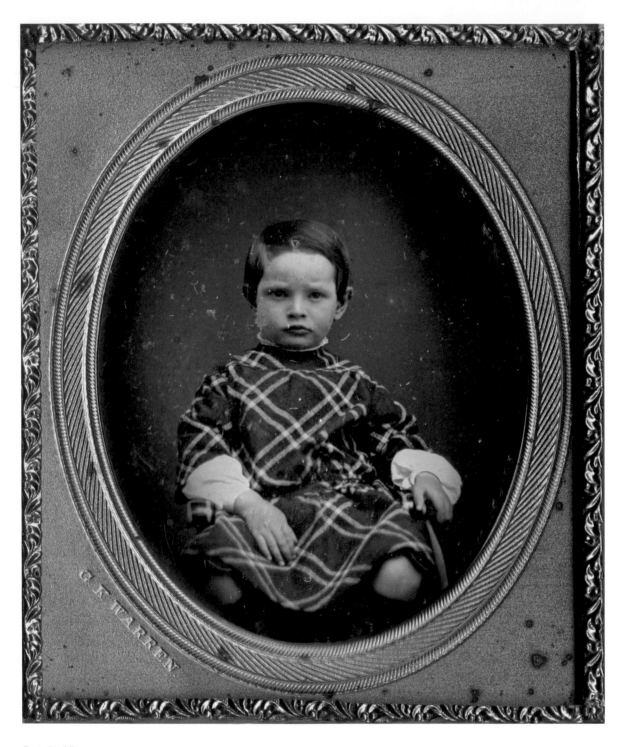

Portrait of Boy
George K. Warren, 1851–1855
Daguerreotype, 3¼ × 2¾ in.
Catalog number 1995.0231.156

Warren's name is stamped on the mat over the
daguerreotype of the boy whose stern expression
may come from trying to remain still.

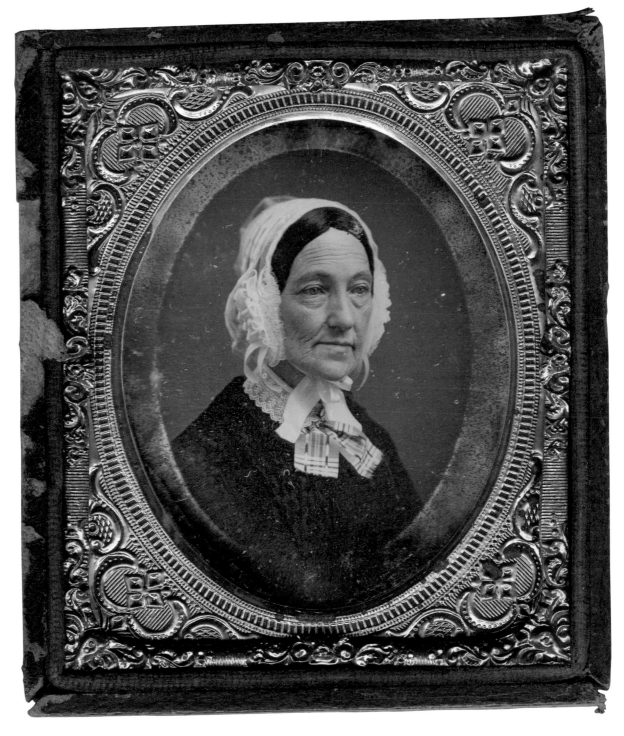

Portrait of an Elderly Woman in Bonnet
George K. Warren, 1851–1855
Daguerreotype, 3¾ × 3¼ in.
Catalog number 1995.0231.141

The ring of tarnish around the woman suggests that a smaller mat once framed her.

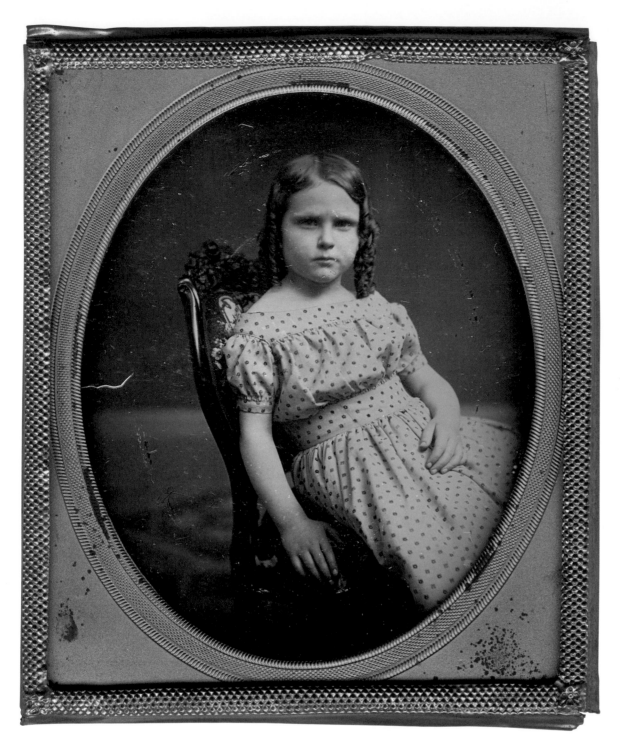

Portrait of a Young Girl with Ringlets
George K. Warren, 1851–1855
Daguerreotype, 3½ × 2¾ in.
Catalog number 1995.0231.155

Warren made a special effort to pose his sitters looking
relaxed. Unlike many stiffly posed children by other
photographers, the girl in this portrait places her hands in
what looks to be a casual position and slouches naturally.

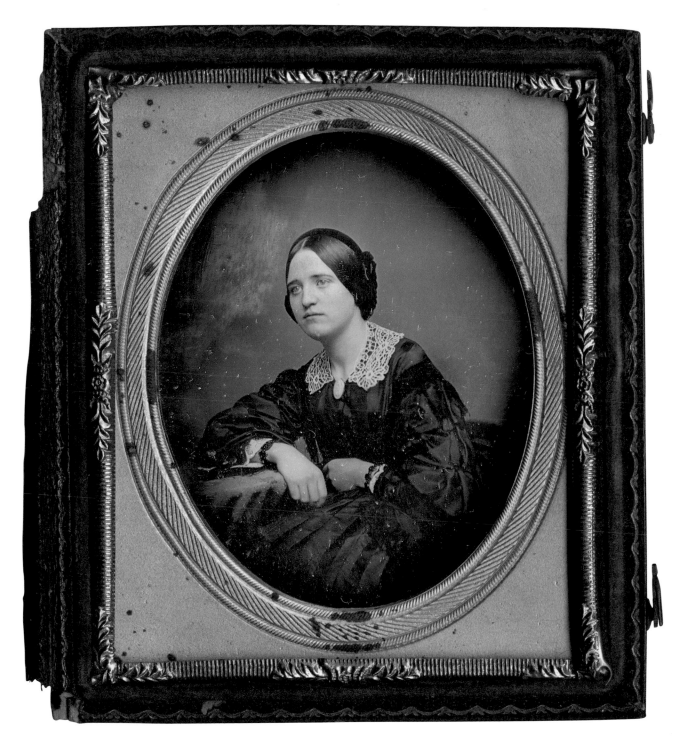

The photographer's wife was often an important figure in the success of his studio. Mary died too early to witness her husband's long, successful career.

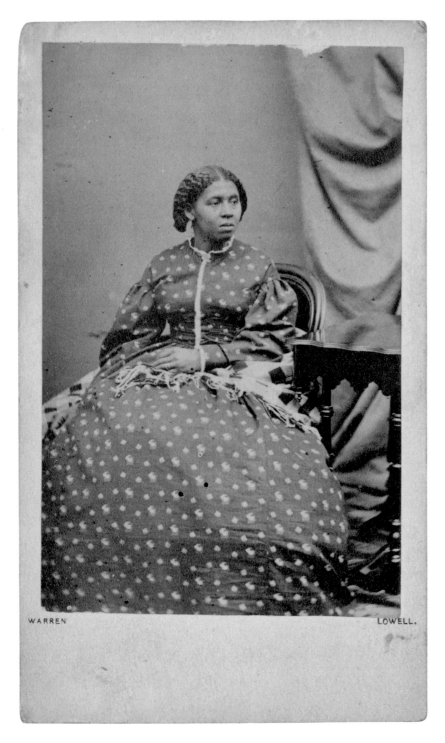

WARREN LOWELL.

Emma, General Banks's Nurse
George K. Warren, c. 1861–1864
Carte de visite, 4¼ × 2½ in.
Catalog number 1995.0231.045

Cartes de visite like these were shared with friends and
family members and collected in albums. Soldiers who
headed off to war often left portraits behind in case they
did not return.

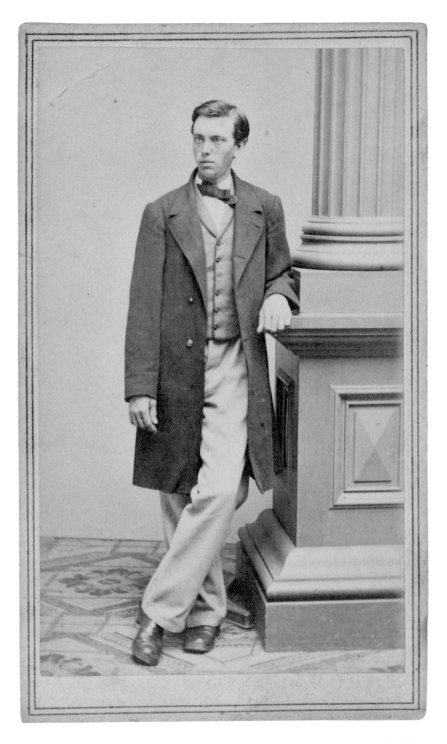

George Fox, Died at Libby Prison
George K. Warren, c. 1861
Carte de visite, 4¼ × 2½ in.
Catalog number 1995.0231.039

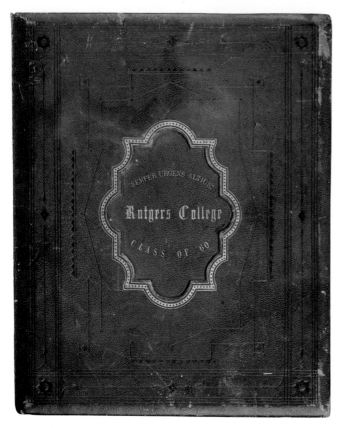

Yearbook Cover

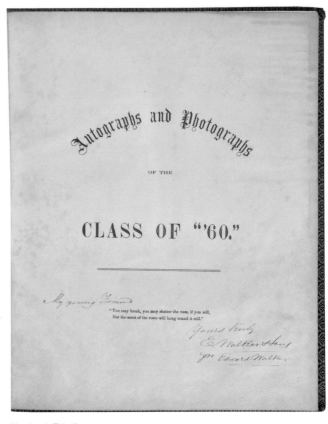

Yearbook Title Page

Yearbook Cover
George K. Warren, 1859
Albumen print, 13 × 11 in.
Catalog number 2003.0149.1

Yearbook Title Page
George K. Warren, 1859
Albumen print, 13 × 11 in.
Catalog number 2003.0149.1

Owners of early yearbooks, like this one belonging to George Washington McNeel, assembled the books and had them bound by professional bookbinders. Each owner decided which designs and patterns would emblazon the covers and whether elegant touches like gilding were within budget.

J. W. Beardslee
George K. Warren, 1859
Albumen print, 13 × 11 in.
Catalog number 2003.0149.1

Beardslee was the unofficial yearbook coordinator for the Rutgers graduating class of 1860. He corresponded with Warren to arrange for portrait sittings and distribution of the photographs.

Henrietta Verteake
George K. Warren, 1859
Albumen print, 13 × 11 in.
Catalog number 2003.0149.1

"Farwell . . . May every hope which while below
To cheer the painting soul is given,
And every joy the heart can know,
Be thine on earth, till thine in heaven."

George McNeel
George K. Warren, 1859
Albumen print, 13 × 11 in.
Catalog number 2003.0149.1

McNeel, the owner of the yearbook, relished his time at Rutgers College and used his yearbook as a way to remember his classmates and professors. Today the yearbook offers a glimpse into a personal dialogue about national concerns.

Theodore Strong,
Vice-President of Rutgers and Mathematics Professor
George K. Warren, 1859
Albumen print, 13 × 11 in.
Catalog number 2003.0149.1

"Let no political foray ever lead you astray, nor induce you to forget, that there are good + true men at the North who regard the Constitution, as the greatest of earthly blessings." Feb. 1, 1860

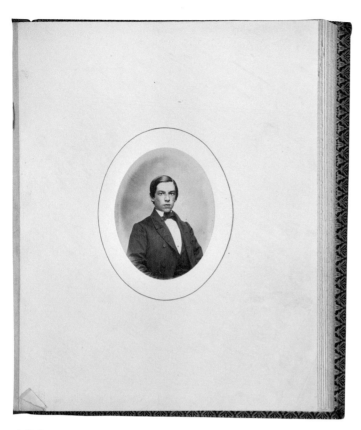

J. W. Beardslee

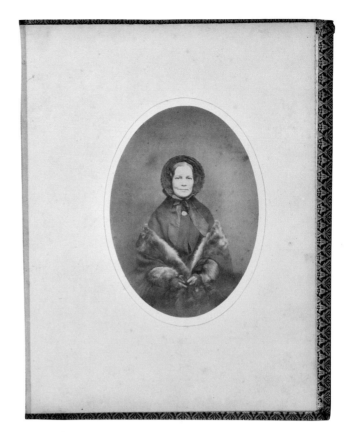

Henrietta Verteake

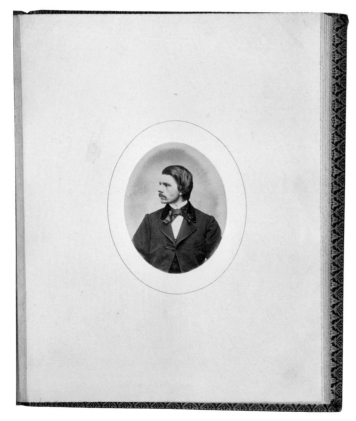

George McNeel

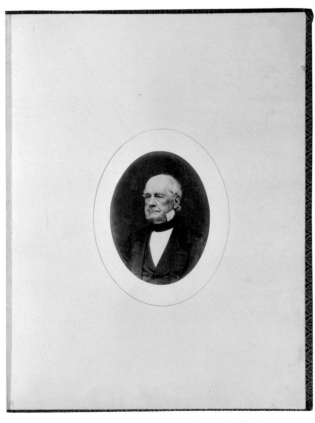

Theodore Strong, Vice-President of Rutgers and Mathematics Professor

JULIA MARGARET CAMERON

(1815–1879)

Spiritual and Intellectual Riches

Julia Margaret Cameron stands out in the history of photography for her bold portraits that were unapologetic in their sentimentality and embraced the medium's unique aesthetics. The exuberant Englishwoman was forty-eight years old when she took up her first camera, and unlike most young photographers, she was intellectually and artistically primed to produce photographic images. For Cameron, life and art were not separate spheres; both were defined by her beliefs and the aesthetics of visual and written arts. Her portraits depict the Victorian feminine domain and offer insights into Cameron's heart and mind. Some 140 years after their making, they remain distinct and compelling.

The Cameron collection at the Smithsonian comprises eighteen photographs. It was built through multiple acquisitions, including a gift from England's Royal Photographic Society of two photogravures published in Alfred Stieglitz's journal *Camera Notes* (1897–1903) and through Smithsonian Secretary Joseph Henry.

Wet-Plate Collodion Process and Albumen Prints

Cameron was a mature and learned woman who had known about photography from its beginning, especially from her longtime friend, the academically generous astronomer and scientist Sir John Herschel (p. 21), whom she met in 1835. Throughout their enduring friendship, he apprised her of developments in the field.

The God of Love
Julia Margaret Cameron, 1866
Albumen print, 22½ × 18 in.
Catalog number 6313D

Cameron often used Freddy Gould, the son of a fisherman, in portraits, but he was not the only local to be commandeered. His androgyny figures into many of Cameron's works referencing childhood innocence and the cupidlike angels in religious paintings.

In 1863, when Cameron's daughter, Julia, and son-in-law, Charles Norman, gave her a camera for Christmas, wet-plate collodion negatives and albumen prints were the dominate forms of photographic production. At that time, one did not simply pick up photography as one might today, since negatives and photographic papers had to be mostly prepared by the photographer. To create the wet-plate collodion negatives, the photographer dissolved guncotton in ether mixed with silver nitrate and he poured the resulting solution evenly over a piece of clean hand-cut glass, which was exposed in the camera while still tacky to the touch. The image was immediately developed to produce a negative on the glass substrate. The glass negative was then contact printed in sunlight on albumen paper.

Albumen paper was a high-quality writing paper that photographers would coat with a solution of egg white and salt, sensitize with silver nitrate, and dry. Using a printing frame, the photographer held the negative and paper in contact with each other and placed them in the sun. After exposure, he or she washed the prints in water (in Cameron's case, in nine buckets of well water often carried by maid, photographic assistant, and frequent subject Mary Hillier).[26] Rinsing in hypo and gold chloride to remove the silver and prevent tarnishing gave the albumen prints a variety of purple and reddish brown tones.

Cameron made photography her priority beginning in 1863, and through much experimentation learned about the toxic and skin-staining chemicals that made capturing her visions possible. It took Cameron several weeks before she hit upon her first success at the end of January 1864—after which she enthusiastically ran through the house, staining the linens and carpets on the way, to show the still wet and dripping negatives to her husband—and then many more weeks to perfect the chemistry and her understanding of the camera and its lenses.

Cameron converted the coal house and henhouse on her rural property into her studio and darkroom. There, she wrote, the "society of hens and chickens was soon changed for that of

poets, prophets, painters and lovely maidens, who all in turn have immortalized the humble little farm erection."[27] The re-tooled spaces first housed Cameron's sliding-box camera that held glass-plate negatives about 10 × 12 inches and was set upon a leggy tripod. Cameron's lens was too large for her camera, so the image projected onto the negative appeared softened at the edges. She accidentally discovered her preference for the slightly out-of-focus faces she came to be known for when turning the lens in preparation for making a portrait.

In 1866, Cameron acquired a 16 × 20–inch camera, but she used 12 × 15–inch plates[28] and pushed the camera close to her sitters so that their faces filled the ground glass. Many of these images are marked in Cameron's writing as "From Life Not Enlarged." In this way, she eliminated external references and details that would commit them to a specific time and place, allowing the sitter's persona to be the complete subject of the photograph. One hundred years later, Richard Avedon (chapter 7) would use a similar technique.

The sticky, tactile wet collodion negative production allowed Cameron to immerse herself in the physical process that records, to some degree, the enthusiastic energy she brought to her work. She made no apologies for the imperfection of the wet collodion process and, unlike most photographers, allowed finger-prints, dust spots, and blemishes in the negative to exist, offering proof that the image was made by a human, not a machine.

It was a challenge for Cameron, and most photographers, to retain the large glass plates. In addition to the volume of storage they required, the salty sea air of the Isle of Wight perhaps caused reticulation across the emulsion of some negatives, as evidenced in John Herschel's portrait. The upper right corner in *The God of Love* (p. 14) also reveals a damaged corner, roughly inked over in the modest attempt to hide it.

Art and Life Are One

Cameron was a force to be reckoned with. Words such as "steamroller," "zealous," and "indefatigable" have been used to express Cameron's boundless energy, voracious appetite for life, and belief in the value of her work. She was rebellious and in-dependent yet maintained Victorian cultural conventions as she sought financial and social mobility.

Cameron spent most of her early life in India, but she was educated in England and France. Her gregarious, entertaining, and literate personality served her well during the ten years she performed official hostess duties for Governor General Lord Har-dinge in Calcutta, where she met many prominent individuals.

As an upper-level civil servant, Cameron's husband, twenty years her senior, was also socially and politically important in In-dia. Charles Hay Cameron was a liberal thinker who authored an essay on visual aesthetics. In an unpublished essay from 1835, he wrote, "There are various States of the human mind, both moral and intellectual, which, [when] we reflect upon them, excite in us the peculiar Emotions called Sublimity and Beauty." In Charles Cameron, Julia found an ardent supporter of her work.[29]

When Charles took retirement in 1848, he and Julia moved their five sons and one daughter back to England. They lived in several places near family and friends. During that time, her cir-cle of friends and acquaintances grew to include England's poet laureate, Alfred, Lord Tennyson, another poet, Henry Taylor, as well as actress Ellen Terry, painter George Frederick Watts, and members of the circle of artists known as Pre-Raphaelites, like Dante Gabriel Rossetti.

In 1860, Cameron acquired two cottages on the Isle of Wight, not far from her good friend Tennyson's estate, Far-ringford House. She named her new home "Dimbola." Charles was often away, in what was Ceylon (Sri Lanka), at his coffee plantations on an estate also called Dimbola.

Ceylon was better known for tea than coffee so it is not surprising to learn that the Camerons struggled financially to remain members of the upper middle-class. Cameron was in part driven by her desire to contribute to the household financ-es. Her conviction that her photographs had value was bold, especially when few art photographers were wealthy as a result of their photographic businesses. Cameron employed a number of strategies to garner recognition and be financially successful, including seeking reviews in noted publications. One reviewer in the *British Journal of Photography* would not deign to write about Cameron's work: "For Mrs. Cameron's heads there must be some excuse made for their being the work of a woman. . . . To expend serious criticism on them is a waste of words."[30] Not all reviewers were as blatantly misogynistic, but the general tone, at least in the beginning, was that she should not expect to make a career or living from her work. Photo historian Pa-mela Roberts writes, "It seems unlikely that she ever made real money from work."[31] In 1875, in a letter to a Miss Osborne, Cameron reconciled a frequent financial discrepancy between the production and the selling of art: "If one believes as I do in the doctrine of compensation one soon accepts the evidence that God gives the material things of this world to some & the spiritual & intellectual riches to others & that the combination of gifts is very uncommon."[32]

Between 1864 and 1872, Cameron entered into a business arrangement with Colnaghi & Company, a well-known print seller in London, to sell her images on commission. The prints she made for Colnaghi & Company are often identified by the company's blind stamp. Cameron attempted to make the prints marketable by asking the famous male sitters to sign the mounts. Although she did sell some photographs, it was never enough to compensate for the revenue losses of the coffee plantations in Ceylon. Cameron was also aggressive at exhibiting her work. In 1868 she held an exhibition of 245 photographs, all of which were for sale, at the German Gallery in London. The show included her photographs from her most well-known commission, Charles Darwin (p. 22).

At the end of her career, before moving to Ceylon in 1875, Cameron worked with the Autotype Company to make carbon prints of seventy of her most popular images.[33] The company cleaned them up, removing dust spots and evening out the streaks. In doing so they also eliminated the character and some of the "mystery," as can be seen in the portrait of Taylor (p. 23). It lacks the contrast and luster of her albumen prints, although the red- and brown-toned ones such as *Saint John* and *Passion Flower at the Gate* (pp. 24 and 25) are somewhat closer to the originals.

Shaping the Photographs

Cameron was at the center of Victorian life and thought.[34] She participated deeply and exuberantly in England's Victorian culture. As was common in middle- and upper-class Victorian households, poetry recitations, theatrical performances of published and original plays, and tableaux creations of painted, biblical, and historical scenes were common. Cameron built her own "Thatched House Theatre" in the gardens of Dimbola.[35] These activities reinforced, exhibited, and explored social mores, religious values, and intellectual ideals about truth and beauty. So when Cameron's daughter and son-in-law first gave her a camera in 1863, her intellectual framework for picture making came easily. Her passion for dramatic storytelling would be reflected in her photography.

Although accoutrements such as head braces were available to help immobilize portrait subjects, Cameron eschewed them in favor of more natural poses and as a way to differentiate her photographs from run-of-the-mill commercial work. She preferred the softened, sculptural suggestion conveyed by her sitters when she turned the lens of her camera slightly out of focus, thus removing some of the edges and harshness of their physical features. In effect, the details of the subject's face are not the focus of attention; rather, much as we engage with a friend, our attention is not on physical scrutiny. Julian Cox and Colin Ford, in the extraordinary catalogue raisonné *Julia Margaret Cameron: The Complete Photographs* (2003), point to painter Sir William Newton's paper "Upon Photography in an Artistic View, and Its Relation to the Arts," delivered in 1853. "Newton advocated the possibility that photographers might consider placing their subjects 'a little out of focus,' thereby giving a greater breadth of effect, and consequently more suggestive of the true character of nature."[36] In a letter to John Herschel in 1869, Cameron herself hoped "to ennoble Photography and to secure for it the character and uses of High Art by combining the real and Ideal and sacrificing nothing of the Truth by all possible devotion to poetry and beauty."[37]

Cameron's time with the Pre-Raphaelites at her sister's home has led some to situate her historically as a Pre-Raphaelite photographer. Although she had close associations and some similarities to the writers and artists of that group, she is in a category of her own. Like them, she drew on religious symbols and biblical stories but dismissed the mysticism in favor of a belief that the secular and the spiritual coexisted.[38] When Cameron found that her famous friends, domestic relations, and sometimes strangers embodied the personification of her ideals, literary characters, religious representations, beauty, and truth, she recruited and commanded them to present themselves for her camera. Cameron had different aesthetic approaches for photographing what she called "Fancy Subjects," men, women, and children based on how her social, intellectual, and religious worlds were actually and conceptually organized.

Fancy Subjects

"Fancy Subjects," a term Cameron used, are drawn from a variety of literary, mythological, or religious themes. "Fancy" meant dressed up, as if for a ball. Cameron sometimes predetermined her titles; other times, she was inspired with a title after she printed the photograph. The inspiration and choice of subject, however, often started with sitters in whom she saw an innate attribute that she might capture or draw on. Freddy Gould, for instance, sat for *The God of Love* and *Love in Idleness* (pp. 14 and 26) from 1866. This son of a fisherman who lived not far from Dimbola began appearing in Cameron's photographs from the time he was three.[39] He was a compliant subject who, as Cameron described him, "submitted to the torment of one

[hour's] trial of various postures & then was still whilst I counted three hundred! With this perfect serenity of countenance and temper."[40] Gould's androgynous beauty echoed painted and sculpted Renaissance cupids. Trimmed to a circle, Love in Idleness goes even further to simulate a roundel of a painted ceiling.

Men

Cameron revered the great intellectual men of her age who contributed to expanding knowledge. Her pantheon includes Herschel, writer and historian Thomas Carlyle, painter Watts, Darwin, poets Tennyson and Henry Wadsworth Longfellow, along with other eminent thinkers. "When I have had such men before my camera my whole soul has endeavored to do its duty toward them in recording faithfully the greatness of the inner as well as the features of the outer man."[41] She presented them in dramatic light and often as floating heads rendered like Roman busts. Austen Henry Layard (p. 27) was one such man.

Cameron wrapped Layard with a dark velvet cloth and placed him in profile, as if in relief like one of the Elgin Marbles in the British Museum. Layard was an important archaeologist who excavated for the Assyrian civilization on behalf of the British Museum. Raised in Italy, he had an interest in Venetian glass, Raphael, and Italian frescoes. He thought the Elgin Marbles were among the greatest of sculptures. In 1869, when Cameron photographed him, he was serving as British commissioner of public lands and buildings. It is possible that Layard introduced Cameron to Italian fresco painting, which were like her wet-plate collodion photographs in that they were executed while the medium (plaster) was damp; he may have encouraged her style of working quickly in a broad, gestural manner.[42]

Women

The Dream (p. 28) is an example of Cameron's version of the Victorian woman and the photographer's ability to blend the sacred and the profane. Mary Hillier is invoked to dramatize part of John Milton's twenty-third sonnet (1658): "Methought I saw my late espoused saint/Brought to me like Alcestis from the grave,/Whom Jove's great son to her glad husband gave,/Rescu'd from death by force, though pale and faint.[43] This image combines Cameron's Mary Magdalena motif—a saint who had known carnal love—with literary reference. It was not necessary for Cameron to have props in her photographs to indicate religious moments; rather, through subtle expressions and gestures within the idealized portraits, she expressed an embodiment of her Christian beliefs, revealing secular truth and beauty. Cameron assumed the viewer would recognize that the posture and robes Hillier wears echo the forms found in religious Renaissance paintings. By using a known woman in a medium that presents its subjects as identifiably real, Cameron removed the allegorical story and replaced it with a contemporary woman to suggest that one lives out the biblical messages.

Another way Cameron imbued her portraits with grand sentiments was to title them with literary references. She called the 1869–1870 portrait of her daughter-in-law, Annie Chinery Cameron (p. 29), Balaustion, after Robert Browning's poem Balaustion's Adventure. Annie and her husband, Ewen, were bound for his Ceylonese plantations shortly after she sat for the photo. The titular character in Browning's poem was described by a critic: "Of all Browning's women, she is the most luminous. . . . She had the Greek gladness and life . . . intelligence and passion."[44] The poem was not published until 1871, and whether Cameron was aware of it before her son and his wife set off is not known. But titling the portrait after a powerful and gracious character was surely a compliment to Annie's personality and a nod to Cameron's high expectations as to her duties as a wife.

Children

Given the conventional domain of Victorian women, Cameron was often around children. She embraced them heartily and valued them. Anna Jameson, a contemporary of Cameron's who wrote four books about Christian art and the Italian High Renaissance, captured the sentiments of the age when she wrote: "We need sometimes to be reminded of the sacredness of childhood." Cameron's images of children are often angelic and androgynous, typifying sublime innocence.[45] They are not necessarily gender specific, as they represent an emotional state above an earthly station in life. Florence Fisher stands in as the young John the Baptist (p. 24). Children representing the pure and untainted love of God are combined with the fancy subjects, such as in The God of Love, in which cupid could be interchanged with sculpted Renaissance angels.

———————

Cameron left England in 1875 and died in Ceylon in 1879. By the time of her death, her son Henry Herschel Hay Cameron was a photographer in his own right. He exhibited his work along-

side hers, helping keep her reputation alive.[46] Cameron defied the typical art photographer's style of insisting on the clearest focus and pristine prints. She challenged conventional studio portraiture by expressing her adoration of learned men, her deep religious convictions, and enthusiasm for poetry and literature. Through her commitment to her photography, she pushed the boundaries of what was acceptable feminine behavior in ways that would be influential many years later.

In Cameron's obituaries, her style of photography was espoused as the forerunner to the work of the Photo-Secessionists (see Käsebier, chapter 4), which embraced the softness, lack of detail, and hand-application of emulsions that reinforced a subjective, nonmechanical photography. In 1904 the same journal that had once refused to publish a critique of her images wrote that Cameron's work "belongs to the modern movement in photography, and that she was a precursor of the revolt against the stereotyped professional portraiture of the 'curtain, pillar and vase type'"[47] (as seen in Barr & Wright in chapter 3). Her association with the Pre-Raphaelites gave her an aesthetic and intellectual framework in which to express the emotions and ideals represented in poetry, literature, and biblical stories.

Cameron's wholehearted assertion of her beliefs and values through photography was in stark contrast to the intellectual prescriptions and emotional reservations to which her fellow male photographers subscribed. Being a woman gave her the advantage of initially working outside a community of photographers and freed her to express herself as she saw fit. Her struggle to gain recognition and make a living from her work was shared by any number of striving photographers and was not owed solely to her gender. Cameron's daring vision for herself and her ability to see something special in her sitters and render them with tactility and erudition continue to inspire and awe photographers, historians, and viewers.

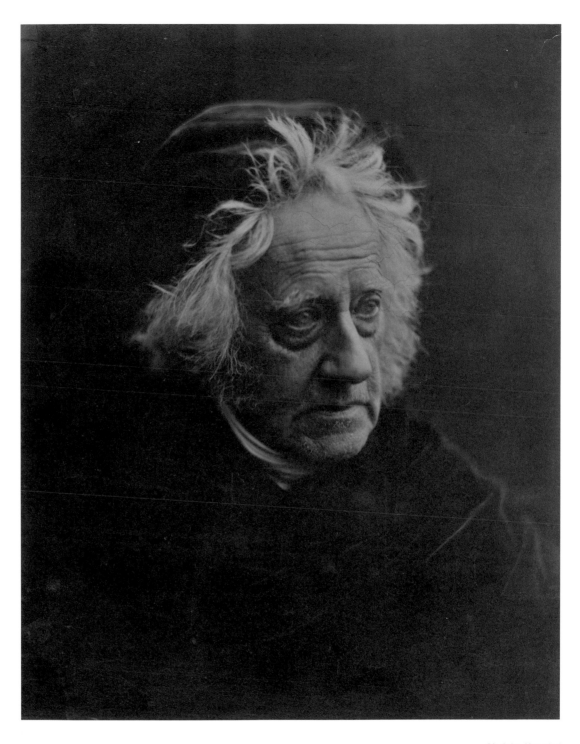

Sir John Herschel
Julia Margaret Cameron, 1867
Albumen print, 10½ × 9 in.
Catalog number 4920

Sir John Herschel was an instrumental figure in the early history of photography. Even though he was not a photographer himself, he invented the word "photography" and discovered the light-sensitive, iron-based cyanotype process. The highly acclaimed astronomer met Cameron while both were in South Africa. There he told her of the impending photographic developments that would eventually be announced by Talbot and Daguerre in 1839. Herschel informed both inventors about his discovery of hypo, or sodium thiosulfate, which could be used to stop the chemical reaction caused by light. This ability to "fix" the image makes chemical photography possible. Herschel is also credited with coining the terms "negative" and "positive" to explain the initial image that is created in reversed tones and the image that results when printed. Herschel remained a close family friend of Cameron's, each naming children after the other, but it was many years after their initial meeting in 1835 before she finally photographed this important figure in photography's development.

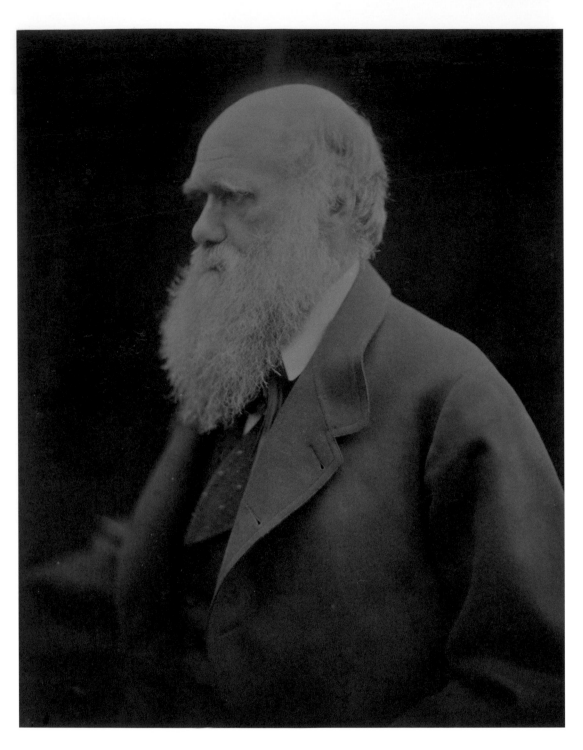

Charles Darwin
Julia Margaret Cameron, 1868
Albumen print, 13 × 11½ in.
Catalog number 4919

In Darwin's portrait by Cameron, he is a heavy-browed
thinker with reserved emotions. He would later employ
photography in his book *The Expression of the Emotions
in Man and Animals* (1872) to explore a range of facial
movements.

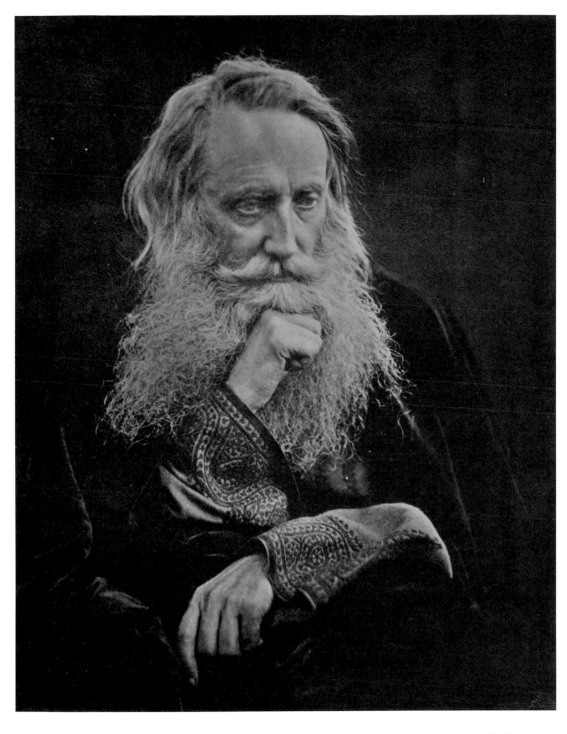

Sir Henry Taylor
Julia Margaret Cameron, 1864
Carbon print, 20½ × 14½ in.
Catalog number 4161B.4

The English dramatist's most well-known play,
Philip Van Artevelde (1834), is a Shakespearean-like
tragedy that honors the Dutch patriot's death in 1382.
Given her friend's poetic sensibilities, Cameron frequently
depicted Taylor as various biblical and literary characters.

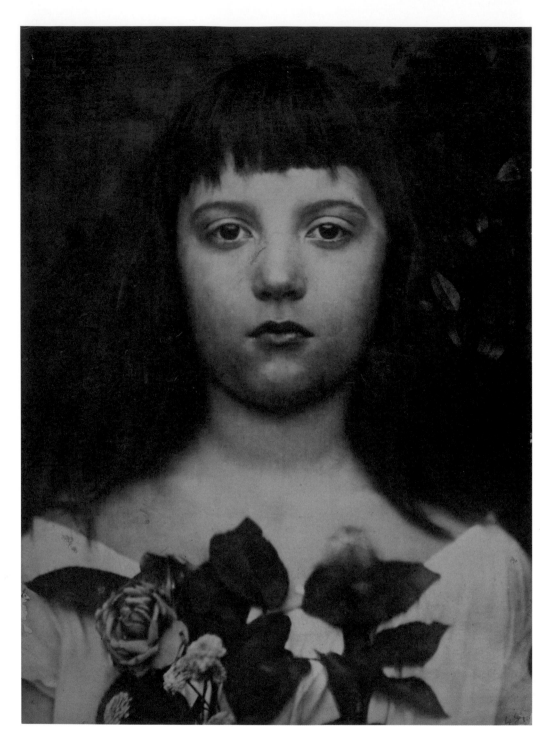

Saint John the Baptist
Julia Margaret Cameron, c. 1872
Carbon print, 9½ × 13 in.
Catalog number 481

Cameron's sitter is her great-niece Florence Fisher.
Cameron believed that females could stand in for male
saints because the Christian message was more important
than gender.

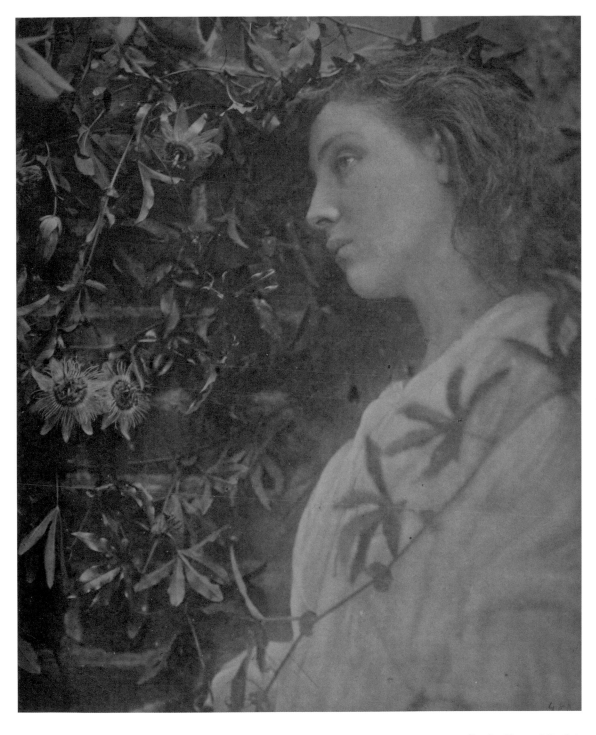

Passion Flower at the Gate
Julia Margaret Cameron, c. 1865–1870
Carbon print, 14½ × 10 in.
Catalog number 480

Cameron felt that women should be the ones to
encourage religious beliefs. Mary Hillier, posed here, is
part of Cameron's Magdalena series. Mary Magdalena,
who had known carnal love before becoming a Christian
devoted to Jesus, represents the human intersection of
sacred and profane love.

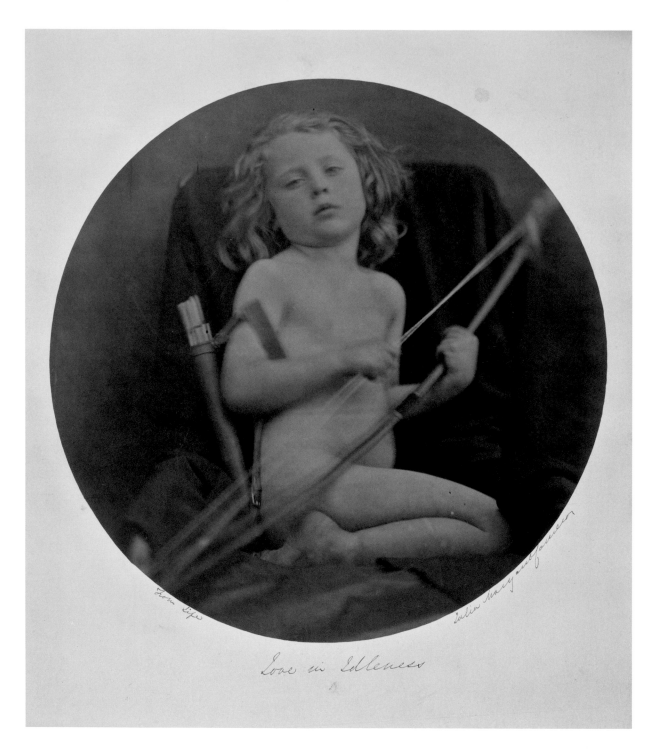

Love in Idleness
Julia Margaret Cameron, 1866
Albumen print, 21 × 17 in.
Catalog number 6313C

Also known as *Cupid*, this photograph features Freddy
Gould, an English fisherman's son who lived on the Isle of
Wight near Cameron's home. Cameron often interchanged
cupid with angels, blending classical sensuality with
Christian adoration.

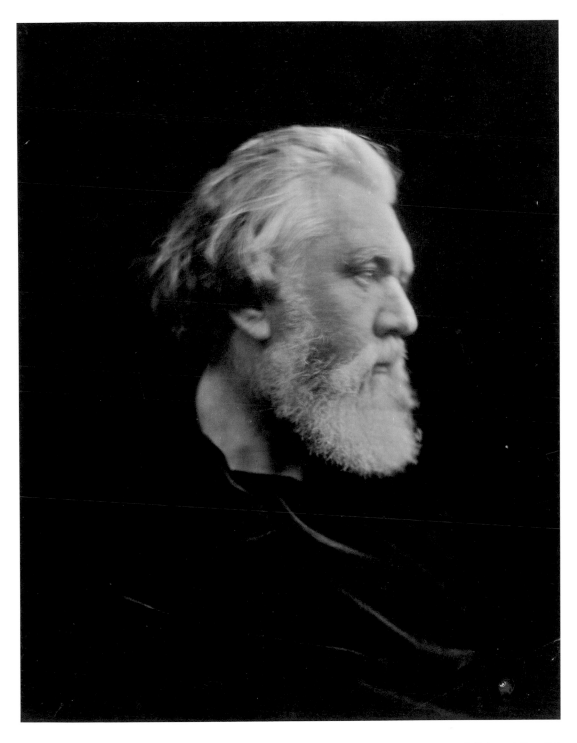

A. H. Layard, Esq, M.P.
Julia Margaret Cameron, 1864
Albumen print, 22½ × 18 in.
Catalog number 6313A

Layard's portrait exemplifies Cameron's aesthetic.
Eschewing the head brace and allowing the emulsion to
record the sitters' movements as they breathed naturally
suggested that her heroic men were mortal.

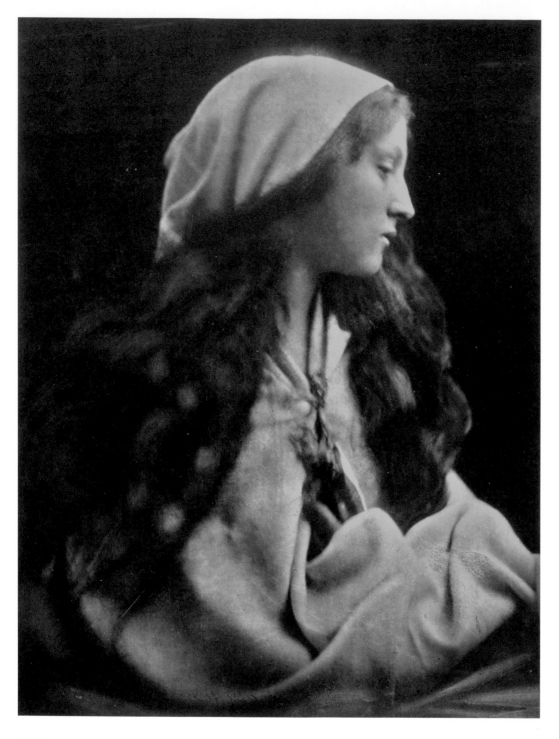

The Dream
Julia Margaret Cameron, 1869
Albumen print, 22 × 18 in.
Catalog number 4161B.5

The title alludes to John Milton's poem "On His Deceased
Wife" (c. 1658). "Methought I saw my late espoused saint/
Brought to me like Alcestis from the grave." Cameron often
used poetry as a source of inspiration.

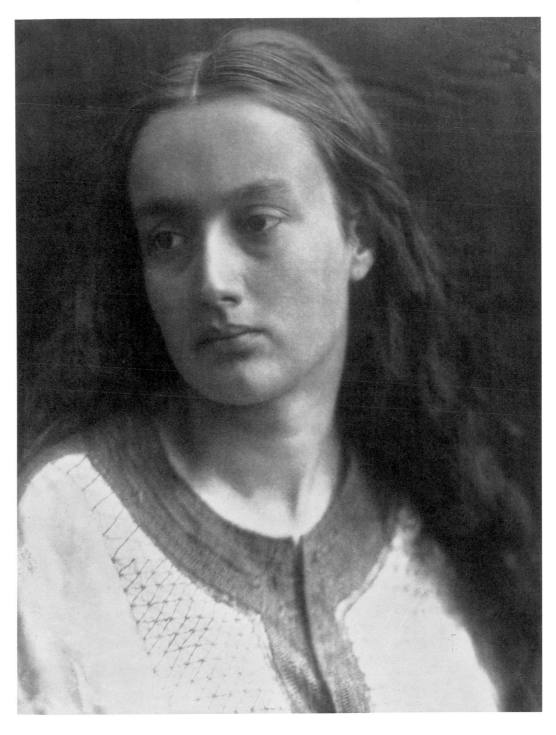

Balaustion
Julia Margaret Cameron, 1869
Albumen print, 23 × 17 in.
Catalog number 4161B.8

Cameron frequently photographed her daughter-in-law,
Annie Chinery.

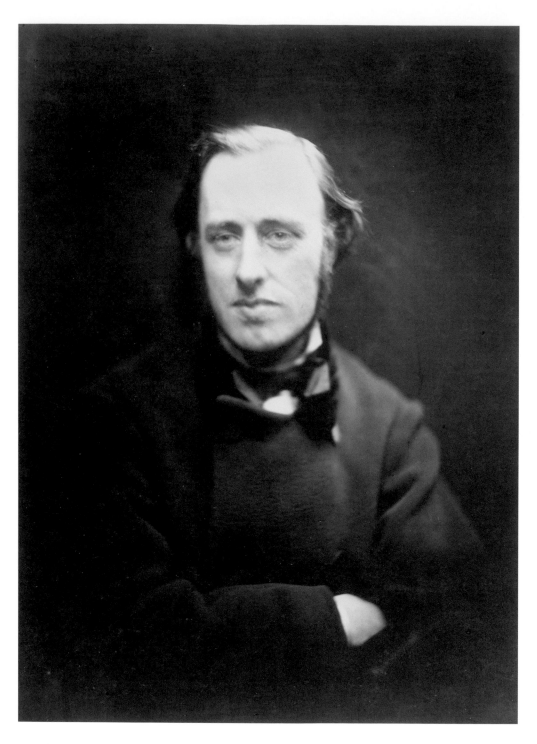

W. E. H. Lecky
Julia Margaret Cameron, 1868
Albumen print, 23 × 18 in.
Catalog number 6313B

Lecky, a historian and moralist, wrote *The Religious Tendencies of the Age* in 1860. He was the sort of intellectual that inspired and intrigued Cameron, one who seamlessly resolved religious and political beliefs.

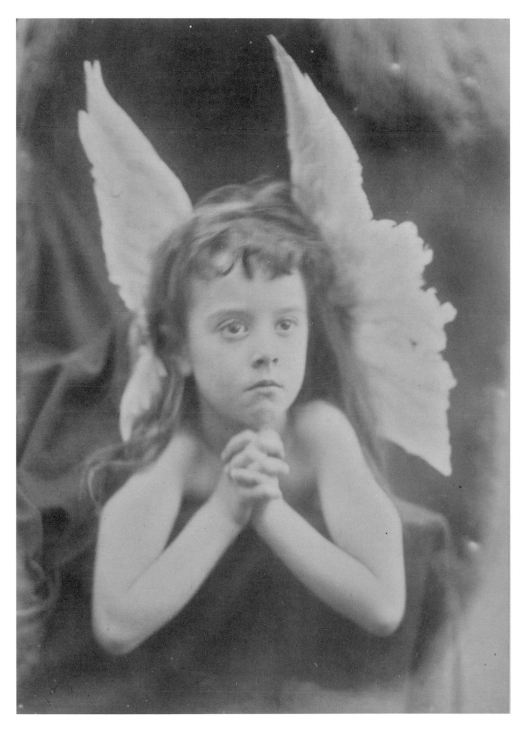

On Wings of Morning
Julia Margaret Cameron, 1877
Gelantine-chloride print, 23 × 18 in.
Catalog number 4161B.2

Cameron made this image to represent one of the two
angels of the Nativity using her niece Laura Gurney as a
model. Laura's home was frequented by Pre-Raphaelite
artists and writers, so sitting for her Aunt Julia in heavy
swan wings was not out of the norm.

BARR & WRIGHT STUDIO
(1870–1880)
Main Street Photographers

In 1977 about two thousand glass-plate negatives joined the Photographic History Collection. They were part of a collection rescued from a now-demolished building in downtown Houston, Texas. The negatives, most of them intended to be cartes de visite, were created by the photography studio Barr & Wright. Proprietors David P. Barr and Charles J. Wright operated their portrait business between 1870 and 1880.[48] Like many photographers of their time, they are almost unknown to us, yet they served the important function of recording their fellow citizens and providing them with images of themselves and their loved ones.

When the glass-plate negatives arrived at the National Museum of American History, they were interleaved with bits of paper. Kept by museum staff, the scraps offer opportunities for speculation. Some of Barr & Wright's negatives were sandwiched between newspapers dating between October and May 1876. Pages of an almanac from 1880 and a report on wheat and corn prices from 1877–1878 were also used. The dates suggest that the negatives were revisited and retained with the intention of preservation, although by whom and to what purpose remains unknown. Other pieces of paper indicate the studio pair's familiarity with photographic material suppliers in Saint Louis, Missouri, and Galveston, Texas, which provided many photographers with similar materials.[49]

Boy with Photo Album on Lap
Barr & Wright Studio, c. 1870s
Wet collodion negative, 5 × 3½ in.
Catalog number 77.43.0404

The boy holds the album that contained the collectible cartes de visite that were the mainstay of many portrait photography businesses from the mid-1850s through the 1870s.

Cartes de Visite

A growing eagerness to produce and possess multiple copies of photographs fueled the move away from the singular daguerreotype to the use of negatives to create paper prints. Englishman Frederick Scott Archer in 1848 created the glass-plate negative and, in 1851, published his wet-plate collodion process (used by George K. Warren and Julia Margaret Cameron, chapters 1 and 2, respectively). Archer's discovery of sensitized collodion on glass facilitated the innovation in 1854 of the popular carte de visite—the French term for "calling card"—by Frenchman André Adolphe-Eugène Disdéri. The carte de visite is an albumen print made from a glass-plate negative and mounted onto card stock about 2½ × 4 inches, roughly the size of a modern-day business card. Instead of bearing the visitor's name, the card bore his or her photograph.

Cartes de visite quickly became collectible beyond their original intention. Purchasers assembled special albums to hold the mounted photographs. The business of cartes de visite expanded through the fashion of collecting images of famous (sometime infamous) politicians, military leaders, monarchs, writers, lecturers, scientists, and performers, as well as of paintings, sculpture, and religious images. A card often bears the imprint of the photographer's name, studio, and address, either on the bottom edge on the front of the card (see chapter 1, pp. xvi and 10) or across the back, sometimes accompanied by a decorative logo.

Over the course of the 1860s and into the late 1870s, cartes de visite were the mainstay of many businesses. By the 1880s a larger version of mounted portraits and photographs, the cabinet card, superseded the smaller card's popularity. Its attractiveness was relatively brief, however, as it was supplanted with the introduction of dry plates, photo postcards, and gelatin silver papers and the rise of amateur photography. Producing, purchasing, and collecting cartes de visite provided both the photographers and the sitters new modes of participating in the broader culture through photography.

Coming to Photography

David P. Barr was born in Ohio in 1839, the same year photography was introduced to the world. Around 1863 he joined with J. W. Young, and the two advertised themselves as army photographers in Vicksburg, Mississippi, and Memphis, Tennessee. During their short time together, their military subjects included Civil War generals Ulysses S. Grant and John A. Logan. After dissolving his association with Young but keeping the business and negatives, Barr remained in Vicksburg until at least 1864.[50]

Barr somehow made his way to Houston, although no records exist to explain precisely why he landed there. Nor do any accounts indicate how he met Charles J. Wright (born c. 1842) or why they decided to go into business together. Wright's biography is equally elusive, with nothing documenting his journey from Massachusetts to Houston, sometime before 1866.[51] When Barr and Wright opened their portrait studio in 1870, Texas was emerging from a period of federally imposed martial law after attempting to leave the Union in 1861. Houston, which had incorporated in 1837, was rapidly maturing and becoming a modern city. Photography had been slow to make its way to Texas; perhaps Barr and Wright were attracted to the expanding population and business opportunities there. While in Houston, they owned several storefronts up and down Main Street.[52] No company records have been located for the firm, which is not surprising, as early photography businesses rarely kept their papers after ceasing operation.

Unless a studio was able to create a significant amount of press for itself and pass on records, photographs, and negatives when it closed, the historical record is thin, with works mostly distributed into personal collections. Despite a lack of archival material directly related to the Barr & Wright studio, its glass-plate collection offers an opportunity to show how common photographic practices were nuanced by a clientele's taste and the local flavor. We can tell that Houston in the 1870s was an ethnically diverse town where African Americans, Mexican Americans, and whites all came down Main Street, with their own sense of style and fashion, to be recorded for posterity. The carte de visite's affordability allowed individuals from many walks of life to participate in this popular form of portraiture. That celebrities and meager wage earners could own the same kind of image suggests a democratizing effect through photography.

While carte-de-visite portraiture seems to have been Barr & Wright's primary business, the DeGolyer Library collection at Southern Methodist University, Dallas, holds stereographs, tintypes, and cabinet cards that show an assortment of the firm's photographic formats, studio imprints, and scenes.[53]

The Vernacular of Portrait Photography

Millions of cartes de visite remain today, but the history of many of their creators is lost. What is astounding is the general uniformity of the mounted photographs, which suggests a broad, if not homogenous, approach to poses, studio decorations, and use of the images. A few photographers, such as Mathew B. Brady, and their studios certainly stand out. But many more photographers were technically sufficient working men (and a few women) who provided a service to their customers. An examination of Barr & Wright's glass-plate negatives offers a glimpse at the intersection of written descriptions in widely distributed photography manuals and a particular studio's interpretation of those suggestions.

The images shown here are not Barr & Wright's final products—the actual cartes de visite—but rather, modern scans of their glass-plate negatives. From the scans we can see some of the photographic process and garner hints about Barr & Wright's business. In these pictures the rough edges of the 3 × 4–inch hand-cut glass are visible, as are the negative numbers etched into the tops of the negatives; purchase orders, such as "½ dozen plain," are scratched along the sides (pp. 41 *right*, 44 *right*, 45 *left*, 46 *left*, and 47 *left*). Names of the sitters, however, are not recorded. In the lower right-hand corner of each plate is the National Museum of American History's catalog number, which museum staff inked on top of the glass plates shortly after the plates arrived at the museum, according to the practice at the time. The corners are dark: collodion that was flowed and spread across a plate did not need to coat the corners because only the center of the plate would be used for printing. The preparer occasionally left a fingerprint (p. 43 *right*, upper right corner).

We are not able to discern what roles Barr and Wright played in their business or who operated the camera, but the negatives show that they were proficient technicians who used well-appointed studio props and conventional posing techniques. Neither is it known how Barr and Wright learned photography or informed themselves about photographic conventions. But based on their lockstep adherence to the recommendations of a popular photography manual of the time, it seems likely that they stayed current through photography journals and technical guides.

The Photograph Manual by Nathan G. Burgess, which was in its eighth edition by 1863, included instructions on how to

make cartes de visite and place the sitters. It suggested that cartes de visite be "generally taken in a standing position with a landscape background, or one made with panel paper, or a plain background having a small portion of a curtain in view." Burgess also encouraged incorporating pedestals, pillars, columns, and balustrades on which the sitters could rest their hands and arms: "A beautiful feature of these cartes de visite is the introduction of the balustrade. . . . Any article of furniture which may be used in the drawing room would always be in good taste in the card picture." Throughout Barr & Wright's negative collection balustrades are frequently employed, such as in the images of a boy in an ill-fitting suit and another with a dog (pp. 42 and 43). Burgess attended to details of flooring as well,[54] which Barr & Wright clearly considered, given the variety of floor treatments in the photographs, including oilcloths, carpets, and sometimes bare planks such as seen under the boy with the rocking horse (p. 43). Barr & Wright heeded Burgess's advice and brought in dirt to imitate a garden path for the little fireman (p. 42).

Barr & Wright's assembly of studio furniture and props was not made lightly. The boy on page 32 holds an example of the popular cartes-de-visite album discussed above and is seen in a parlorlike setting. The surroundings and accoutrements may indicate that the child's family was socially and culturally aware and imagined itself in such well-appointed rooms; perhaps such an environment made an important statement in the blossoming city of Houston. Identical pieces of furniture, drapery, and props are found in various combinations throughout the Barr & Wright negatives. The double frame on a table has the same pictures that appear in the portraits of a woman holding flowers (p. 45) and a girl with striped stockings (p. 41). A look at cartes de visite made by other photographers reveals that the refinement of the furniture may vary among the images made by different photographers, but the conventions of the sitters' poses do not.

Whatever social, cultural, and photographic contrivances may have existed, and whatever artistic skills the photographer may have brought to bear, the ultimate goal of the studio photographer was to make the customer happy, which usually meant producing flattering portraits. That objective may have required the photographer to suppress artistic experimentation and tailor aesthetics to the sitter's pleasure. Despite Burgess's highly regarded ideas and the ornateness of Barr & Wright's carefully conceived studio ambiance, plenty of clients seem to have preferred a plain backdrop. Photographs using simple backgrounds tend to show seated subjects taken from the waist up. The frame is filled with the sitter's body, and the details of clothes, jewelry, and hair are more visible than would be possible against a decorative background, which would compete for visual attention.

A sitter occasionally brought objects representing a vocation, avocation, or prized possession, such as represented by a girl and her doll (p. 40). The decision to have a portrait made was sometimes defined by opportunity (having the time and money) or the desire to document a particular moment. Perhaps the man with his glass and liquor bottle had recently come into Houston from one of the cattle trails, had a bit of cash, and recorded his high time in the city before heading back out (p. 46). Portraits made at special occasions—birthdays, weddings, graduations, religious milestones such as a girl in her Communion dress (p. 40)—are ubiquitous and remain common today. On page 47, the older man wears a ribbon denoting his participation in an 1874 reunion of the veterans of the Republic of Texas Army (1836–1846). Other veterans had their pictures made by Barr & Wright at the same event, but the gentleman here is the only one in the collection with a curious hand gesture, perhaps from a secret society.[55]

Special Situations

Given the long exposure times necessary to produce a photograph, squirmy children and babies posed a challenge. The head braces used to create adult immobility (see p. 46 *right*, discernable between the legs of the chair) were not suitable tools for tender little necks. Burgess writes: "The rule with children's portraits is, to sit as long as they will without moving, then develop [the negative] until the picture appears. The tone is never so desirable but the likeness will be there, which is often prized by the parents more than the most splendid productions of the artist."[56] Despite the dubious overall quality of the image, the mother's pleasure over her child is especially resonant in the image on page 39 (right) in which the mother, clearly visible, secures the baby's out-of-focus head with one hand while the other, hidden under the blanket, holds the infant upright. In other images the parents' arms are concealed beneath the drapery. In one negative the mother's face is visible twice, caught in motion (p. 39 *left*), but in the print she would have been cropped out. In another, the father's fingers are emerging from the back of the chair (p. 38 *left*). Barr & Wright's negatives reveal the close proximity of parents, who were employed to comfort, support, and sometimes cajole children into a good mood, if only for an instant.

The frustrations of photographing wiggly babies and fussy sitters were surely preferred to the grim task of photographing

the dead. Philadelphia photographer John L. Gihon's 1871 article in *Photographic Mosaics*, a journal of general photography articles, gently but directly broaches the topic of postmortem photography. "Every photographer should at all times be prepared to make such a picture," he writes, as the call to perform such a service comes quickly. He advises taking a small camera kit and asking the family to provide a dark closet, buckets, and water for preparing and developing the glass-plate negatives on the spot. Gihon reminds the photographer several times to be "callous to the affecting surroundings," not afraid to move the body as necessary, and ask those who are unhelpful to leave so the work can be accomplished quickly and without distraction. As to approaching the difficult task, he offers: "If you believe that what you are doing is to be held as a reminiscence, . . . a last memento, then endeavor to make a photograph that, if it cannot be pleasing, will, at the least, be devoid of repulsive suggestions."[57] He continues, "Children are easily managed. Laid upon their little beds, in their cots or carriages, placed upon a sofa or lounge, or even in a large arm-chair, they can be made to look as if 'fallen asleep.'"[58] Gihon remarks that his most successful photograph of a dead child was with the child held in the mother's arms.

Barr & Wright's image of a postmortem infant (opposite) may have been posed as a sleeping baby, but the small bouquet in the folded hands signifies that the child is dead. The family ordered a dozen prints. The white of the pillow is extended by hand painting, and clear marks in an oval shape on the negative indicate that a mask was used during printing to create a vignette. The oval and vignette help smooth the edges of the image and, by extension, soften the painful loss. Out of almost two thousand images, this one is the only postmortem photograph in the Barr & Wright collection, but as Gihon implied, many photographers were called on to create final records.

After the two men dissolved their business, Barr moved to San Antonio and maintained a series of photography studios through the 1920s.[59] Wright stayed in Houston and worked on and off with other photographers; it is likely that he retained the negatives in the event that former sitters asked for reproductions. He seems to have been employed in some capacity in the undertaker business after leaving photography in 1895.

Barr and Wright were not exceptionally innovative, creative, or cutting edge, and Barr & Wright was not renowned. But the two were hardworking men who remained fairly successful by maintaining the status quo established by other photographs and popular expectations. Their lack of notoriety does not diminish the value of their output. Their collections serve to represent many photographers who brought affordable, personally meaningful photographs into the lives of their socially and financially diverse customers. They stand for a host of photography businesses and camera operators remembered only by their listings in business directories and extant fragments of their work dispersed among albums, museums, historical societies, and antique stores.

The Barr & Wright negative collection at the National Museum of American History makes visible a sampling of Houston's citizens in the 1870s. The photographers' overall style and studio components are brought to light and can be compared to the nationally known literature about portrait studios. The volume and breadth of Barr & Wright's work begins to hint at the important social and cultural function of the professional portraiture business during the last quarter of the nineteenth century. As long as one could afford the photographs, one would be photographed the same way, with the same props, as all other customers. The photographers thus created a kind of pictorial democracy based on equal economic access. The format of photographs we choose to pay for reveal a participation in, or at least a desired alignment with, certain social and cultural status.

This situation remains true whether one visited and got dolled up for glamour shots in mall stores in the 1980s or selected a well-known photographer to record important events such as bar and bat mitzvahs, Quinceañeras, weddings, or other significant moments. The physical photograph, aside from the image, is a cultural artifact that holds cultural and social status with which we consciously and unconsciously associate ourselves.

Infant Holding a Pole
Barr & Wright Studio, c. 1870s
Wet collodion negative, 5 × 3½ in.
Catalog number 77.43.0107

Postmortem Infant
Barr & Wright Studio, c. 1870s
Wet collodion negative, 5 × 3½ in.
Catalog number 77.43.0103

The Barr & Wright Studio images above and on the
following pages are contemporary black-and-white scans
from the original creamy brown or tan glass-plate
negatives, which would have been used to make
cartes de visite and cabinet cards.

Infant Portrait with Man's Hand
Barr & Wright Studio, c. 1870s
Wet collodion negative, 5 × 3½ in.
Catalog number 77.43.0146

Asian Infant in Chinese Robe
Barr & Wright Studio, c. 1870s
Wet collodion negative, 5 × 3½ in.
Catalog number 77.43.0113

Because early photography required a second or two to make exposures, babies and young children were a bit of a challenge to photograph.

African American Infant with Mother
Barr & Wright Studio, c. 1870s
Wet collodion negative, 5 × 3½ in.
Catalog number 77.43.0629

Woman Holding Infant on Chair
Barr & Wright Studio, c. 1870s
Wet collodion negative, 5 × 3½ in.
Catalog number 77.43.0203

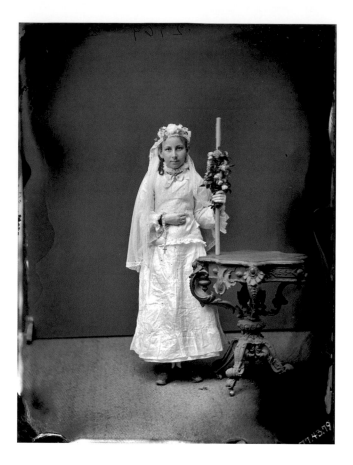

Girl in Communion Dress
Barr & Wright Studio, c. 1870s
Wet collodion negative, 5 × 3½ in.
Catalog number 77.43.0079

Girl Holding Doll
Barr & Wright Studio, c. 1870s
Wet collodion negative, 5 × 3½ in.
Catalog number 77.43.0813

Before snapshot photography, important moments in life such
as birthdays, religious milestones, and other achievements
were sometimes noted by a visit to the portrait studio.

Girl Wearing Striped Stockings
Barr & Wright Studio, c. 1870s
Wet collodion negative, 5 × 3½ in.
Catalog number 77.43.0028

Girl Wearing Scarf with Western Motif
Barr & Wright Studio, c. 1870s
Wet collodion negative, 5 × 3½ in.
Catalog number 77.43.0313

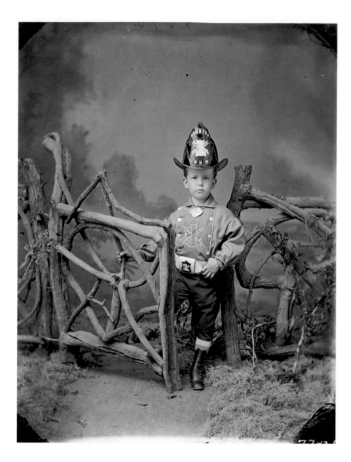

Boy in Fireman Costume
Barr & Wright Studio, c. 1870s
Wet collodion negative, 5 × 3½ in.
Catalog number 77.43.0001

Boy in Ill-fitting Suit
Barr & Wright Studio, c. 1870s
Wet collodion negative, 5 × 3½ in.
Catalog number 77.43.0010

This group of boys' portraits shows a range of studio
settings, from the simple, unencumbered background
to the elaborate setting with costumes and props.
Using the studio's objects might lend an air of style
and class, but bringing a favorite pet or toy made the
experience personal.

Boy with Rocking Horse and Wagon
Barr & Wright Studio, c. 1870s
Wet collodion negative, 5 × 3½ in.
Catalog number 77.43.0027

Boy with Dog on Banister
Barr & Wright Studio, c. 1870s
Wet collodion negative, 5 × 3½ in.
Catalog number 77.43.0542

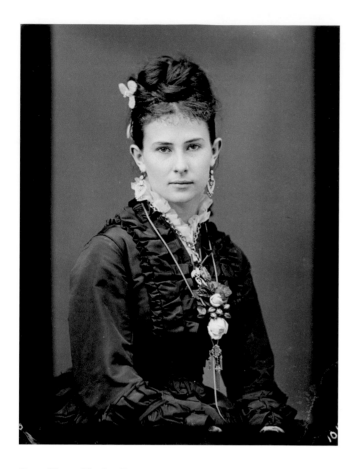

Young Woman Wearing Flowers
Barr & Wright Studio, c. 1870s
Wet collodion negative, 5 × 3½ in.
Catalog number 77.43.1018

African American Woman
Barr & Wright Studio, c. 1870s
Wet collodion negative, 5 × 3½ in.
Catalog number 77.43.0167

These images of women show that despite repeating
motifs and posing conventions, the sitter brings her own
personality and style to her portrait through choices of
props, clothing, and hairstyle.

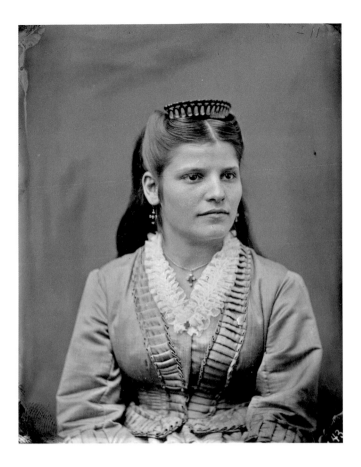

Woman with Comb in Hair
Barr & Wright Studio, c. 1870s
Wet collodion negative, 5 × 3½ in.
Catalog number 77.43.0199

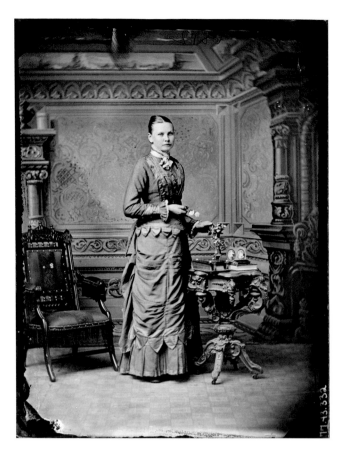

Woman Holding Flowers
Barr & Wright Studio, c. 1870s
Wet collodion negative, 5 × 3½ in.
Catalog number 77.43.0332

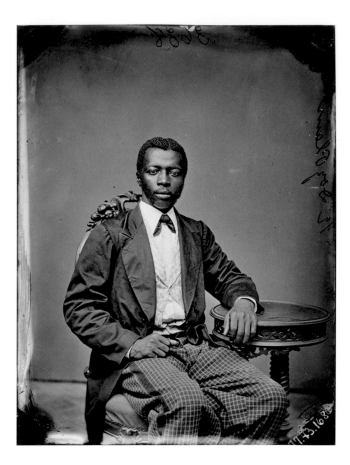

African American Man
Barr & Wright Studio, c. 1870s
Wet collodion negative, 5 × 3½ in.
Catalog number 77.43.1686

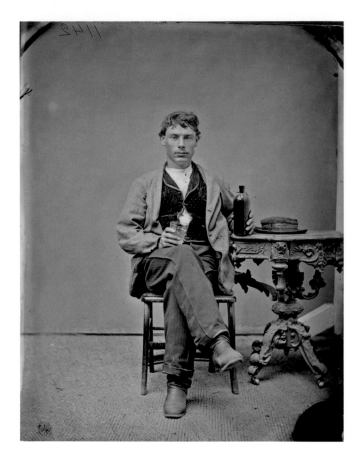

Man at Table with Bottle
Barr & Wright Studio, c. 1870s
Wet collodion negative, 5 × 3½ in.
Catalog number 77.43.1800

The range of men suggest various reasons one visited
a studio, perhaps to mark a visit to the city, memorialize a
reunion, or record one's unique style. These images were
purchased in small batches by the sitters and shared
with family and friends, who often kept them in albums
and frames.

Elderly Man with Reunion Ribbon
Barr & Wright Studio, c. 1870s
Wet collodion negative, 5 × 3½ in.
Catalog number 77.43.1259

Man with Interesting Hairstyle
Barr & Wright Studio, c. 1870s
Wet collodion negative, 5 × 3½ in.
Catalog number 77.43.1022

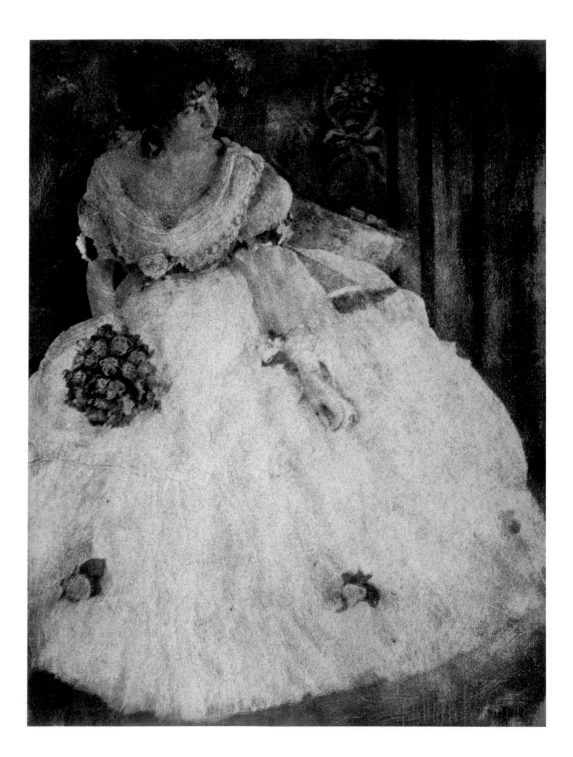

GERTRUDE KÄSEBIER

(1852–1934)

Forging a Path to Beauty

Gertrude Käsebier came to the fore as a portrait photographer just before 1900 in New York City. In addition to her artistic skills, her business sense, maturity, and determination helped her forge and maintain a photography career that saw the rise and fall of pictorialism in the late 1920s. Käsebier printed her softly focused, domestically oriented photographs in a variety of ways that allowed her to finesse each image by hand. For all her well-known pictures conveying feminine strength and crafted with the urban sophistication of the early twentieth century and a painterly sensibility, Käsebier did not commodify a particular body of work. She kept her platinum and gum-bichromate portraits of the Indians in Buffalo Bill's Wild West Show from being commercialized.

The Photographic History Collection acquired most of the Käsebier collection as gifts from Käsebier's granddaughter in the 1960s and from a multi-photographer collection assembled by Alfred Stieglitz. Some of the photographs are among Käsebier's best known and frequently reproduced: *The Manger, Blessed Art Thou among Women, The Heritage of Motherhood, Happy Days*, and *Portrait of Baron de Meyer*.[60] The images in this volume offer some of her less frequently seen photographs. The largest part of the collection, portraits of Native Americans from 1898, is explored in Michelle Delaney's *Buffalo Bill's Wild West Warriors: A Photographic History by Gertrude Käsebier* (2007).[61]

Virginia Gerson
Gertrude Käsebier, 1906
Gum-bichromate print, 11 × 8½ in.
Catalog number 73.15.10

The soft lighting and expectant expression in this portrait gives the impression of a hazy memory, rather than offering photographic details.

Gelatin Dry Plates and Pictorialism

At the end of the nineteenth century, the second industrial revolution yielded an America ripe with new technologies and innovations. There existed new products and markets that conflicted with established modes of photography. Käsebier's emergence and career as a female artist is an example of how paradigm shifts played out. In particular, the dialogue about the lines between commercial and artistic photography was spurred by mass manufacturing and the amateur's consumption of cameras. The introduction of gelatin dry plates in the 1880s eliminated the need to prepare one's own negatives. While easing up labor for professional photographers, it also facilitated the amateur's access to photography. Some photographers hoped that critics and viewers would find an easy relationship between the commercial and artistic photography, and others, like Alfred Stieglitz, hoped to remove utilitarian functions to promote photography purely as art.

Professional photographers needed to distinguish themselves from one another and from amateurs. One technique was to reintroduce the visibility of the artist's hand. This approach often translated into applying a variety of light-sensitive materials to fine tissues or papers rather than purchasing manufactured photographic printing papers. Manipulating the image to soften the focus also removed the hard, sharp edges that suggested the camera was simply a mechanical recorder. The photographer could produce well-exposed negatives and later, in the darkroom, make decisions about artistic effects.

For Käsebier, this method, defined as part of the Pictorialist movement, gave her the opportunity to create photographs beyond the original sitting to shape ideas about her subjects and incorporate artistic gestures to express and invite emotional and intellectual responses. Pictorialism, especially for women, provided an artistic space in which to explore subject matter that was familiar and close to home, such as motherhood, the lives of children, domestic activities, and other topics that often seem

overly sentimental in today's world. Käsebier's photographs, much like her personality, were not overly sweet, but rather represent her response to deeply felt emotions.

Getting an Education

Determined to become a portrait painter even though she was married and had three children, Käsebier enrolled in 1889 at the newly founded coeducational Pratt Institute in Brooklyn, New York. During the course of her education at Pratt, she studied drawing and painting from life and attended lectures on art history, anatomy, and design. She found the staff at Pratt treated the female students as serious artists and helped prepare them for careers. After graduating from the Regular Art Course in 1893, Käsebier reenrolled for another year of painting studies, a decision that proved to be pivotal in her artistic development.

Although photography was not taught at Pratt, it was acknowledged as an art form, and photographers such as Henry Herschel Hay Cameron (Julia Margaret Cameron's son; see chapter 2) gave lectures.[62] At Pratt, Käsebier's exposure to photography was primarily through study prints of paintings and sculptures. Before attending art school she had dabbled with snapshot photography with the sole ambition of recording moments of her children's lives.[63] Over time, she began to merge concepts of painting and sculpture with photography, and in 1894 she won her first two photography prizes.[64]

Käsebier spent the summer of 1895 in Europe with fellow Pratt students, studying with artist and illustrator Frank DuMond. Experimenting with indoor portraiture on a rainy day that prevented painting in the open, she took a timed exposure. She claims to have so loved the result that she knew she had found her vocation.[65] Before returning to New York, Käsebier visited her in-laws in Germany and studied there with the German photochemist Hermann Wilhelm Vogel to improve her skills. Although Alfred Stieglitz had raved about him, her experience was lukewarm. Whatever Vogel's responses to her work, studying with him did strengthen Käsebier's personal vision and commitment to photography.[66]

In the fall of 1895, Käsebier took a class with painter Arthur W. Dow, who used a planning technique that required students to compose an image within a rectangle before beginning, much as one frames an image with a camera. Dow also emphasized the organization of light and dark masses as part of the composition. Because she worked with monochromatic images, the control of highlights and shadows in relationship to the composition became even more important to her.

Her Own Studio

Pratt Institute had been a rich source of information and support for women seeking careers in the arts. An article published in the school's journal in 1894, titled in part "Business Principles for Women," assured women that going into business was not the sole domain of men and they did not risk losing their femininity by pursuing such activities. The text went on to promote the idea of women speaking concisely and without hesitation.[67] The directness and independence that Pratt fostered were two of Käsebier's own strong personality traits, and in 1896 Käsebier decided to open her own portrait studio as a means to generate her own source of income.[68]

While Pratt may not have pointed women to photography in particular, many female advocates of it did, even if with a wary note. In 1894 a Miss M. E. Sperry wrote an article, "Women and Photography," for the journal *Pacific Coast Photographer* in which she advised, "On the whole there is success for women in photography, but it's a hard road to travel. Girls, weigh the subject well before you start in, and unless you are willing to go in, heart and soul, and overcome all obstacles and sacrifice many pleasures, do not decide to enter upon it."[69] To prepare herself for success, Käsebier apprenticed with the photographer Samuel H. Lifshey. The experience taught her how to run a studio and expanded her knowledge of printing techniques.

Having put her mind to becoming a portrait photographer, she found a studio off Fifth Avenue close to wealthy clientele who would have the means and inclination to spend money on art images. She also located herself within a personally supportive environment near the Women's Exchange—a shop where gentlewomen sold handicrafts on commission. While Käsebier's intention was to make artful portraits with unencumbered compositions that captured the sitter's "temperament, soul, humanity,"[70] she was clever in choosing her site.

By setting up a portrait business, Käsebier was classified as a commercial photographer. But she deftly maneuvered between what seemed to be the clear lines separating the commercial and art worlds. In 1900, after three years of work under her belt, she had photographs included in the first exhibition exclusively centered on America's top female photographers. Organized by entrepreneurial photographer Frances Benjamin Johnston, the exhibition traveled to Paris and later to Saint Petersburg.[71]

Käsebier's photographs were viewed not just by those who employed her for creative portraits, but also by those in photography circles. A writer for the Minneapolis Camera Club reported:

> Her work is too well known to need any extended description here, as examples of it appear frequently in the eastern photographic magazines. Her art is not confined to the limits of photography, or perhaps we should say that she recognizes no such limits in the handling of her subjects; some of the prints showing a breath of treatment and atmosphere that make it hard to believe that they are made from photographic negatives, but are rather the work of brush and pen. The prints are largely of the impressionistic school and while Mrs. Käsebier has no peer in the line of work, such portraits as she chose to light according to ordinarily accepted methods and bring out with some degree of sharpness, seemed a relief from the hazy, indistinct and apparently-out-of-focus work which seems to predominate.[72]

In 1899 English actress Ellen Terry (who as a youth had been photographed by Julia Margaret Cameron) purchased a print of Käsebier's photograph *The Manger*[73] for one hundred dollars, setting a record for the most expensive photograph ever sold to date, by a man or a woman. Käsebier's successes were widely noted in popular newspapers and by specialists alike. Art critic Charles Caffin included a chapter on Käsebier's portraiture in his book *Photography as a Fine Art* (1901) because her photographs conveyed "character and individuality," he wrote. "For uniformity of definition and delighting she substitutes the suggestiveness of light and shade; not merely posing her figures, she composes them with the surroundings, and makes the whole composition a beautiful pattern of line and form and color, contriving at the same time that this pattern shall help to elucidate the character."[74] His commendation goes on, "To express the character and make a beautiful picture the means employed have been those of sound and serious art, without any trace of affectation or trick to secure distinction."[75]

Alfred Stieglitz, one of the most powerful voices to shape the world of photography, brought the already successful Käsebier into his circle. He included her work in his first issue of his groundbreaking journal *Camera Work* in 1903. Käsebier consistently produced well-received portraits that focused on the sitter's individuality. Her style within the Pictorialist mode further highlighted her sitters' attributes through her choice of printing processes and techniques.

A Textured Approach

Käsebier approached photography as an expressive artist. She created portraits in which she left the photographic details of faces, hands, and bits of clothing but pushed around the gum-bichromate and platinum while the print was developing to add pictorial effects, thus heightening visual interest and shaping intellectual and emotional responses to the image. Her portrait of the sculptor of *The Thinker*, Auguste Rodin (p. 54), employs this practice.[76] While in Paris in 1900, Käsebier met and befriended Rodin. She made several visits over the next few years, each time making various portraits. With Rodin, she shared a bond in that they both modulated light to craft a form,[77] he in marble and bronze, she with photographic processes on paper. The brush marks of this platinum print suggest preliminary sketches Rodin might make and reveal the photographer's manipulation of light.

From Käsebier negatives located at the Library of Congress, Washington, D.C.,[78] in particular those of American sculptor Solon Borglum, known for his works depicting the western frontier (p. 55), and of Virginia Gerson (p. 48), one can see that Käsebier created well-exposed and -processed negatives. Comparing the gum-bichromate print of Gerson with the negative reveals the softening and manipulation Käsebier employed to create a romantic rendering of the woman in a ball gown. Gerson was the sister-in-law of painter and printmaker William Merritt Chase. The soft drapery in the background and painterly work may, in part, reference Chase's portrayal of Gerson in his *Portrait of a Lady against Pink Ground* of 1886.[79] As the photograph is a somewhat fairy-tale-like image, it may also reflect Gerson's penchant for imagination: she helped edit the popular playwright Clyde Fitch's work and wrote children's books. Käsebier's best-known biographer, Barbara Michaels, describes the photograph as more in line with a fashion photograph and suggests that Gerson designed the dress for the Crinoline Ball at the old Astor House in 1906.[80] Whatever the photographer's intention, she acknowledges her subject's creativity. Not all of Käsebier's photography is so heavily worked; the degree of manipulation depended on her goals for the photograph's aesthetics and how it reflected the sitter's personality.

Portraits like that of influential painter Robert Henri (p. 56) are softened by virtue of the platinum's presence in, rather than on top of, the paper fibers. Holding his hat and umbrella in one hand, as if he is about to leave but not quite ready to go, Henri

seems to have paused to engage with the photographer. He was, in fact, departing within a few days to take a group of students to Holland in April 1907.[81] The interesting composition calls to mind those of Henri's own paintings, with a plain background, relaxed natural pose, and studied light across his face.

Käsebier's portrait of Rose Cecil O'Neill (p. 57) reflects the sitter's independence. The light coming in through the window moves elegantly through the diaphanous material of O'Neill's hat and dress with delicate femininity that is contrasted by the then-masculine act of smoking a cigarette. Käsebier was not afraid to present modern feminine issues. O'Neill, illustrator of the pudgy babies known as Kewpies (for "cupids"[82]), struggled in her relationships with men. The amorphous light and dark haze of the background seem to echo what might have been her inner turmoil.

Perhaps some of Käsebier's most sensitively produced photographs are those of Native Americans. When Buffalo Bill brought his show to New York in the spring of 1898, Käsebier set her sights on photographing members of the Native American troupe. Having spent her early childhood in Colorado, where she played with Native American children, she felt friendly toward them and sent William "Buffalo Bill" Cody a letter explaining her interest. She was granted the opportunity, and nine men were able to pose that April in her Fifth Avenue studio.[83] While they waited for their individual turns to sit in front of her large camera, they made drawings to pass the time. An example is seen on page 58, where Käsebier affixed her portrait of Whirling Horse onto what is presumed to be his drawing.[84]

It was not out of the ordinary to have a photographer request such a portrait session, or even for the show to hire a photographer. Cabinet cards could easily have been made and sold as souvenirs, a common practice (see Introduction, p. xii). Käsebier's portrait studio did not produce token photography, and she did not see the men in her studio as anomalies to be objectified. She photographed them as she did everyone else—filling the frame with their relaxed, naturally posed bodies in front of plain or simply draped backgrounds. Most of the images are not heavily manipulated, although they are softly focused and somewhat atmospheric, as was her style. After the first visit in which all parties were pleased, Käsebier asked to photograph others in the troupe.

One of the most moving portraits is of Mary Lone Bear (p. 59). The little girl was one of the few children Käsebier was allowed to photograph. The nine year old looks directly into the camera and commands the viewer's attention with an almost un-readable expression. One can only imagine what thoughts and

questions were forming behind those intense eyes. Neither she nor Käsebier could possibly know that in a short few weeks Mary Lone Bear would die.

A letter that accompanies the photograph expresses Käsebier's sorrow and frustration and a white woman's bias she probably thought she did not have. "They said the squaws had a superstition that it would kill the child. I told them they ought to know better having been to Carlisle School and around the world with the show. . . . But weeks later when I visited the show and went out to the tepees to visit, the squaws grabbed their kids and ran looking at me viciously. . . . What killed her?" [emphasis Käsebier's] Despite the sad incident, Käsebier re-mained a friend of Mary's brother, Samuel "Sammy" Lone Bear and corresponded with him for many years. Although her experiences of the initial studio visit were recounted in the New York Times and later illustrated in a 1901 issue of Everybody's Magazine, she held the photographs close. Her dark photograph "The Red Man,"[85] swathed in a blanket with the center of his face in the top third of the photograph, was the exception that was frequently exhibited. Käsebier's non-specific title and composition represents her idea that Indians were private, intense, and mysterious and existing in a different space than the viewer, who was most likely a white person. Prizing the individual, she never sold and only sparingly shared her portraits of Native Americans.

Owing in large part to a falling out with Stieglitz, by 1909 Käsebier was moving away from her Photo-Secessionist colleagues. The critics who once praised her now turned on her in their writings. Though hurt, Käsebier had strong ties to other parts of the photography world and retained her status as a premier portrait photographer.

Käsebier's friend and fellow former Photo-Secessionist Clarence White opened his School of Photography in Maine in 1910 and another in New York City in 1914. Käsebier's thoughtful approach to image making, as well as her experience running a successful portrait studio, having work in galleries and museums, providing work for publication, and contending with opposition, made her a valuable member of White's faculty. Dorothea Lange (chapter 5) was a student; Käsebier lectured and taught occasion-al classes until about 1925, when her eyesight began to fail.

Käsebier's daughter Hermine was also a photographer and picked up Käsebier's portrait business beginning in 1923.

Despite her failing health, the stock market crash of 1929 in which she lost a significant amount of money, and shifts in photographic styles, Käsebier continued to receive visitors as well as requests for interviews and prints for exhibitions, remaining a photography star until her death on October 13, 1934.

Käsebier's style emerged from a dialogue that was in part initiated by the introduction of gelatin dry-plate negatives, which opened the door for amateur photographers. Käsebier was one of the amateurs who benefited from this easy access, and she applied academic lessons learned from art school to move her photography into the worlds of art and commerce. Her ability to engage frankly and directly with her subjects prevented her from being a run-of-the-mill portrait photographer. One sees in her portraits that she gave each image deep consideration and a unique treatment to reflect the specificity of the sitter. Her intensity and persistence over more than two decades helped her create a body of work that rewards the viewer who is interested in gaining insight into the subject's life or personality. Käsebier's portraits challenge the photographer to be emotional without sentimentality. Her ability to select a printing technique that best supported the messages of her photography should encourage today's portraitists to embrace the opportunities of the digital world.

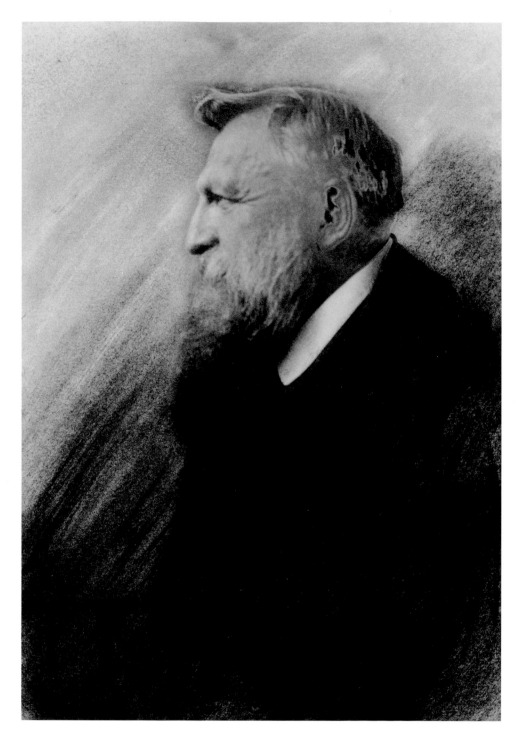

Auguste Rodin
Gertrude Käsebier, 1907
Gum-bichromate print, 9 × 6 ⅝ in.
Catalog number 73.15.30

Käsebier manipulated the application of gum-bichromate
so much that parts of this portrait look more like a
sketch than a photograph, serving to suggest the artist's
preliminary work before executing his sculpture.

Solon Borglum
Gertrude Käsebier, 1902
Gum-bichromate print, 6 × 8 in.
Catalog number 73.15.19

Borglum was noted for his sculptures of Native Americans,
horses, and those commemorating Civil War generals.

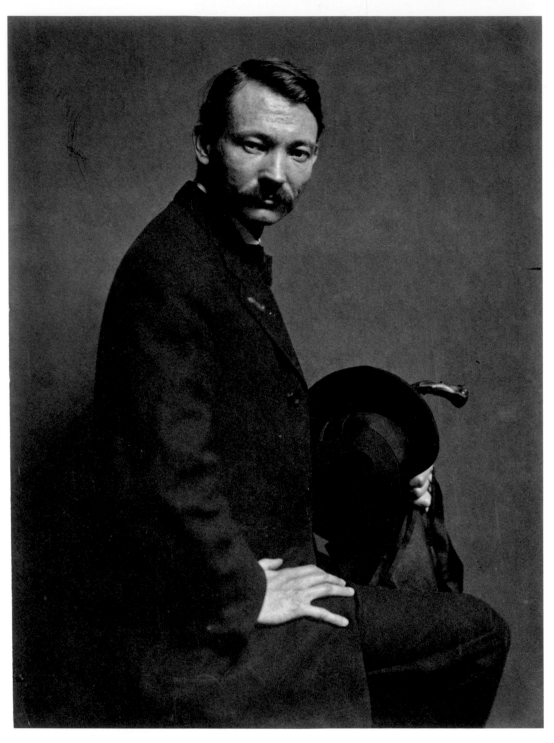

Robert Henri
Gertrude Käsebier, c. 1900
Platinum print, 8 × 6 in.
Catalog number 73.15.32

Käsebier, like the painter Henri and his fellow
Ashcan artists, embraced individuality and frankness
and sought subjects that reflected modern urban life.
Both artists sought realism against a background of
impressionistic influences.

Rose O'Neill
Gertrude Käsebier, c. 1900
Platinum print, 8 × 5 in.
Catalog number 73.15.23

Käsebier's portrait of O'Neill reveals that the well-known
illustrator of Kewpies and "shutterbugs" for Kodak Brownie
advertisements was more complex than her innocent
creations. While the smoke of her cigarette creates an
atmosphere, it also suggests her rebellious side.

Whirling Horse
Gertrude Käsebier, c. 1898
Platinotype and drawing, 8 × 6 in.
Catalog number 69.236.77

Whirling Horse's portrait is affixed to a drawing he
created during the portrait session in Käsebier's studio;
the photograph and the drawing both reflect the
photographer's desire for unencumbered authenticity.

Mary Lone Bear, Sioux Indian Child
Gertrude Käsebier, c. 1898
Platinum print, 8 × 6 in.
Catalog number 69.236.112

It took three years for Käsebier to build enough trust with the Native Americans who traveled with Buffalo Bill's Wild West Show to photograph six-year-old Lone Bear.

F. Holland Day
Gertrude Käsebier, 1907
Platinum print, 8 × 4 in.
Catalog number 73.15.31

Käsebier photographed her frequently costumed
photographer friend drinking from a glass flask that
she rendered with finesse.

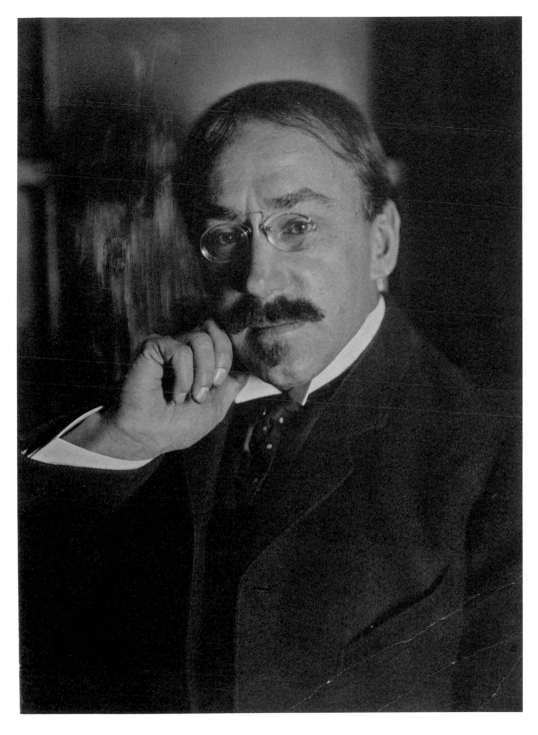

Gelett Burgess
Gertrude Käsebier, c. 1900
Platinum print, 8 × 6 in.
Catalog number 73.15.34

An independent woman, Käsebier would have
appreciated Burgess's line "Love is only chatter; friends are
all that matter," from his poem Willy and the Lady (1901).

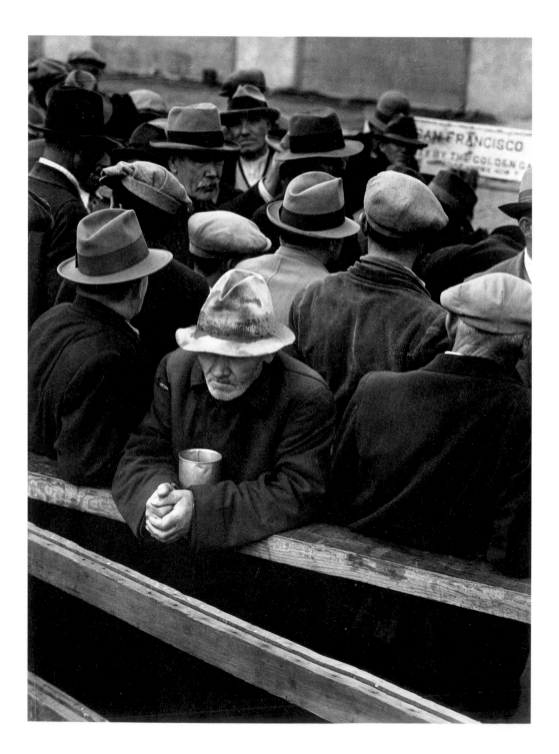

DOROTHEA LANGE

(1895–1965)

Migrant Mother Lives On

Dorothea Lange is among the most well-known photographers who worked for the federal Farm Security Administration (FSA), which generated an extraordinary photographic record. during the Great Depression. Lange's photographs, together with those by Walker Evans, Gordon Parks, Arthur Rothstein, and Marion Post Walcott, formed a national vision of what a number of Americans were experiencing from 1935 to 1942, when their lives were affected by national economic and natural resource disasters. Lange worked mostly in western states, especially California, with an artistically trained eye to document and collect evidence of social and political injustices. Her *Migrant Mother* is one of the most famous images to emerge from the American government's mammoth photographic project of the Dust Bowl–era. Lange's years as a studio portraitist positioned her to keenly frame and record the mother's humanity although her goal of gathering evidence about the state of farmworkers took priority. Lange's image of the destitute mother suppressed the common function of portraiture to express individuality and instead served to present the plight of many.

The Photographic History Collection holds a sampling of Lange's work from across her career. *Migrant Mother* is drawn from a collection of images donated by her FSA colleague Arthur Rothstein.[86] Lange's negatives and personal archives are located at the Oakland Museum of California.

White Angel Breadline
Dorothea Lange, 1932
Gelatin silver print, 22 × 15½ in.
Catalog number 71.64.03

Lange's elegant compositions made it easier to look at and see images of destitution and despair during the Depression while still conveying her concern for humanity.

Turning the Portrait Upside Down

When Robert Taft wrote *Photography and the American Scene* (1938),[87] the FSA and its photography project were just emerging. It was yet to be determined how sustained an impact the photographs would have. Lange and her FSA colleagues, whose works remain easily accessed at the Library of Congress, Washington, D.C., established the baseline of documentary portraiture by their sheer volume, shared subject matter, and wide distribution. The solemn, tired, worried expressions on the weatherworn and dirt-smudged faces of agricultural laborers closely framed in stark black-and-white photography formed the baseline for documentary portraiture. Lange's portraits in particular omit the names that would honor individuality in favor of photographs that seek to represent many people in crisis.

Taft writes, however, of a change in the kinds of photographs being produced, describing them as "arts of peace" and "pictorial news of normal and quiet labor."[88] He closes the chapter "Photography and the Pictorial Press" by hypothesizing, "Through the use of this medium it should be possible, if ever, to reach more rapidly that long sought goal—the brotherhood of man."[89] That sense of optimism perhaps gives some shape to the idealism that FSA chief Roy Stryker, his photographers, and the press generally sought when *Migrant Mother* was created and distributed.

The FSA project was not the first photographic endeavor to record the plight of American citizens, instigate change, or issue a call to action. Jacob Riis's images of New York City's wretched tenements published in *How the Other Half Lives* (1890)[90] brought significant attention from then–police commissioner Theodore Roosevelt. Lewis Hine's photographs of children in fields, coal mines, and factories for the National Child Labor Committee (1908–1918) were key to implementing child labor laws. Riis's and Hine's images were integral to publications and lectures on the topic. Lange's personal interest in the disenfranchised was piqued as a teenager.

Developing a Photographic Eye
and Becoming a Photographer

Born in 1895 in Hoboken and raised in Weehawken, New Jersey, Lange contracted polio at age seven. Because she was struck by the disease before it hit epidemic proportion, doctors were unable to treat it and she was left with a twisted right foot and stiff leg. Her disability was humiliating but also empowering as she devised strategies and called on her inner will to pursue an independent life. A few years later, her father left the family. His desertion created such emotional and psychological scars in her that she eventually dropped her last name of Nutzhorn and took her mother's name, Lange.[91]

As a student, Lange commuted into New York City with her mother, who worked at the New York Public Library.[92] Lange's long walks back to the library from her school on the Lower East Side introduced her to lively immigrant life that played out in front of the buildings, quite unlike that of her middle-class neighborhood. Wandering the streets alone, ever more daringly, she took in the city visually, embraced its modernity, and wrestled with its ethics.

Skipping out of high school classes, Lange and her friend Fronsie Ahlstrom explored a number of arts venues in the city, including Alfred Stieglitz's newly opened gallery at 291 Fifth Avenue.[93] As the niece of several successful lithographers and typesetters, Otto, Fritz, and William Nutzhorn,[94] Lange increasingly saw the world in terms of form, line, and tone. In 1912, when asked what career path she might seek after high school, she stated photography, even though she had never even held a camera.[95]

Lange boldly asked studio photographer Arnold Genthe for a job. A well-known photographer who had made a name for himself in San Francisco before moving to New York in 1911, Genthe agreed to teach the enthusiastic Lange to make photographs with a typical studio Graflex camera that utilized glass-plate negatives. After leaving Genthe's studio, she apprenticed herself to at least seven photographers, who taught her a variety of technical, business, and cultural lessons. Lange also took actual photography classes with the well-known Pictorialist Clarence White (see chapter 4), who taught at Columbia University's Teacher's College before opening his own school of photography. His open approach to teaching allowed his students to find their individual styles; the instruction on composition and observations of the ordinary environment suited Lange well, even if she rebuffed the formality of class assignments and admitted his strong influence only later in her career.[96]

Ahlstrom and Lange saved their money to travel the world. Six weeks after setting off, the young women found themselves in the marvelous city of San Francisco. After Ahlstrom's purse money was stolen, the two decided to get jobs instead of calling on parents and relatives for help. Ahlstorm returned to Western Union. Lange worked at Marsh & Company, where she packaged snapshots and sold photography supplies, among other tasks. Looking at others' pictures, she saw details that were missed by their creators, who valued the images mostly for sentimental reasons.[97] At the store and the San Francisco Camera Club, Lange met many of San Francisco's famous photographers and other individuals who would prove to be helpful. By 1919 Lange's friends Joe O'Connor and Jack Boumphrey had loaned her three thousand dollars to open a studio.[98]

Her Own Studio

From 1919 to 1934, Dorothea Lange ran her own studio in San Francisco where she specialized in portraits of women and children. It was located above an art gallery that sold prints by modern artists as well as those by Albrecht Dürer and other Renaissance masters. Next door was an Elizabeth Arden salon. She was well connected with the area's community of artists, marrying painter Maynard Dixon in 1920. Although she considered herself a craftswoman and was not competing for recognition and salon awards, her visually astute photography was nonetheless exceptional.[99] The customers of her upscale neighborhood combined with Genthe's former San Francisco clients made her the most popular portrait photographer in Northern California. Among her patrons and friends were the politically active liberal elite, with whom she shared political concerns. Lange's *White Angel Breadline* (p. 62) is often noted as a demarcation in her switch from studio to documentary photography, when she began to describe herself as a "photographer of people."[100] The making of *White Angel Breadline* occurred during a transition in her personal life as well. Her willingness to submit to her urge to document the struggles of others in an effort to create change, and the dissolution of her marriage to Dixon, which opened the door for her marriage to economist Paul Taylor, set the intellectual, emotional, and professional stage for her abundant work for the FSA.

Taylor was an adviser to the Resettlement Administration (predecessor to the FSA) created under President Franklin D. Roosevelt (see Nickolas Muray's portrait of Roosevelt, chapter 6, p. 83) and introduced the head of its Historical Section, Roy

Stryker, to Lange. Lange became the photographer assigned to cover the western section of the United States, documenting the plight of migrant laborers and other aspects of poverty brought on by economic depression and drought.

Lange's visual and written recording process was influenced by Taylor's sociological approach of keeping detailed written journals of data, and Stryker's shooting scripts suggesting ideas about what to photograph. Although FSA photographers had individual styles, they started developing their visual stories under Stryker's direction. In tandem with Stryker's vision and management of the photography office, the photographers maintained the concept of working collectively toward a common goal. They believed that what they were doing made a difference.[101]

The Making of *Migrant Mother*

Over its seventy-five-year history *Migrant Mother* has come to represent many ideas and interpretations. The image quickly became an icon and remains so today; regrettably, not all of the reasons for its stature can be fully explored in this essay. It is helpful, however, to understand the context in which the photograph entered into the vernacular and some of the mechanisms that perpetuate its status.

A sense of idealism is embedded in the retelling of the making of the photograph that came to be known as *Migrant Mother*. While the story probably speaks to Lange's conscience and work ethic, it also heightens the mystique that surrounds the image. It was a cold and rainy day in late February 1936. Lange was returning home after spending a month photographing by herself with her 4 × 5 Graflex and having exposed an abundance of film. When she drove past a small hand-lettered sign, "Pea-Pickers Camp," outside Nipomo, California, she debated whether to turn around for a closer look or continue heading home. After twenty miles, she turned around. When she arrived at the camp, she saw a woman and her children. The photographs in the FSA repository at the Library of Congress reveal a short series of images captured as the experienced photographer moved nearer and reframed each image.[102] Linda Gordon, Lange's most recent biographer, describes the situation. "Then the master photographer of children made the unusual decision to ask the two youngsters leaning on their mother to turn their faces away from the camera. She was building the drama and impact of the photograph by forcing the viewer to focus entirely on Florence Thompson's beauty and anxiety, and by letting the children's bodies, rather than their faces, express

their dependence on their mother."[103] The photograph taken, some information recorded, Lange headed home to Berkeley.

Through her data gathering, Lange ascertained that the woman was thirty-two with seven children and that another twenty-five hundred people at the camp shared her desperate circumstances. The FSA photographers collected socioeconomic information to accompany the photographs, but obtaining names was not necessarily part of the recording process, especially for Lange. Omitting an element as humanizing as a name contributes to the idea that the FSA images were to be used as evidence of poverty and that the resulting volume of photographs was the accumulation of visual data to show human need and to garner government attention. That the woman and her children were visual statistics seems at odds with the aesthetic evocation of her humanity; so began the dynamic life of this particular picture.

An Icon in Its Time

When Lange returned to Berkeley and examined her processed film, she felt she had a strong photograph and offered *Migrant Mother* to the *San Francisco News* instead of sending it immediately back to Washington, D.C. The newspaper ran the photograph on March 10, 1936. It created an instant response, raising $200,000 for the migrant workers in Nipomo. What was it about this image that moved individuals to action, when other FSA photographs had not? It wasn't the woman's story or the photograph's caption that motivated people to pull out their wallets; it was the composition of the photograph and the meanings that viewers imposed on it.

Historians often cite two factors that drive Lange's composition—religious overtone and gender. Although she did not overtly use a religious framework to set up the photograph, Lange was certainly aware of the use of Madonna motifs in artworks. In photography, one need only turn back to the work of Julia Margaret Cameron (see chapter 2) in the 1860s to see the purposeful application of religious and allegorical constructions to structure meaning. In combination with the reluctant participation of her sitter, Lange's practiced technical skills and intuition from years of exposure to art enabled her to create a brilliant image, with hints of previous successful compositions and reference to the economic drama playing out before her.

Despite her subject's ragged clothes and smudges, Lange protected the mother's dignity by allowing her to look away from the camera. The edge of the tent pole on the right-hand side of the photograph creates a barely noticeable sense of separation

that may be interpreted as defining the space into which the viewer is intruding. These elements set up an emotional reaction, stimulating a sense of sympathy, especially in reaction to the woman's look of deep concern.

In their book *No Caption Needed* (2007), Robert Hariman and John Louis Lucaites make several interesting points about how Lange's photograph is perceived. "At its most obvious 'Migrant Mother' communicates the pervasive and paralyzing fear that was widely acknowledged to be a defining characteristic of the depression and experienced by many Americans irrespective of income." The authors continue: "By depicting what was known to be a generalized anxiety within the specific form of a woman's body, that emotion is both made real and constrained by conventional attributions of gender." Finally, "In 'Migrant Mother' class is framed and subordinated in its allusion to religious imagery and its articulation of gender and family relations."[104]

The fear that Hariman and Lucaties refer to is associated with the economic depression of the 1930s, but homelessness and destitution have not gone away; in fact, they have been seen increasingly in print if not in real life. It is emotionally wrenching to witness the homelessness of children, who have no control over their situation. As Gordon as well as Hariman and Lucaites point out, the absence of a man in the photograph plays to a social construction in which it was expected that a man should be a provider. The woman's inertness, her physical inability to move because her children are attached to her, contributes to her powerlessness to effect change for them. The reaction to her situation is not one of blame but of pity, and it stokes the desire to help her and others like her. Gordon suggests that *Migrant Mother* "can connote victimization, the irrepressible resilience of Americans, or the selflessness of mothers." Further, "The picture could be said even to stand for the nation."[105]

Its malleability of meaning combined with easy acquistion allowed for wide distribution of the photograph. Throughout the 1930s and 1940s it tended to appear in newspapers and magazines in association with Dust Bowl–related articles, but it also was reproduced to highlight the work of the FSA photographers, as a group or individually.

Expanding the Image

The context for seeing *Migrant Mother* changed in 1955, although its emotional meanings did not, when it was included in Edward Steichen's seminal exhibition *The Family of Man* and in a book of the same name.[106] The Museum of Modern Art curator and famed photographer created the exhibition to embody the "brotherhood of man" (a vestige of the optimism expressed in 1938 by Robert Taft). Lange, essentially an uncredited assistant curator, helped shape some of the themes, such as "fear, love and belonging."[107] *White Angel Breadline, First Born* (pp. 62 and 70), and several other photographs by Lange were included among the 503 photographs in the exhibition that hoped to express the value of life and celebrate it through the photographs of many known and unknown photographers.

Nearly twenty years after *Migrant Mother* was seen in the museum environment, it passed into a new phase and presented as a historical document. In 1973 in his book with Nancy Wood, *In This Proud Land: America 1935–1943 as Seen in the FSA Photographs*, Roy Stryker declared Dorothea Lange's *Migrant Mother* to be the symbol of the project. "She has all the suffering of mankind in her but all of the perseverance too. A restraint and a strange courage. You can see anything you want to in her. She is immortal."[108] Stryker refers to the woman in the photograph simply as "she," a heroine embraced by the country.

As the photograph took a trajectory of its own, its female subject continued her life and watched her face appear in print again and again. In 1958, Florence Thompson wrote to U.S. Camera Magazine after it published *Migrant Mother*, identifying herself as the woman in the photograph and claiming that she would sue if Lange continued permitting use of the image.[109] Although Lange was upset that her image had caused Thompson distress, she was neither liable nor in control of its use, as the government had possession of the FSA photographs. That situation remains true; one need only contact the Library of Congress to acquire a copy of the image.

Even though she had identified herself in 1958, Thompson remained anonymous to the public until 1978, when a reporter for the *Modesto [California] Bee* tracked her down and published her story.[110] Bill Ganzel's *Dust Bowl Descent* (1984) set down her story together with those of other people and places featured in FSA photographs.[111] Thompson did not have an easy life. She was frustrated that an image she felt was unflattering of her and three of her children circulated freely. It was difficult to reconcile that while she was doing all she could for her family in 1936, the rest of the nation was making judgments and using the photograph outside her control, even when it was for charitable purposes. The conflict between private and public spheres came up in an interview in 2009 with one of Thompson's daughters,

who appears in the photograph. "We were embarrassed by that picture. We didn't want people to know we were poor. But we are proud of the story behind the picture."[112]

Lange worked on and off for the FSA, receiving lower wages than equally experienced male colleagues, between 1935 and 1939. Laid off at the end of 1939 for spurious reasons, Lange was hurt but continued to believe in the value of such projects.[113] The work of the FSA was never as productive as during her tenure. Today Lange's image still stands as a quintessentially American photograph. The U.S. Postal Service included it in the 1998–2000 Celebrate the Century stamp series.[114] In addition, *Migrant Mother* is on the cover of the Oxford History of Art book *American Photography* (2003).[115] The photograph's resonance accommodates its use in parody and political statements. On the January 3, 2005, cover of *Nation*, a graphic artist gave the mother a Wal-Mart blue sweater and a nametag to illustrate its feature story "Down and Out in Discount America."[116]

Migrant Mother is the rare photograph that combined the maker's luck and skill and documented an event in a way that deeply affected its audience. As in the work of Riis and Hine, the artist's passion for the human condition translated to her images, moving individuals and government agencies to action. The emerging fields of modern news and documentary photography were shaped by the ethics and aesthetics of the widely distributed FSA images. *Migrant Mother* still stands as a visual benchmark against which to check our economic and social status.

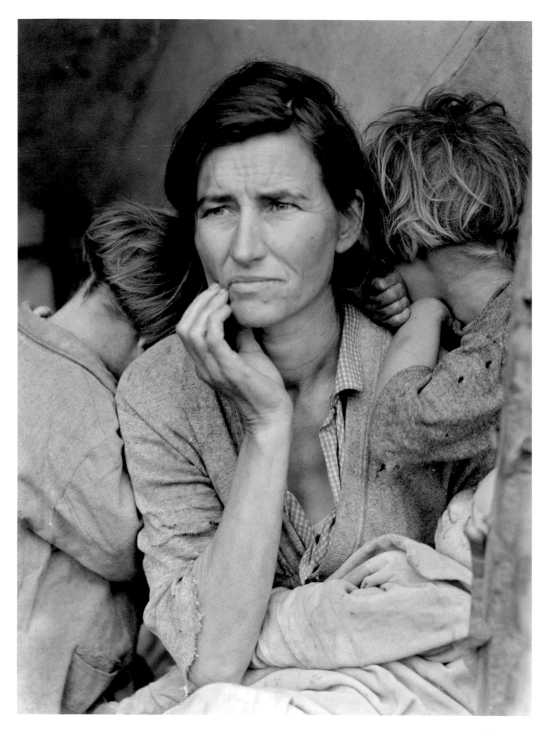

Migrant Mother
Dorothea Lange, 1936
Gelatin silver print, 13¾ × 10¾ in.
Catalog number 1983.0069.07

Lange's years as a studio portrait photographer,
her philosophy about labor, and tasks set by
the Farm Security Administration shaped the
making of her famous photograph.

First Born, Berkeley
Dorothea Lange, 1952
Gelatin silver print, 19½ × 16 in.
Catalog number 71.64.15

Lange photographed her son John carrying his
firstborn across the threshold of her home in
Berkeley, California.

Funeral Cortege,
End of an Era in a Small Valley Town, California
Dorothea Lange, 1938
Gelatin silver print, 19 11/16 × 15 7/8 in.
Catalog number 71.64.04

Lange's portrait of the woman within the car's oval window
permits the viewer to linger over the passing woman's grief.

Damaged Child, Shacktown, Elm Grove, Oklahoma
Dorothea Lange, 1936
Gelatin silver print, 15 × 14 in.
Catalog number 71.64.06

Usually one who held her emotions closely,
Lange could be brought to tears recalling
the girl's tough and unkind circumstances.

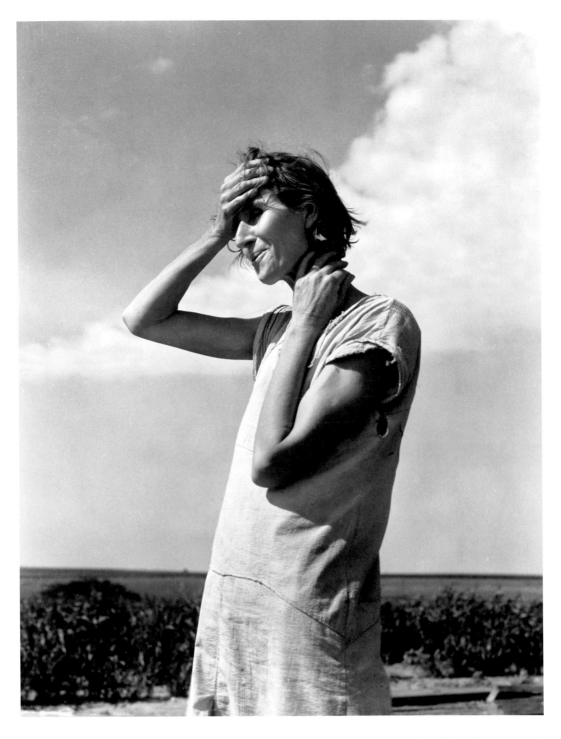

Woman of the High Plains, Texas Panhandle
Dorothea Lange, 1938
Gelatin silver print, 22 × 15½ in.
Catalog number 71.64.07

Lange elevates her subject's stature by
photographing her from below, so that we literally look up
to her for enduring a harsh environment and trying life.

NICKOLAS MURAY

(1892–1965)
An Affectionate Front

Since the arrival of photography, audiences have clamored for portraits of the famous. At the beginning of the twentieth century, the rise of the movie industry, improved magazine publishing techniques, and the emergence of modern mass-marketing all contributed to a synergistic environment in which the public's eagerness to see the famous was paired with businesses' desire to sell products. The result was celebrity endorsement. Nickolas Muray's early photographs in *Vanity Fair* encouraged positive feelings about well-known dancers, actors and actresses, socialites, authors, and businessmen. His later color carbro photographs utilized celebrity status to sell magazines and products.

The Nickolas Muray collection in the Photographic History Collection stands as a tribute to the beginnings of photographic color advertising.[117] Muray's photographic portraiture helped lay the groundwork of today's visual culture. The collection of forty-six color carbro works donated by his wife in the late 1960s includes advertisements for Seagram's Distillers, Mazola Corn Oil, Hunt's Catsup, Campbell's soup, and American Cyanamid, a producer of the oral polio vaccine. These advertising photographs and his work of the 1920s graced the pages of *McCall's*, *Modern Screen*, and *Vanity Fair*.

Life Is Colorful

The desire to record faces in color has existed since photography's arrival in 1839. While photographers and their assistants tinted portrait cheeks and lips by hand, many experimenters were endeavoring to capture the entire world in color. Light is recorded in red, green, and blue; color photographs are typically printed with cyan, yellow, magenta, and black. The process of translating images made with light onto paper printed with inks and dyes and achieving colors exactly matched to the original is challenging.

The Lumière brothers' Autochrome in 1907 was the first commercially successful color process (see Introduction, p. xii). The Lumière Autochrome used multiple layers of varnish to hold dyed potato starches and silver nitrate on glass. The beautiful, soft pictures that resulted were ideal for such subjects as gardens and landscapes or sitters who could remain still for a bit of time. Exposed in the camera, the result was a unique image with no existing negative for reproduction. In its July 1914 issue, *National Geographic*, a magazine now known for its saturated color photographs, included a Lumière Autochrome of a garden in Ghent, Belgium, as a demonstration to readers that color imaging was possible.[118] At four times the cost of printing in black and white, however, publishing the magazine in color was not sustainable.

By the late 1920s and early 1930s, in response to the economic depression following the stock market crash of 1929, publishers and advertisers were switching from featuring glamorous, highly stylized photography that appealed to consumers to images with a more direct, descriptive approach. The idea was to entice consumers with the products themselves rather than overall style and glamour, a goal that was perceived as achievable within the scope of the decreasing salaries of the public. As the compositions of the images became more connected to readers' lives, color was increasingly employed to garner attention and suggest a heightened reality.[119] The color carbro emerged as a photography process that suited the needs of the magazine industry.

The color carbro process creates a richly saturated photograph. Special three-color cameras record images on red, green, and blue negatives. The photograph is then physically built by the accurate registration of layers of pigments on paper—using color tissues of cyan, magenta, and yellow—that have been

Frida with the Magenta Rebozo
Nickolas Muray, c. 1939
Color carbro pigment print, 20 × 16 in.
Catalog number 69.247.24

Muray's use of the layered and rich color carbro process
enlivens the Mexican surrealist painter.

exposed to red, green, or blue negatives, respectively. A black layer of tissue is often added to enhance shading. Although color carbro is laborious and exacting, it is a stable process and the pigments remain vibrant. When the printing is done well, the effect of seeing a portrait in rich, luminous color carbro is visually exciting, especially when it is nearly life-size.

Technological Leanings and Artistic Flair

The Hungarian-born Muray began honing his technical skills and artistic leanings at age twelve when his father apprenticed him to an artist's studio. Within a few years he entered the Budapest Graphic Arts School, where he studied photography, photoengraving, and lithography.[120] After graduating at age sixteen, he began building his graphic production skills as a journeyman lithography engraver at Weinwurm & Company.[121]

In 1909, Muray moved to Germany to refine his technological and artistic skills. At the National Technical School there, he studied photochemistry, color photoengraving, and how to make color filters. Muray earned the International Engraver's Certificate, which afforded him the freedom to work anywhere in the world. In *I Will Never Forget You* (2004), Salomon Grimberg sums up Muray's transition from Europe to America: "In August of 1913, armed with $25, a fifty-word English vocabulary, an Esperanto dictionary, and an unrelenting determination, twenty-one-year-old Miklós Murai arrived at Ellis Island, where he became Nickolas Muray."[122]

Muray was employed within about a week, and he eventually arrived at *Vanity Fair* publisher Condé Nast, where he produced color separations and halftone negatives. Also interested in finding photographic work, he began showing his portfolio and meeting photographers, including Edward Steichen, with whom he would share a lasting friendship. Another friend, well-known New York portrait photographer Pirie MacDonald, suggested that Muray's work was good enough for Muray to open his own studio. Following his suggestion, Muray maintained—barely—a photography studio where he lived in Greenwich Village, keeping office hours from morning to midafternoon; at night he worked at Condé Nast from 6 P.M. to 2 A.M.

His big break came when Henry Sell, art director at *Harper's Bazaar*, saw Muray's photographs in the *New York Tribune* and called on him to photograph actress Florence Reed, who was performing on Broadway in *The Mirage*.[123] One photograph from that time is his portrait from 1921 of actress Ann Harding (p. 80), who was performing on Broadway in *The Lonely Heart*.[124]

Muray's photographs of the illustrious personalities of writers and performers that shaped the Roaring Twenties, established the beginning of his photographic career.

In 1926, Frank Crowninshield, then publisher of *Vanity Fair*, asked him to photograph the students of dancer Helen Moeller, who taught Isadora Duncan's dance steps.[125] The pupils danced nude under translucent, gauzy togas, similar to those seen in *Hilarity* (p. 81), which features an unnamed member of the newly formed modern ballet troupe organized by Michel Fokine.[126] The muscular bodies, captured in a sensuous and 1920s elegantly modern style, quickly gained Muray a reputation as a dance photographer.

It was not long before Muray was photographing and befriending actors, writers, dancers, and politicians. His charm and erudite sensibilities, as well as his location in Greenwich Village next to the theater in which Eugene O'Neill's plays were performed, contributed to his growing circle of famous and influential friends. He encouraged those friendships by holding Wednesday-night soirees. The record of his access and contributions to photography during this period are well-documented in Paul Gallico's *Revealing Eye* (1967)[127] and Muray's *Celebrity Portraits* (1978).[128]

Muray's understanding of human form and athletic control and his appreciation for grace were enhanced by his own extraordinary skill as a fencer. At the time he was becoming known for his photography, he was also winning fencing tournaments; in 1928 and 1932 he competed on the U.S. Olympic fencing team. Muray's nuanced attention to form, his exacting personality, and his rich background in color printing facilitated his embrace of the color carbro when it was introduced in the 1930s. His publishing contacts and well-connected friends facilitated his ascent as one of the most desired photographers in the medium. Despite his close association with a variety of artists, Muray considered himself a photographic technician and professional: "As a photographer, I am just a good plumber."[129]

In 1930, after signing a four-year contract with *Ladies' Home Journal* to produce color fashion photography, Muray traveled to Europe to buy the best commercial equipment.[130] He returned with a single-shot three-color camera, the Jos-Pe. Rhombus-shaped with a single lens, the Jos-Pe had three plateholders to simultaneously record the image through red, green, and blue filters. The color carbro process created excitement, and Muray and a handful of other color photographers exhibited their work and gave demonstrations to engage and inform the public.[131]

Magazines trying to recover lost revenue from the Depression had to work hard to garner the consumer's attention. Color sold. In 1931, Victor Keppler, working for the *Saturday Evening Post*, created the first color photographic magazine cover using two ice skaters sailing across a red background; it stood out from an abundance of monochromatic newspapers and magazines. Like Keppler and Paul Outerbridge, also masters of the three-color carbro process, Muray quickly adapted his aesthetic to incorporate the new compositional challenges of color while still creating images for publishers and advertisers. In 1935, *McCall's* homemaking magazine had a photography contest, which Muray "won" (he was actually selected in advance). His "prize" was to create covers for magazines and the homemaking and food sections for the next ten years.[132] Many of his images can be seen in the Photographic History Collection as well as the George Eastman House, Rochester, New York.[133]

Portraiture Four Ways

The Nickolas Muray collection in the Photographic History Collection offers four approaches to portraiture, each with a twist of color. The Frida Kahlo image is an example of the photos Muray created for himself and a small group of viewers. Tony Sarg, Franklin D. Roosevelt, and Marlene Dietrich represent commercial portraiture. Edward G. Robinson's image blends the commercial portrait with celebrity endorsement. The last group uses celebrity portraits on magazine covers. The arrangement of the images in this section heightens the differences in the relationships among the subject, photographer, and viewer as the purpose of the image shifts.

One series of images that Muray made with color carbro was not on commission: his portraits of Frida Kahlo, the Mexican surrealist painter. In 1923, Muray met Mexican illustrator and caricaturist Miguel Covarrubias through the writer and photographer Carl Van Vechten, a mutual friend. Covarrubias and Muray became good friends, and after an acrimonious divorce from his third wife, Muray went to Mexico for a visit. During that trip, in 1930, Muray met Kahlo, the artist emerging under Mexican muralist Diego Rivera's tutelage, and they had their first tryst. Although she was always linked to Rivera, whom she married, Kahlo held part of her heart for Muray until her death in 1954.

Frida with the Magenta Rebozo (p. 74) is from a series that Muray took in his New York studio in 1939. Intending to show Kahlo the new color carbro process, he ended up making several portraits of her, one of which remains in Rivera's bedroom in the Frida Kahlo Museum in Coyoacán, Mexico. It is understandable that the two men who adored her would embrace the photographs that most accurately depicted her dark penetrating eyes, her love of color, and the tone and texture of her skin. About a year after he made this photograph, when he realized that she would never untangle herself from Rivera, Muray began to ease out of his romantic relationship with her, although they stayed friends to the end of her life.[134]

Muray attracted numerous friends to his studio, among them Tony Sarg (p. 82), a well-known puppeteer who created many of the early balloons for the Macy's Thanksgiving Day parade. Even New York governor and Democratic presidential nominee Franklin D. Roosevelt (p. 83) sat for a series of color photographs.[135] We know most people from this era through black-and-white photography; seeing the subjects in color makes them seem more human and accessible.

Celebrity endorsement has been in vogue since the end of World War I in tandem with modern advertising.[136] Although celebrity endorsement was not without ethical, legal, and federal complications, many companies embraced it, especially for tobacco and liquor products. One of the most successful campaigns was for Lux soaps, beginning in 1933 and running into the 1940s. Kerry Segrave in *Endorsements in Advertising* (2005) writes, "Celebrity endorsements sold tons of Lux and gave the Hollywood Stars the benefit of free publicity for themselves, and for their current or upcoming films, since that was almost always mentioned in the ad." Many of the actresses did not receive compensation, convinced—by studio executives—that the publicity value was worth it.[137]

In 1946, Muray made a portrait of actress Marlene Dietrich (p. 85), typical of the type one might find of a celebrity. She is in her home, striking a dramatic pose and contrasted with the Paul Gauguin painting behind her. Compare Dietrich's portrait to the one of film actor and fellow art collector Edward G. Robinson (p. 84). Both well-known actors are elegantly attired in their well-appointed homes in front of modern art paintings. The Dietrich portrait, taken to accompany a magazine article about her, gives the reader a sense of getting to know the actress in a private setting. The photograph of Robinson also builds on the reader's excitement of gaining access to the celebrity's private life and ups the ante with the actor's unspoken invitation to join him for a drink. If Pabst Blue Ribbon beer is good enough for Robinson's fine tastes, it is good enough for the viewer, who now has positive feelings associated with the beer.

By the 1950s, when Robinson posed for the advertisement for Pabst, celebrity endorsement advertising and contracts were slightly more sophisticated than those of the early Lux era. Jules Alberti, founder of Endorsements, Inc., in 1946, specialized in celebrity endorsements and had three guiding principles: the endorser and the product had to be "solidly entrenched" and have "unassailable successes"; the personality of the celebrity must pair well with the product; and the endorser actually had to use the product.[138] Lord Calvert Canadian Whiskey ran a campaign on this philosophy for about a decade beginning in the mid-1940s. Called "Men of Distinction," it showed men of high achievement, such as professors, lawyers, high-ranking military officers, and businessmen reposed in their homes or libraries sipping the liquor. The message was simple: to be smart and important, sip Lord Calvert. Pabst was following in the campaign's success.

The celebrity relationship to magazines is different from endorsements in that they and their projects are often the subject of the magazine articles. Muray's photographs incorporating celebrity portraits as shown on the following pages should be understood as the foundations for *Modern Screen* magazine covers (pp. 86–89). The empty spaces would be filled by the magazine's name and other text. The penciled outline of the cover and notes about the issue number are visible.

The Hollywood system that raised the stature of actors to superstars utilized fan magazines as one mechanism for building popularity and establishing some actors as household names. In *Inside the Hollywood Fan Magazine: A History of Star Makers, Fabricators, and Gossip Mongers* (2010), Anthony Slide quotes an unnamed fan magazine editor from 1948: "We are writing inverse statements of frustration. We paint beautiful pictures of love, excitement, wealth, prestige, security, and glamour. . . . We give the reader a feeling of identification with the stylized intimacy of a movie star's existence."[139]

While *Modern Screen* seems less erudite than *Vanity Fair*, it was fitting that Muray worked with the fan magazine. His color carbro photographs paired well aesthetically with the vibrant Technicolor movies in which some of his subjects were seen. He was comfortable around the rich and famous and their sometimes challenging personalities. And his goal as a portrait photographer was to capture his sitters' "affection front," which suited his subjects, the publishers, and the consumers just fine.[140] On the magazine cover, the celebrity portrait is used to promote the actor's Hollywood image and movies and to sell magazines. These are not the intense familiar portraits such as those of Kahlo and Sarg, but rather stylized and whimsical.

Esther Williams (p. 87) and June Allyson were the two most popular stars of the 1940s. Muray's portrait of Williams highlights the elegance of her simply cut green silk dress and red lipstick, which average readers could emulate.

The actors on the covers seemed friendly and neighborly while also glamorous. Before she married Tony Curtis or performed in her famed role in Alfred Hitchcock's *Psycho*, Janet Leigh (p. 86) posed for the December 1950 cover of *Modern Screen*. The issue advertised a contest in which an unnamed celebrity would come to the winner's dance party.

Other cover images—such as of Larry Parks (p. 88), which shows the actor at the front and also on a motorcycle in the background, and Frank Sinatra (p. 89) with records flying behind him—created depth and visual complexity. The images that seem to exist on multiple picture planes were produced by simply cutting photographs printed in smaller scale and pasting them on the page. Today, computer programs use the language of "cutting and pasting" with text and images that derived from the publishing world's understanding about how to move content around. Computer technology facilitates playing with image scale, quality, and color, and marrying text and images is a seamless task.

<hr>

Muray remained a master of color carbro until his death in 1965 from a heart attack during a fencing match. Although other color photography processes were introduced over the course of Muray's career, most notably Kodachrome, the first successfully mass-marketed color film produced from 1935 until 2009, Muray never adopted other color technologies. His attachment to color carbro afforded him the opportunity to create flattering, lifelike portraits that processes introduced at the end of his career could not.

Muray's work stands out in the Photographic History Collection as representing a master color carbro printer and offering a look at celebrity portraiture and its use in publishing from the 1920s through the 1950s. The course of Muray's career followed the modern emergence of celebrity portraiture in advertising, which lured us to pay attention to specific products in hopes of gaining a bit of star power by acquiring those products.

Muray's celebrity portraiture is highly controlled and limits what we know about his subjects as individuals. The stars present themselves with confidence and glamour with the intention of selling their movies and augmenting their public persona. By

contrast Richard Avedon, in this volume's chapter 7, sought to look beyond the crafted personality, and Robert Weingarten, in chapter 10, provides his well-known subjects an opportunity to explicitly shape the content of their portraits.

The heightened glamorization of celebrities and the desire to be like them, whether through product purchases or physical emulation, are benign for some. But for others, such as those in Lauren Greenfield's photographs (chapter 9), it can be debilitating. Muray's photographs help us understand and reflect on the way celebrity portraiture has been utilized in marketing and has an impact on our daily lives.

Ann Harding
Nickolas Muray, 1921
Gelatin silver, 19 × 14 in.
Catalog number 3535

Many of Muray's early portraits, like this one of the
actress Ann Harding, appeared in *Vanity Fair*.
The richness and texture of this gelatin silver were
meant to emulate the more expensive
platinum process.

Hilarity
Nickolas Muray, 1921
Gelatin silver, 19 × 14 in.
Catalog number 3534

As an Olympic fencer, Muray had an appreciation for
dancing that gave him an edge when photographing
and writing about the strength, speed,
and elegance of the human form.

Tony Sarg
Nickolas Muray, c. 1936
Color carbro pigment print, 20 × 16 in.
Catalog number 69.247.23

Muray depicted his friend Sarg with a loose tie
suggesting his whimsical nature as a puppeteer whose
marionettes were featured in stage performances in
London and New York City.

Franklin Delano Roosevelt
Nickolas Muray, c. 1932
Color carbro pigment print, 20 × 16 in.
Catalog number 69.247.20

This portrait of Roosevelt reveals his piercing blue eyes,
a feature that is lost in black-and-white photography but
was a noted trademark when meeting him in person.

Edward G. Robinson, Pabst Beer
Nickolas Muray, c. 1950
Color carbro pigment print, 20 × 15 in.
Catalog number 7923

Most known for his demeanor as a tough-guy actor,
Robinson also endorsed U.S. Savings Bonds, razor blades,
and Maxwell House coffee.

Marlene Dietrich
Nickolas Muray, c. 1946
Color carbro pigment print, 20 × 16 in.
Catalog number 69.247.22

Dietrich, a fashion icon and screen siren, strikes a
pose in front of a painting from her art collection.
Bringing well-known personages to life through the use of
color photography helped fuel the cult of celebrity.

Janet Leigh,
photograph for the cover of Modern Screen *magazine*
Nickolas Muray, 1950
Color carbro pigment print, 20 × 14 in.
Catalog number 7916

More than a decade before her famous role in *Psycho*,
Leigh was titled the number-one glamour girl in Hollywood
in 1948. The penciled lines indicate the dimensions of the
magazine cover.

Esther Williams,
photograph for the cover of* Modern Screen *magazine
Nickolas Muray, c. 1951
Color carbro pigment print, 20 × 14 in.
Catalog number 7919

Williams, the swimming and diving movie star, was
returning to work after the birth of a baby and had just
launched a line of swimwear and completed filming
Texas Carnival when Muray photographed her for the
March 1951 cover.

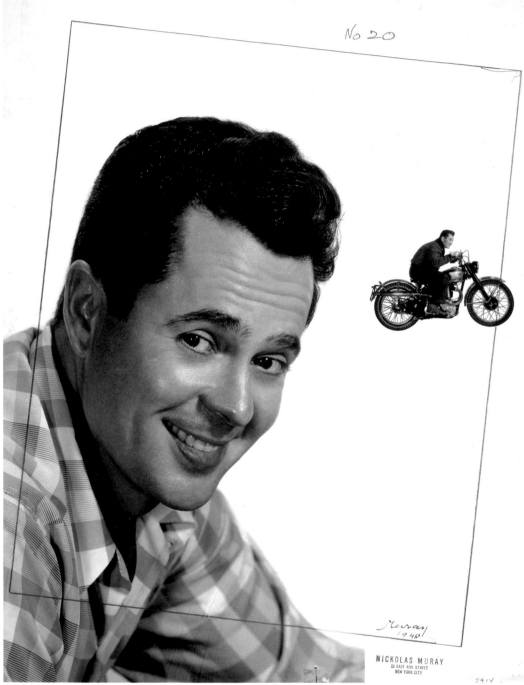

Larry Parks,
photograph for the cover of Modern Screen *magazine*
Nickolas Muray, c. 1948
Color carbro pigment print, 20 × 14 in.
Catalog number 7914

In addition to color, collaging visual elements and
text helped create dynamic designs that would entice
readers to purchase the magazine, at a cost of about
fifteen cents in the late 1940s. The inexpensive magazines
fueled career actors like Larry Parks, who was known for
portraying another performer, Al Jolson.

Frank Sinatra,
photograph for the cover of **Modern Screen** *magazine*
Nickolas Muray, 1946
Color carbro pigment print, 20 × 14 in.
Catalog number 7917

Sinatra was featured as "Man of the Year" on the
January 1947 cover of *Modern Screen*.
His song "Five Minutes More" was a hit in 1946.
The crooner–actor was known for his blue eyes, which
are terrifically highlighted by color photography.

RICHARD AVEDON

(1923–2004)

A Portrait Is Not a Likeness

Richard Avedon is primarily known as a fashion photographer who enlivened his models by setting them in motion and taking them out of the studio. At the onset of his career in 1944, he worked mostly in black and white, although numerous cover images he produced for *Harper's Bazaar* were in color. As Avedon's work matured and was seen beyond the fashion magazine's pages, he began thinking about how fashion emphasizes the exterior without recognizing the interior life of his subjects. In his nonfashion photographs, otherwise known as editorial portraits, he sought to capture the complex emotional and psychological life of his sitters. In doing so Avedon turned portraiture upside down by rejecting flattery and searching for a deeper meaning. The breadth of the Avedon collection in the Photographic History Collection encompasses the first part of Avedon's career, including the image that had brought Avedon to the attention of *Harper's Bazaar* art director Alexey Brodovitch and launched him into his profession, the film negative of a little Italian boy with a tree in the background that looks like the explosion of an atomic bomb. In total the collection consists of five hundred photographs, contact prints, and tear sheets as well as two hundred negatives by Richard Avedon.

In 1962 the Smithsonian Institution gave Richard Avedon, just in his early forties, his first solo exhibition. *Richard Avedon* arose from his participation in the Famous Photographers School, a correspondence program that teaches photography to individuals and included Irving Penn, Alfred Eisenstaedt, and Bert Stern. In agreement with Victor Keppler, head of the program, each of the famous photographers was given an exhibition at the Smithsonian[141] in exchange for participating in a promotional testimonial for the Smithsonian's Photographic History Collection curator, Eugene Ostroff.

The dramatic and innovative exhibition that Avedon had designed was mounted on the second level of the Smithsonian's Arts and Industries Building in Washington, D.C. Tear sheets and printer's proofs from Avedon's photography book *Observations* (1959), for which Truman Capote wrote text, cut-up contact sheets mounted on notebook paper, 3 × 4–feet murals (or larger), and standard-size photographs were adhered with pushpins over the three walls that formed a U shape. One had to physically move forward and backward to see the photographs. The push-pull tension was reinforced by images laid out to contrast life and death, exquisite beauty and the banal, and youth and old age.

Avedon donated the entirety of the exhibition to the National Museum of American History. He made additional gifts to the Smithsonian in 1965 and 1966, just as the design and editorial strengths of *Harper's Bazaar* were waning and he was shifting to work for *Vogue*. The gift consisted of two hundred photographs mounted on shiny black boards, their matching negatives, and contact prints. The images presented here are from those donations. The works convey emotional and psychological tension and represent Avedon's anxieties as expressed in his first exhibition and throughout his career.

Developing an Audience

The careers of Avedon and Nickolas Muray (chapter 6) overlapped in the 1940s and 1950s. Each worked predominately for print publications to bring products and celebrities to a mass-market, although in very different styles. Muray saw himself as a color carbro technician utilizing color photography to enhance advertising and sales for the magazine he worked for. Avedon was employed by the then-cutting-edge fashion magazine *Harper's*

Aldous Huxley
Richard Avedon, 1956
Gelatin silver print, 15½ × 15½ in.
Catalog number 67.102.024

Huxley once wrote, "There are things known and there are things unknown, and in between are the doors of perception." Avedon's portraits are those perceptions.

Bazaar. The magazine was the epitome of contemporary style. Its modern sensibility was defined by the magazine's typography, designed by art director Alexey Brodovitch, the inclusion of writers like Capote and Carson McCullers, the innovative photography of Irving Penn, Louise Dahl-Wolfe, and Richard Avedon, and, of course, the fashions themselves.

Modernism embraced abstraction by paring down composition, color, and shape to their essential form and meaning. Avedon incorporated those ideas into his photography by working in black and white and using extreme cropping and white or gray backgrounds that eliminated environmental details. By peeling away the manner in which people project ideas about themselves through fashion and persona, Avedon began to reveal essential emotional and psychological components of his sitters. His portraits that pared down the human experience were widely seen and distributed on the pages of *Harper's Bazaar* and challenged conventional portraiture.

Commercial photographers employed a wide variety of cameras in that era. Large-format 8 × 10–inch cameras produced beautifully detailed photographs but required time and staging. Photojournalists, needing to record images as quickly as possible, were using small, hand-held 35mm cameras. The film and lenses in the compact cameras provided flexibility and spontaneity, but the quality of film it generated was sometimes grainy and gritty.

The Rolleiflex, first introduced in 1933, became Avedon's signature camera, although he also used a large-format 8 × 10–inch camera. The Rolleiflex twin-lens reflex is a medium-format camera in which two lenses are placed one on top of the other. The recorded image passes through the lower lens, and the upper lens projects the image onto a small ground glass that can be seen on the top of the boxy camera. The camera is usually held about waist-high so that the photographer can see whether the image is in focus. It produces a highly detailed, 2¼-inch square negative. Using a Rolleiflex allowed Avedon to move with his subjects as they moved. He could maintain a conversation instead of ducking behind a camera and under its dark cloth, risking breaking a mood or losing a photographic moment. Avedon maximized the advantages to keep the subject from being fully aware of when he was actually making the exposure. He sometimes had an assistant hold the camera to ensure the subject was in focus, while he managed the cable release, further reducing the likelihood of the sitter's self-conscious performance for the camera and increasing Avedon's ability to capture a passing expression.

Learning to Show Emotions

Avedon grew up in New York, where his father owned a women's clothing store on Fifth Avenue. Although the young Avedon papered his bedroom with pages from fashion magazines, he was more interested in music and poetry. He was even named the Poet Laureate of New York high schools in 1941. Avedon met writer James Baldwin when they coedited a high school literary magazine together; they would later collaborate on the book *Nothing Personal* (1964).[142] After high school Avedon joined the merchant marines and was charged with making identification card portraits. As a going-away present, his father gave him a Rolleiflex camera.

When he left the merchant marines (1942–1944) and returned to New York, Avedon was determined to work with Brodovitch. After fourteen canceled interviews, Avedon finally met with the famed graphic designer, who was often known for saying, "Astonish me!" Avedon did just that at a moment when the *Harper's Bazaar* art director was fed up by the tantrums and demands of seasoned photographers Dahl-Wolfe and George Hoyningen-Huene, creating an entrance for the energetic, wide-eyed twenty-two-year-old Avedon.[143] Within the pages of *Harper's Bazaar*, with guidance and encouragement from Brodovitch and editors Carmel Snow and Diana Vreeland, Avedon's creativity flourished. Each editor was committed to a high level of excellence and ambition, and the environment fostered Avedon's eagerness to learn, absorb, and produce.

Avedon's interest in music and poetry had nurtured his understanding of emotional and intellectual abstraction and lyricism. He drew heavily on those attributes and on his enthusiasm for life, wanting to show the models as real people and not just mannequins draped in elegant fabrics and contemporary designs. During Avedon's career, he became a superstar with a pantheon of intense, textured, and intriguing subjects.

Substance over Flattery

Portraiture's long success has been built on flattery; the fashion world is dependent upon it. Avedon's sister, Louise, had been told all her life that all she needed to do was be pretty. But beneath her beautiful face and those of many of the models he knew were dynamic personal lives struggling with inner voices, pain, and insecurities, an experience he also knew. Avedon began to photographically explore how to move beyond a lovely surface to get at the elements that make us human. The pages of *Harper's Bazaar* featured his dynamic

fashion photographs as well as those revealing stark lives beneath the surface.

Avedon's pictures are striking, showing that he usually won the battle of ego and agenda. As photography matured, the calculated use of portraits to promote one's image expanded. By the time Avedon invited noted culture makers, not necessarily celebrities, to his studio, the individuals were quite self-aware about how they wanted to present themselves to the camera. Harold Rosenberg, in the introductory essay to Avedon's *Portraits* (1976) raises the point: "A conflict arises between the portraitist and his subject … a battle of human wills and imaginations."[144] Avedon himself is often quoted as having said that his portraits are more about him than the sitter. "They are all pictures of me. … I don't walk through the streets looking like [Bert] Lahr or [Charlie] Chaplin or Marian Anderson but I go along feeling like them."[145] In fact, Avedon and his camera are literally reflected in the eyes of many subjects (see *William Casby*, p. 96). A third player in the dance of ego and agenda must also be acknowledged—the viewer.

It is sometimes difficult to look at Avedon's photographs. In exhibition they loom over the viewer with unsightly skin, vulnerability, menace, anxiety, and confrontation that one generally wishes to turn away from. At the same time the compelling subjects, strong graphic composition, and stark contrast of the photographs beckon the viewer to explore the emotional and psychological intensity and the landscape of physically aging bodies.

The Sitters

Many of Avedon's sitters had their heydays long before he recorded them. Subjects were selected for their contributions to culture and society and their ongoing impacts on both; complexity and depth derive from the experience of the viewer, who often brings some knowledge and recognition of the individuals' remarkable and long-lasting achievements. Marianne Moore and Ezra Pound (pp. 97 and 98), for example, are both portrayed with their eyes closed while reciting poetry; shutting out the external world, they retreat inside themselves. Once an aspiring poet and a lifelong lover of the theater, Avedon sought to goad his viewers to wrestle with life's big questions.

Perhaps the first feature one notices about Avedon's portrait from 1956 of Aldous Huxley (p. 90) is his eyes. The English novelist, whose *Brave New World* was published in 1932, has eyes of different shades looking in two directions, as if one eye is focused on the present and one on the future. The viewer familiar with the writer's seminal novel knows the work projected contemporary issues regarding love, marriage, ethics, and government to a futuristic world. Avedon's photograph echoes Huxley's literary approach by capturing the author's momentary physical presence and drawing attention to his eyes, suggesting Huxley's ability to look to the current state of being but have an eye toward an alternate view. A photographer does the same: records the physical presence of the person in front of the camera, but applies his or her own vision. Some photographers, like some writers, have great clarity of vision and the ability to articulate it on film.

Like Julia Margaret Cameron (chapter 2), Avedon often filled the frame with the sitter's head and shoulders and left the surrounding space void of clutter or context. In Avedon's case, the space tends to be white, in part owing to his graphic training with Brodovitch, whose designs incorporated plenty of white space.[146] Again like Cameron, Avedon creates monumental heads. Philosopher Bertrand Russell's head is the central feature of Avedon's portrait of him (p. 102). Russell's profile is pushed to the left, his nose almost touching the edge of the image. The shadow in his ear pulls the viewer's eye from the front of his face to the back of his head with the effect of noting how large his brain must be, for his head seems quite big. The viewer must notice his hearing aid; it might be seen as his willingness to listen, or perhaps his ability to selectively avoid hearing what others have to say. Both approaches probably contribute to a meaningful thoughtfulness. Around the time this image was made, Russell was honored with the 1963 Jerusalem Prize, a literary award given to writers whose work deals with themes of human freedom, society, politics, and government. That Avedon photographed Russell with his cheekbone at the center of the photograph shows that he honors the head in which Russell's thoughts were formed and speaks to the photographer's praise of the cerebral and philosophical. Russell's signs of aging—receding white hair, a neck of wrinkles, and age spots—are not detriments, and he holds his head with pride and steady vision.

While Avedon's photographs were often seen in *Harper's Bazaar*, they are not fashion pictures. Even his photograph from 1958 of Gabrielle "Coco" Chanel (p. 99), with her requisite signature strings of pearls, is not about fashion. With the lens pointing up, she has been recorded from below. Perhaps viewers recall a similar experience as a child, looking fondly up to an aged grandmother or great aunt and being fascinated by her neck. Avedon highlights Chanel's loosened skin and the wrinkles on her face, the dark lips, and the exceptionally prominent vocal cords known

for issuing many fashion-oriented quips, such as "Nature gives you the face you have at twenty; it is up to you to merit the face you have at fifty." Avedon was thirty-five when he photographed her, as Capote's text describes in *Observations*, "mid-flight in one of her nonstoppable monologues." Graphically, her earrings form pearly Os, and the dark of her hat forms a C. It may seem a bit simplistic, but perhaps it is Coco's own recognizable logo of two overlapping Cs, one facing forward, one backward, that forces the viewer's mind to see the letters of her name.

Avedon's photograph *William Casby, Born into Slavery* (p. 96) confronts you head on. Casby's entire face fills the frame, and the lack of white space continually pulls the viewer's eyes back to his. It is uncomfortable to look into his aging, watery eyes and to know he has experienced extraordinary racism. His set jaw contends that it is not over. Indeed, in 1963, when this image was taken, the civil rights movement was a prominent political issue moving toward the Civil Rights Act of 1964. The struggle played out violently, with dogs and fire hoses, in southern cities such as Birmingham, Alabama. Using his resources—camera, darkroom, and access to *Harper's Bazaar* and book publishers—Avedon printed the image to help draw attention to the cause. Casby's eyes, reflecting the photographer, stare directly at the viewer and ask, "Now that you have acknowledged me, what are you going to do?" The question may be subtly reinforced by Casby's left ear, which looks something like a question mark. As with Chanel's hat and earrings, Avedon here displays a poet's sensibility in using literary cues succinctly and seamlessly to enhance the effect of his photographs.

Casby's portrait also appeared in Avedon's *Nothing Personal*, along with Joe Louis's fist (p. 100). Louis's claim to fame was boxing, and his right fist was the tool that earned him heavyweight championships between 1937 and 1949. He was not only a brilliant boxer, but also a figure the African American community rallied around. Harlem Renaissance writer Langston Hughes wrote, "No one else in the United States has ever had such an effect on Negro emotions—or on mine. I marched and cheered and yelled and cried, too."[147] Between 1942 and 1945, Louis volunteered for duty in the U.S. Army. After receiving the Legion of Merit for his contributions to general morale, he went back to boxing and remained popular, although he never regained his physical prowess. He made many public and filmed appearances; in 1962 he was featured on the television show *Here's Hollywood*, which filmed celebrities in their homes. In the following year Avedon took the photograph of the fist that made Louis famous.

In *Nothing Personal*, Louis's fist appears after text in which James Baldwin tells a story about being harassed by New York City police for simply being black and walking down the street with a white friend visiting from Switzerland. He goes on to discuss rampant racism in America and the "violence ... perpetuated mainly against black men."[148] The last text before Louis's fist, the latter printed to the edge of the page with no white space, is "The best that can be said is that some of us are struggling. And what we are struggling against is that death in the heart which leads not only to the shedding of blood, but which reduces human beings to corpses while they live."[149] Louis's giant fist moves from being a remarkable portrait of a great boxer's signature feature to a symbol of unity and solidarity.

Perhaps one of Avedon's most poignant portraits is of Bert Lahr. In 1956, Lahr, best known for his role in 1939 as the cowardly Lion in *The Wizard of Oz*, was performing as Estragon in Samuel Beckett's absurdist play *Waiting for Godot* (1953). Critic Claudia Cassidy wrote, "The play is what you make of it. The performance, with Bert Lahr coming into his own as a great clown, is a spatter brush of styles flung in a wild, free, yet tautly cohesive pattern, for it concerns the infinite loneliness of the human soul." About Beckett's tragicomedy, as he called it, she says: "Man's infinite terror is that he exists in a void . . . and that his timeless courage is to keep on hoping,"[150]

Avedon caught Lahr's character praying in a moment of extraordinary existential pain: "Beneath every great comedian is this photograph. . . . People laugh at it because they can't cope with its sadness."[151] The portrait so captured Lahr's essence, it was used as the cover for his biography, *Notes on a Cowardly Lion*, by his son John Lahr.[152] Avedon was able to create a multilayered portrait that echoed Lahr's performance of deep internal strife at the moment it intersected with Lahr's life and his own, knowing that others feel that pain as well.

Avedon was energetic, restless, and constantly looking to encapsulate human experiences in his photographs. He simultaneously photographed for the fashion industry and produced editorial projects of his own design until his death in 2004, which occurred while he was working on his photography project "Democracy" for the *New Yorker*. The issue that featured his incomplete project also included his advertising work for Hermes, Kenneth Cole, and Harry Winston.[153]

In his *New York Times* obituary for Richard Avedon, Andy Grundberg recalled the decades in which Avedon's works presented in this volume were created as Avedon's "optimistic years in the 50's and early 60's."[154] Indeed, Avedon's pantheon from his *Harper's Bazaar* era includes notables who strove to make the world a better place.

By taking advantage of the Rolleiflex's high-quality negative and portability, Avedon could make portraits that revealed elemental human emotional and psychological experiences. His portraits of notable individuals made it acceptable for us to delve into our own hardships along with those of his sitters and discuss them publicly. His works have freed other photographers to include what is difficult and troubling to further inform their works as psychological portraits. Avedon offered images that make the viewer reflect on the meaning of human existence.

William Casby, Born into Slavery
Richard Avedon, 1963
Gelatin silver print, 18½ × 13¼ in.
Catalog number 66.64.046B

The close cropping of the image does not allow the
viewer to escape direct engagement with Avedon's sitter,
whose set jaw, cloudy eyes, and permanently furrowed
brow suggest he has endured a hard life with stoicism
and pride.

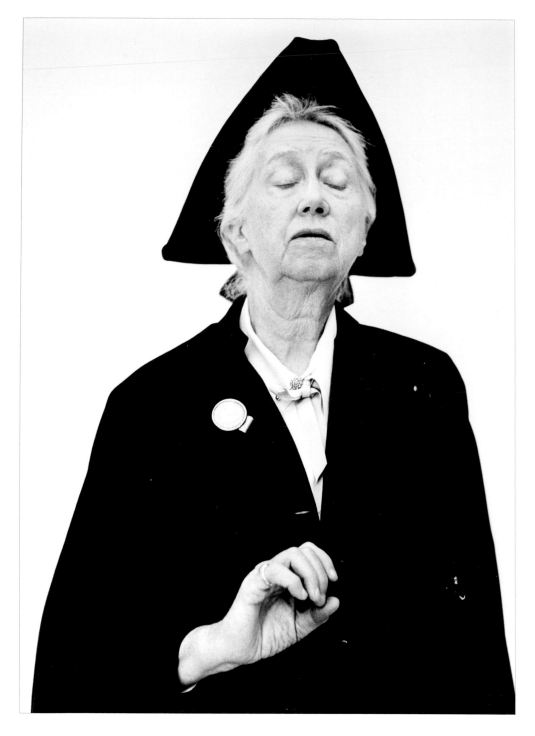

Marianne Moore, Poetess
Richard Avedon, 1958
Gelatin silver print, 19½ × 14½ in.
Catalog number 66.64.009B

Avedon used Moore's trademark triangular hat
and cape to create dark directions steering the viewer
to the poet's face. Here, the poet is lost in the recitation
of her own words.

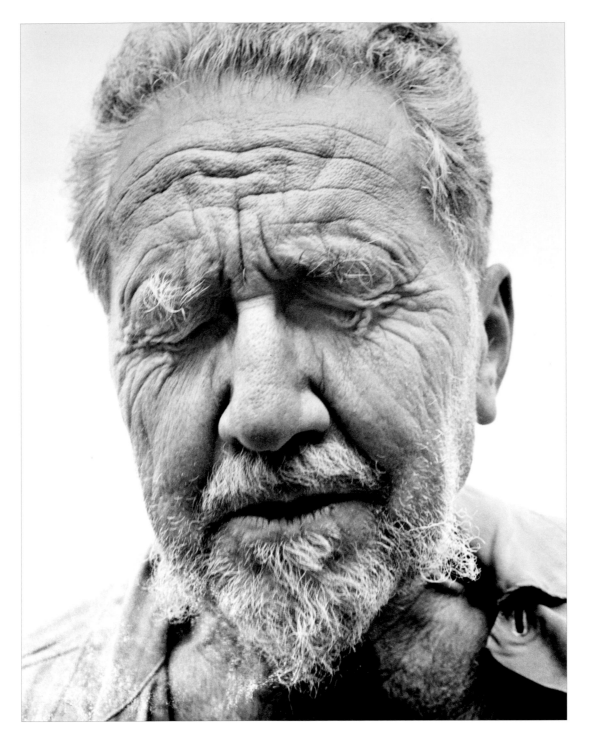

Ezra Pound
Richard Avedon, 1963
Gelatin silver print, 19½ × 15¼ in.
Catalog number 67.102.026

Avedon's photography favored Pound's modern poetry
with tight construction and precise imagery. Photographing
the poet with his eyes closed, as in the portrait of
Marianne Moore (p. 97), emphasizes the internal and
personal experience of creating poetry.

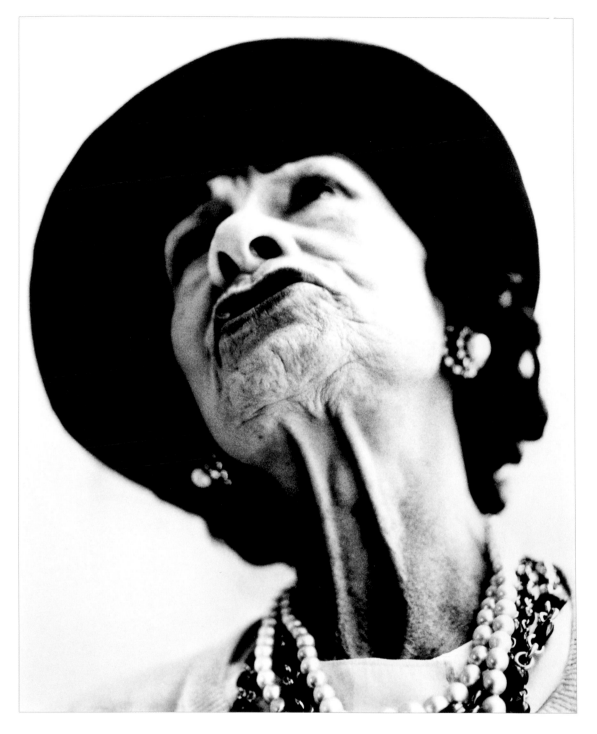

Gabrielle Chanel, Dressmaker
Richard Avedon, 1958
Gelatin silver print, 17½ × 14¼ in.
Catalog number 66.64.005B

Chanel disliked this photograph of her throat as it
emphasized her aging body, rather than her sense of
style and fashion.

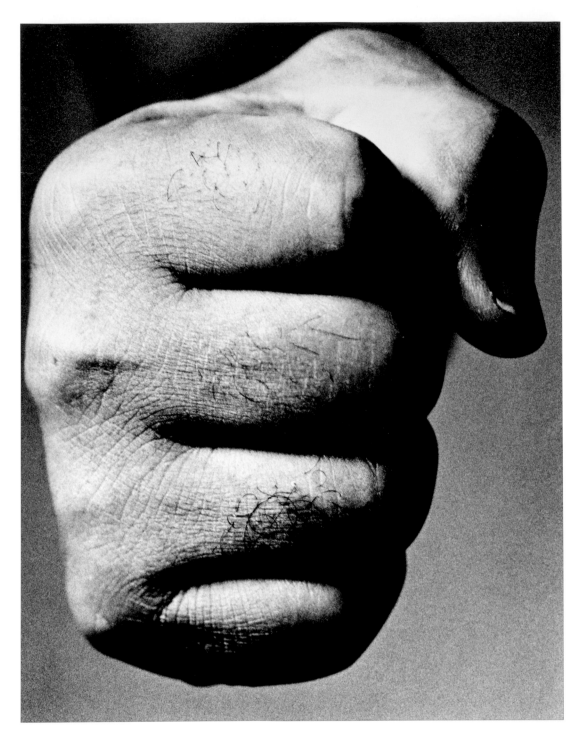

Joe Louis, Fighter
Richard Avedon, 1963
Gelatin silver print, 19 × 15 in.
Catalog number 66.64.039B

Louis's fist defined who he was more than anything else,
so Avedon boldly recorded his signature feature. The fist
became a political symbol of black solidarity and suggests
the boxer's dual fight within the ring and against racism.

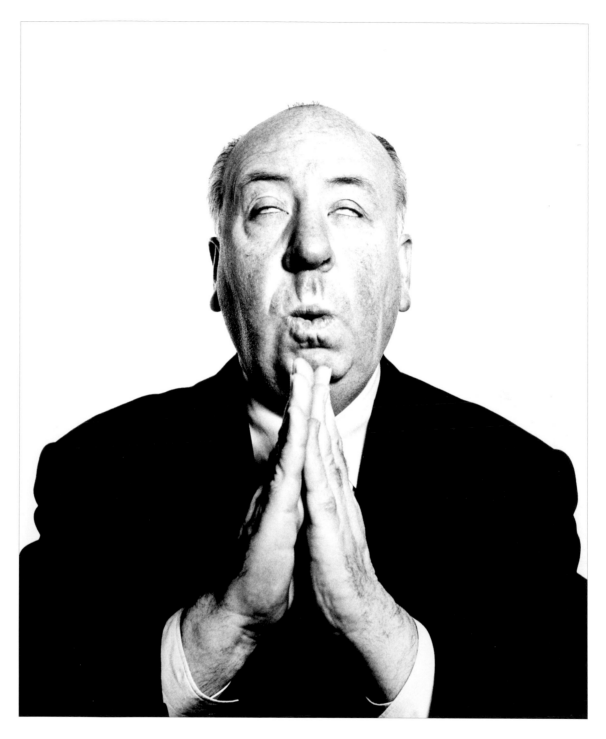

Alfred Hitchcock, Film Director
Richard Avedon, 1956
Gelatin silver print, 19 × 15½ in.
Catalog number 66.64.077B

Like Hitchcock, Avedon was interested in the
psychological tension of the beautiful women who
appeared before his camera. Both were willing to bring
anxiety and fear to the surface. Here he portrays
Hitchcock in a strange pose, with eyes rolled back and
his hands folded like a mystical seer who has a unique
vision of the world.

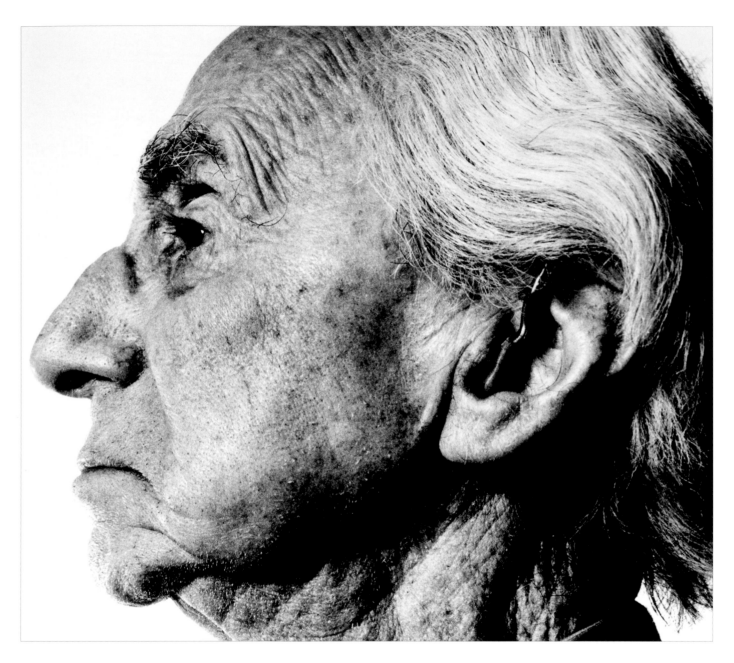

Bertrand Russell, Philosopher
Richard Avedon, 1963
Gelatin silver print, 13 × 14½ in.
Catalog number 66.64.047B

This philosopher once said, "To conquer fear is the
beginning of wisdom." Avedon photographed aging
and death in attempts to overcome his own fears.

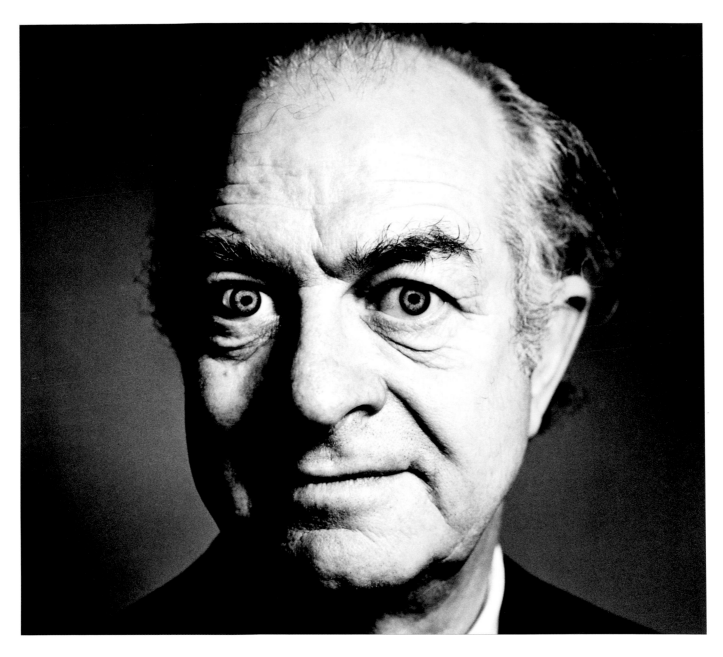

Dr. Linus Pauling, Scientist
Richard Avedon, 1963
Gelatin silver print, 15½ × 18½ in.
Catalog number 66.64.001B

Avedon presents Pauling, who won the Nobel Prize
in 1962 "for his campaign against nuclear weapon
testing," as a wild-eyed visionary.

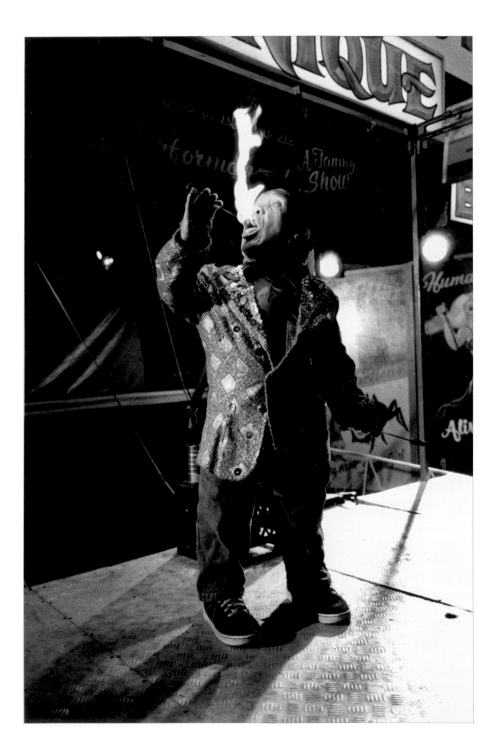

HENRY HORENSTEIN

(b. 1947)

Time Marches On

Henry Horenstein came of age just as photography was shaking off the question of whether or not it was a valid form of art and was beginning to establish itself with its first formal college degrees, emerging photography markets, and expanding dialogues about photography's possibilities. For more than forty years Horenstein has photographed with a historian's sensibility, documenting communities at the edges of mainstream American culture and those who may be historically underrepresented. Horenstein approaches his work with a primary commitment to composition and photographic technique, combined with respect for his subjects, a wealth of historical interest, and often a touch of levity to create a straightforward, honest viewing experience. Seen in print publications, books, galleries, and museums, his portraits capture individuals to show who they are and to suggest they are members of a larger community.

The Photographic History Collection holds more than one hundred of Horenstein's photographs that represent his consistent use of portraiture across four decades and multiple projects; the content is mostly related to his *Honky Tonk* photographs of country music performers and their fans from the 1970s.

Creating a Career

Horenstein came to photography in the early 1970s as more opportunities in the field were becoming available. A burgeoning industry for photography books, museum retrospectives of midcentury photographers, and increased television viewership

Little Cowboy, Sword Swallower
Henry Horenstein, 1997
Gelatin silver print, 19 × 12½ in.
Catalog number 2011.0033.05

Horenstein balances tight composition and includes enough of the subject's surrounding environment to create portraits that place individuals into a specific context.

bringing news directly to Americans created new audiences and validated a variety of forms of photography. Horenstein and other photographers were able to sustain documentary projects of their own design outside commission-based photography for federal agencies such as the Farm Security Administration (FSA) (see chapter 5) and publishers (see chapter 6) or news agencies because they found emerging outlets and audiences for their specific projects.

Horenstein forged a path for himself so that he could make a living doing what he loved, making great photographs, within the framework of his academic passion: history. Out of that emerged a career of teaching and creating documentary photographs that record the American working class as well as fringe and underrecognized communities.

Horenstein used his love of teaching and supplemental commercial jobs as a way to fulfill financial obligations so that he could also pursue his documentary photography projects. As a historian with a camera, he considered portraiture to be central to his ability to represent a variety of communities as they faded or were underappreciated.

After World War II, photography was produced by a multitude of amateurs and professionals, highlighted in dedicated picture magazines, given import on the front of newspapers, and embraced in snapshots. Thirty-five-millimeter cameras in particular were highly popular, as many G.I.s brought them home from overseas. For the general public they were relatively inexpensive, had good optics, and offered creative opportunities with the ability to change lenses based on the desired outcome. Vietnam veterans brought an infusion of money from the G.I. Bill, which helped form schools like the New England School of Photography. The new involvement in photography by all kinds of students increased the need for darkroom instructors and photography teachers.

Simultaneous with increased participation in photographic production, the American culture of the 1960s and 1970s, with

the civil rights and counterculture movements, opened new doors of visual expression and opportunities to challenge the status quo of images found in popular magazines such as *Life* and the *Saturday Evening Post*. Photographs like Richard Avedon's (chapter 7) had begun to push on the aesthetic and content barriers in the 1950s and 1960s. But it took an accumulation of photographers to bring the directness of documentary photography and the candor of street photography to the fore of American visual culture. Reviewing Horenstein's *Honky Tonk* photographs in the *New England Journal of Aesthetic Research*, Greg Cook explores the development of photography during that period. "In retrospect, the '70s was a highwater mark for modernist photography. The work of photographers like Edward Weston, Ansel Adams and Aaron Siskind, which emphasized the formal and abstract qualities of photos, was finally beginning to be perceived as art by museums. [Diane] Arbus, Lee Friedlander and Garry Winogrand's documentary photos were getting attention."[155] From Harry Callahan and Siskind, Horenstein acquired a strong sense of form and the ability to talk about photography, and from artists such as Arbus, Weegee, and Friedlander he saw that it was acceptable and interesting to pursue whatever subjects compelled him as an individual, even if the topics were not necessarily mainstream.

Many photographers have used portraiture to record jobs and communities in transition. One example is Irving Penn's gorgeous series *Small Trades* showing modernizing Paris, London, and New York from 1950 and 1951.[156] German photographer August Sander's seminal study *Man of the Twentieth Century* (1980) begins in the early 1900s and continues through the 1950s in its documentation of rich and poor, professionals, laborers, intellectuals, and even "the idiot" in an effort to identify historical types.[157] The FSA's collection at the Library of Congress,[158] offering revealing portraits of individuals and families caught in national and local political, agricultural, and economic upheaval, have inspired hundreds of photographers. Horenstein's portraits locate his subjects in their community while retaining their individual identities. Sometimes the community may be as small as a family unit, sometimes as large as baseball fans in a stadium, and sometimes as fringe as contemporary burlesque.

Horenstein recorded his subjects with compact medium format and 35mm cameras then eventually added digital cameras. With a flash and fast film, Horenstein could photograph in low light; Horenstein actually favors the brightness as it resembles the aesthetic and function of snapshot photography. A more casual, less self-conscience look to the photographs often supports the

less formal situations and cultures that Horenstein photographs. Horenstein, however, eschews the sentimentality often associated with snapshots but embraces the medium's other qualities in tandem with the technical acuity and artistic concerns that underlie his photographs.

Merging Photography and History

Thinking he would eventually earn a PhD in history, Horenstein entered the University of Chicago in 1965.[159] As part of this plan, he studied in England with E. P. Thompson, the English historian whose most well-known book is *Making of the English Working Class* (1963).[160] Thompson's approach to history validated the study of the underprivileged, fringe movements, and subcultures. From Thompson, Horenstein embraced the idea that history is built not just by military and political leadership, but also through the lives and activities of a community's members. This idea informed the subjects of his photographs throughout his career.

In 1968 Horenstein took an entry-level photography class at Harvard Summer School with Arthur Siegel, a photographer with a sociology degree who was known for experimental photographs. Siegel, who had been shown books by gritty news photographer Weegee and outsider documentarian Robert Frank, helped Horenstein imagine making the shift from historian to photographer.[161] Having been a history student for a few years, Horenstein responded with piqued interest. Documentary photographer Danny Lyon, who had been an earlier history student at University of Chicago, gave Horenstein "the idea that [he] could be a historian with a camera at a time in [his] life when it seemed an impossible choice."[162] Caught in an on-campus demonstration and expelled in 1969, Horenstein left the University of Chicago and switched to photography at the Rhode Island School of Design (RISD) in 1970. He began studying with famed photographers Harry Callahan and Aaron Siskind, who had been Siegel's teaching colleagues during the 1940s and 1950s at the New Bauhaus that became the Institute of Design in Chicago. All were inspired and influenced by a variety of innovative photographic techniques and teaching styles supported by the Bauhaus-style photographer and educator László Moholy-Nagy. When Horenstein graduated with an MFA from RISD in 1973, tools for teaching darkroom photography were still minimal.

At RISD, Callahan advised Horenstein, "Photograph what you love. Even if you make bad pictures, you'll at least have a

good time."[163] In following Callahan's advice, Horenstein began photographing his family and friends, and the events at country music parks. From this endeavor, Horenstein began documenting the country music scene, creating a body of work now known as his *Honky Tonk* photographs.

Horenstein has sought ways to define and forge a career for himself as a photographer. After several teaching jobs, including spending five years at the New England School of Photography during which he gave Nan Goldin her first class in photography, he returned to RISD as an instructor. Well aware that students needed a useful textbook to guide them, he published *Black and White Photography: A Basic Manual* in 1974. Now in its third edition, his manual has taught three decades of emerging photographers how to develop and print their own film. In 1977 he published a companion text, *Beyond Basic Photography*.[164]

With a small budget and easy access to willing family and friends, Horenstein took many photographs of loved ones to include in both books. A photograph of Horenstein's mother and her two poodles in her kitchen in New Bedford, Massachusetts (p. 110) was printed twice in *Beyond Basic Photography*. First it was "developed in Kodak Dektol" and then comparatively "developed in GAF 120" with a noted decrease in contrast.[165] The images that Horenstein accumulated of family and friends during these projects, including the one of his mother, were published in his book *Close Relations* (2006).[166] The building of this body of work over time revealed hints about his New England middle-class American family in the 1970s and the life of its photographer son.

Horenstein's jovial, energetic, friendly, and sincere personality goes a long way to build trust between him and his sitters. That connection is especially important when Horenstein is photographing as an outsider, even if he is sympathetic to the community's values.

Horenstein considers himself a portrait photographer in the broadest sense, one who makes portraits of individuals, animals, communities, subcultures, and lifestyles. "I want to make fundamentally good pictures—well-crafted photographs that make you stop and look and maybe reflect. Beyond that, I have no grand design, no hidden or overt agenda. You can choose to see these pictures in any way you want, as graphic images, as metaphors or even as documents. It really doesn't matter to me."[167] Horenstein's modest and open attitude reflects a cultural sentiment of "anything goes" from the counterculture era of his youth. His photographic intentions are shaped by an allegiance to craftsmanship that emerged from a modernist photographic education, and the content of his work is informed by his academic grounding in history.

In a recent artist's statement Horenstein wrote: "For subjects, I prefer older culture and places, and disappearing ones."[168] The photograph of Aunt Loney (p. 111) in southern Maryland is haunting in its reference to a dying way of life. In his documentation of the Wesorts in southern Maryland, Horenstein delicately records a community that has specifically chosen to remain outside mainstream culture. Even their name, "We Sorts," indicates a desire to keep to themselves. He was introduced to them through a friend and member of the community who was writing its history. The area dates to colonial times when whites, free blacks, and Native Americans lived peaceably and did not wish to engage in the divisive social and political structures imposed on them.[169] By remaining a closed community and intermarrying, the people became intermingled, and outsiders became confused in trying to pigeonhole the group's races and backgrounds. A walk through the graveyard can be a way to remember those who have died and prompt the telling of their stories. The photograph speaks to the storytelling idea, but it is also prophetic and poignant. Many of the young people have left the community and chosen to marry outsiders, and those remaining are dwindling in number.

In Horenstein's book *Honky Tonk* (2003) National Museum of American History curator Charles McGovern describes Horenstein as having "made a career of loving, quirky and honest engagement with subcultures hidden from the mainstream."[170] The same holds true for his current work documenting contemporary burlesque.

Horenstein's unabashed directness occasionally makes viewers uncomfortable. Sometimes the issue is a confrontation with social acceptability, such as a fire eater (p. 104) or a burlesque dancer (p. 112). Sometimes the viewer is disconcerted by proximity to a stranger's body, as is possible to feel when looking at *Humans* (2004), his book of extreme closeup images of the landscape of human bodies.[171]

Photographing the characters of circuses, sideshows, and carnivals is not new. Images of freaks, as some were known, date to the earliest days of photography and increased in the 1880s with sales of collectible photographs, usually cabinet cards (see Introduction, p. xii and chapter 1, p. 5). Contemporary burlesque, tagged by the media as "neo-burlesque" is as much about performance art as it is about the risqué.[172] Horenstein is seeking out the historical threads in addition to documenting the performer. This particular image of Peekaboo Pointe (p. 112) is connected to a long tradition of objectifying the female nude by

the wallpaper that contains a picture of a Victorian-style naked woman. Adding to the history is Peekaboo's tattoo that hearkens to the 1940s era of the pinup girl. In a single portrait, multiple eras are referenced, suggesting and complicating historical issues of objectification, voyeurism, art, and performance as well as how this one woman has negotiated those aspects of life for herself.

Horenstein's impetus to seek out communities and cultures that are less well-known and give them historical value through his photographs has been steadfast over more than four decades. The photograph of Gerald Wald (p. 113) resembles an FSA picture of a farmworker—strong hands that have seen many years of labor, clothes dirtied by work, a barren landscape in the background, and the photographer's directness combined with the subject's reticence to engage with the camera (see chapter 5, p. 73). Horenstein's use of this well-known style has the effect of placing the man within a political context of the 1930s. Wald's particular community is a rural area in central Louisiana, but it may as well be Texas, Oklahoma, or any number of places. The portrait represents Wald specifically as burly, Christian (denoted by his necklace), tobacco chewing (note the circular container in his shirt pocket), and gun toting, but he can stand for many who maintain a certain lifestyle. Recording Wald in the style of an FSA photograph links him to an honored status as a historical labor hero that would make Horenstein's history mentor E. P. Thompson proud.

The continued success and multiple editions of the manuals, guides, photography for children's books, and more than a dozen monographic titles, together with his teaching salary and gallery sales, have afforded Horenstein the opportunity to pursue his passion for photography on his terms.[173] While he tested the corporate waters of Polaroid from 1979 to 1981, he preferred making his own assignments, although he did benefit from occasionally assisting well-known photographers like the clever absurdist Elliott Erwitt and street-photographer Garry Winogrand.

Horenstein's legacy exists photographically in rich bodies of work, quietly augmented by the thousands of students, his own and others, who use his books and manuals to learn and strengthen their technical knowledge of photographic picture making. Over the course of his forty-plus years of photography, the man who literally wrote the book on darkroom photography has experienced the significant technological shift from film to digital, and in 2011 Little, Brown and Company issued his *Digital Photography: A Basic Manual*. He continues to embrace the photographic, no matter its photographic origin.

Horenstein openly acknowledges the photographic trails forged by the modernists like Callahan, those who offered new and challenging subject matter like Weegee and Arbus, and those who recorded the laborer in an attempt to recognize his contributions to shaping everyday life in the manner of the FSA or August Sander. Although he may draw heavily on their lessons, his work is shaped by his own sense of commitment to the craft and his agenda to record the people that history may forget to include. Horenstein's photographs prevent his subjects from becoming casualties of history by documenting their existence and environment; Horenstein validates their history and visually preserves their stories. His work causes the viewer to ponder the communities of which he or she is a part, assessing his or her own place in history and wondering how one's own participation and existence will be noted in the future.

***Last Call, Tootsie's Orchid Lounge,
Nashville, Tennessee***
Henry Horenstein, 1974
Gelatin Silver Print, 15 × 14¾ in
Catalog number 2011.0033.12

The bar behind the Grand Ole Opry, Tootsie's Orchid
Lounge hosted country music fans, as well as famous
and aspiring singers and songwriters. One of Horenstein's
most well-known bodies of work is *Honky Tonk*, which
documented the changing country music scene
across the 1970s.

Mom, Chammie, and Studley,
Kitchen, Newton, Massachusetts
Henry Horenstein, 1971
Gelatin silver print, 15 × 14¾ in.
Catalog number 2011.0033.01

Horenstein's photograph is at once casual and formal,
with its domestic and familial content set against its
photographic considerations.

***Aunt Loney Walking through
the Graveyard, Maryland***
Henry Horenstein, 1997
Gelatin silver print, 19 × 12½ in.
Catalog number 2011.0033.07

Horenstein is drawn to out-of-the-way communities that
live at the fringe of mainstream America and are at risk of
slipping away, unknown, if they are not documented.

Peekaboo Pointe,
This Is Burlesque, Corio, New York, New York
Henry Horenstein, 2009
Gelatin silver print, 15 × 14¾ in.
Catalog number 2011.0033.08

Horenstein enjoyed the same kind of freedom of access to
many burlesque performers as he had with country music
performers in the 1970s.

Gerald Wald, Marksville, Louisiana
Henry Horenstein, 2009
Gelatin silver print, 15 × 14¾ in.
Catalog number 2011.0033.09

Horenstein's training as historian informs his choice of
subject matter. With a goal of recording individuals who
might be lost to history, this image echoes the photographs
of farm laborers and sharecroppers during the Depression.

Del and Alice, Thompson Speedway
Henry Horenstein, 1972
Gelatin silver print, 15 × 14¾ in.
Catalog number 2011.0033.03

This portrait of a mechanic in front of the remains of a car
named Alice gives a sense of the environment in which
the cars were prepped. Horenstein's photographs of the
workers, racers, and fans were included in the racetrack's
souvenir programs.

Man in Diner, Route 6, Fall River, Massachusetts
Henry Horenstein, 1985
Gelatin silver print, 19 × 12½ in.
Catalog number 2011.0033.02

As interstates were built, small towns that depended
on local highway traffic saw their business diverted,
here leaving the quiet diner to locals.

Maryland George, Northampton County Fair
Henry Horenstein, 1985
Gelatin silver print, 19 × 12½ in.
Catalog number 2011.0033.04

The advent of electronic betting saw the loss of
racetrack characters like this man, whose hat was
wrapped in winning bets.

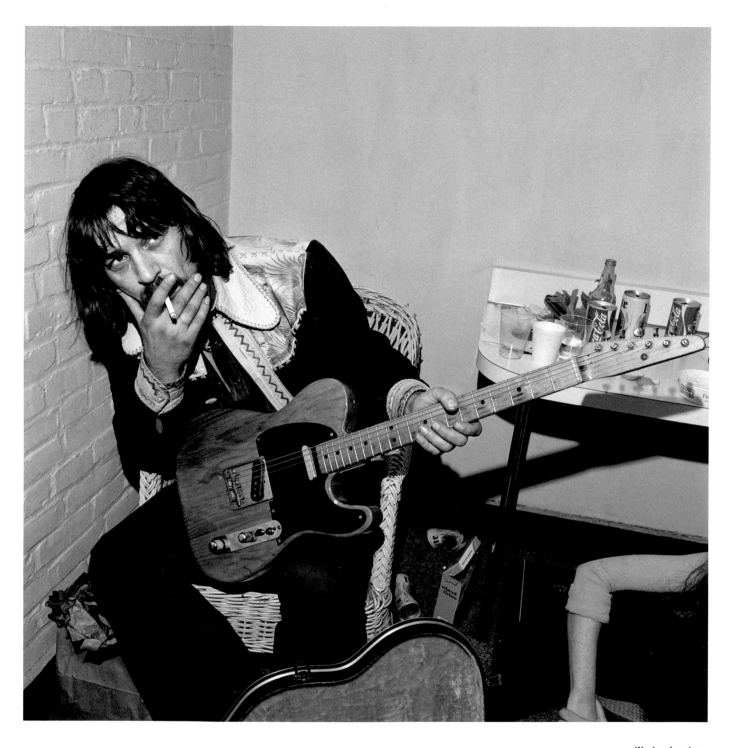

Waylon Jennings,
Performance Center, Cambridge, Massachusetts
Henry Horenstein, 1975
Gelatin silver print, 10 × 10 in.
Catalog number 2003.0169.029

Access to performers was easy to garner in the 1970s,
when far fewer managers kept photographers at bay.

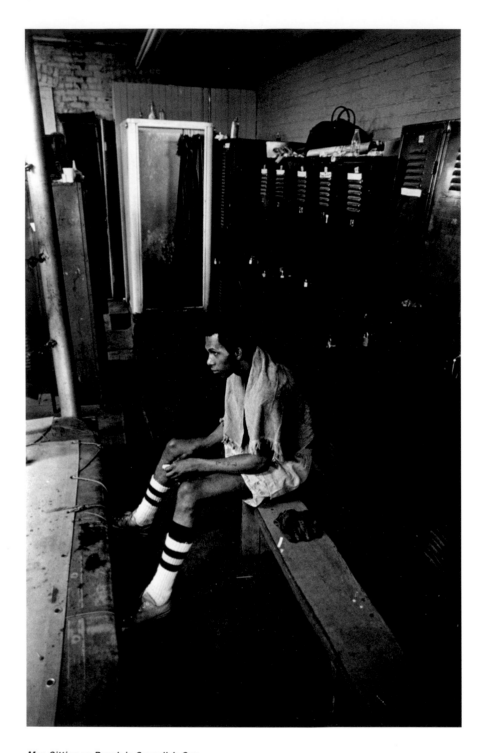

**Man Sitting on Bench in Connally's Gym,
South Boston**
Henry Horenstein, c. 1985
Gelatin silver print, 19 × 12½ in.
Catalog number 2011.0033.10

Rocky IV was released in 1985. In contrast to that
character's grand heroism, the quiet photograph of this
amateur boxer showing the sweat, or maybe blood, on the
edge of the ring suggests the gritty reality of boxing gyms.

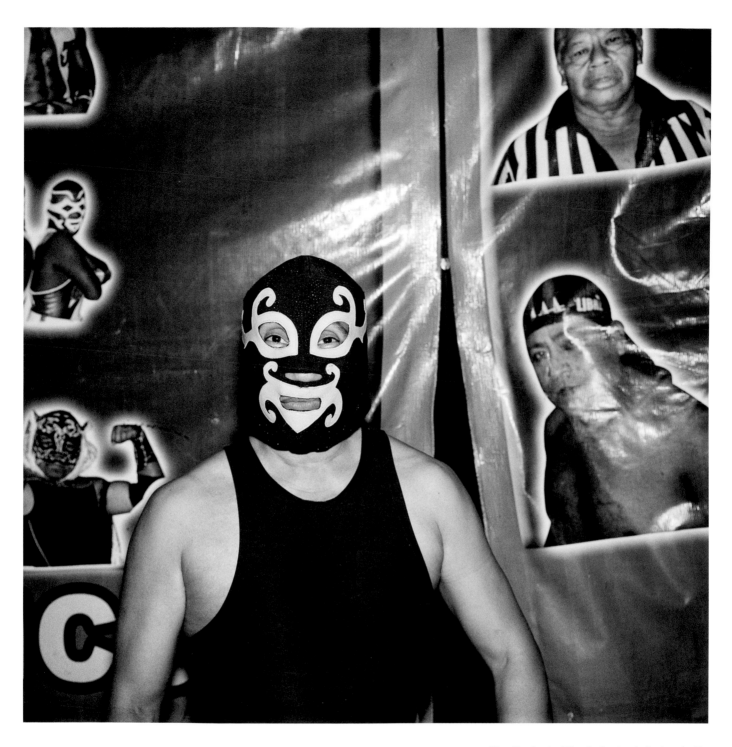

Wrestler, Lucha Libre Professional, Guatemala City
Henry Horenstein, 2010
Gelatin Silver Print, 15 × 14¾ in.
Catalog number 2011.0033.13

Horenstein expands his work beyond the United States,
yet even these photographs connect to his interest in
underrepresented and fringe communities.

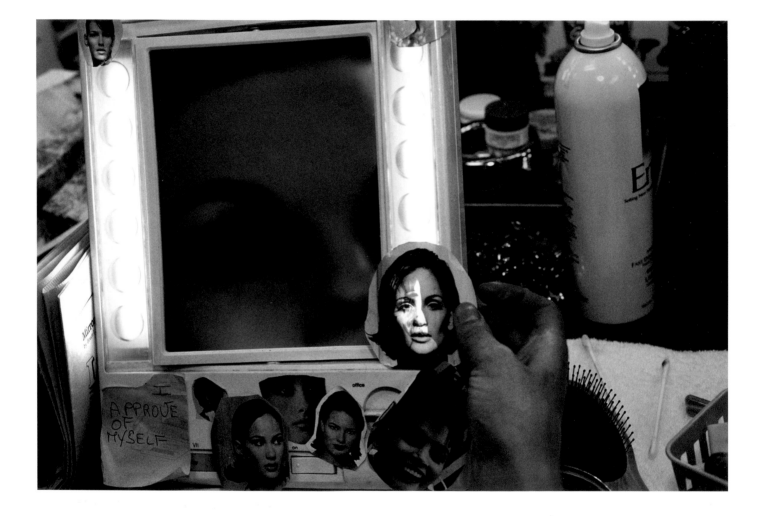

LAUREN GREENFIELD

(b. 1966)
The Personal Is Potent

Lauren Greenfield is among a group of photographers from the late twentieth century who have blended aspects of photojournalism and documentary photography. The rise of digital resources in media outlets and a thriving interest in humanistic topics have contributed to the merging of the two forms. By working independently and maintaining control of her images, Greenfield follows in the footsteps of innovative *Life* magazine photographer W. Eugene Smith (1947–1954) as well as the international group of photographers who founded the Magnum Photos agency after the Second World War, namely, Robert Capa, Henri Cartier-Bresson, and Chim (David Seymour). Greenfield's color photography focuses on highly individual portraits to convey issues affecting a broad population.

A visual studies graduate of Harvard University, Greenfield quickly refined and demonstrated a personal photographic vision. Her work is often seen in books that contain interviews of her subjects, for which she has received widespread media coverage in newspapers and magazines and on television. Greenfield has expanded to filmmaking and creates multimedia pieces combining still and moving pictures with sound. Simultaneously, she produces editorial and advertising images that, like Richard Avedon's (chapter 7), afford her the ability to pursue her own projects.

The photographs explored here comprise the entirety of the Photographic History Collection's holdings of Greenfield's photographs, which includes work published in her books *Fast Forward* (1997), *Girl Culture* (2002), and *Thin* (2006).[174] In these volumes the subjects tell their own stories alongside Greenfield's framing narrative.

Showgirl Anne-Margaret
Lauren Greenfield, 1995
Cibachrome, 16 × 20 in.
Catalog number 2011.0034.01

Even the most glamorous of women have self-doubt. Greenfield documents the effects of women wrestling with external forces and internal voices.

Documentary Photography and a Social Conscience

At the beginning of the twenty-first century, the opportunities and ease for photographers to commit themselves outright to a set of ideals and causes as a means of shaping the messaging within their photographs are unprecedented. Greenfield's ability to direct her career is owed not just to her strong vision and the meaningful images she creates but also to a cultural and digital environment that allows photographers to generate their own projects and control the end product. The autonomy photographers have today is based on the history of publishing and the groundwork laid by previous photographers.

Life magazine's early years, beginning in 1936, established a benchmark for traditional photojournalism; the printed black-and-white images were compositionally striking and brought a range of topics to its readers. A basic precept of American journalism is the idea that the reporter and the photographer should remain neutral, or at least diminish their personal biases as much as possible and provide "just the facts." Photojournalists were supposed to get in, get the pictures, and leave. The documentary photographer, on the other hand, was allowed time to develop a story. The resulting work may or may not have been published; it might be described as scholarly; and it was often independently funded.

As *Life's* photographer, Smith began to blur those arguable distinctions when he insisted on taking the time he needed—a full year, for example, to control the editing and captioning for his photo essay *Spanish Village: It Lives in Ancient Poverty and Faith* (*Life*, April 9, 1951)—and ensuring that his intentions would not be compromised. His commitment to the *Minamata* series (1971–1973), the first images published in *Life* (June 2, 1972) for which he and his writer wife, Aileen, suffered through physical attacks to raise awareness of industrial mercury poisoning in a Japanese village, is often held up as a pivotal moment in which the photographer's neutrality is let go in favor

of creating documentary photographs with a social message. Like Smith, Greenfield generates her own projects within her desired time frame and selects subjects that address her social concerns.

Kerry Tremain, in his introduction to *Ken Light's Witness in Our Time: Working Lives of Documentary Photographers* (2000), called those working in Greenfield's mode "social documentary" photographers.[175] More recently, Brett Abbott further identified them as "engaged observers,"[176] and he included Greenfield among the subjects in his book for an exhibition in 2010 at the J. Paul Getty Museum at the Getty Center, Los Angeles. Titled *Engaged Observers: Documentary Photography since the Sixties*, the book and show also featured powerful works by Magnum photographers such as Susan Meiselas, Leonard Freed, and Larry Towell plus ex-Magnum photographers such as Mary Ellen Mark and Sebastiao Selgado.

The rise of the photographer as an engaged observer has been fostered by new forms of electronic publication and distribution. During this time some news organizations have disappeared, leaving photographers in a position to distribute and control their own work. Greenfield spent seven years (2002–2009) as a member/owner of the VII Photo Agency, which was founded in reaction to the collapse of the news agencies of the late 1990s. Greenfield left VII to found the Institute for Artist Management (INSTITUTE), run by her husband, Frank Evers. INSTITUTE was created to manage, facilitate, and promote the work of visual storytellers across all platforms, including web, mobile, and multimedia. The agency's goals are similar to those of Magnum Photos, which was established in 1947 as a cooperative to assert and protect photographers' rights to negatives, authorship, and freedom of subject selection, especially exploration of social issues that other agencies were reluctant to cover.

The 35mm hand-held single-lens reflex (SLR) camera has been the photojournalist's signature tool. Its portability, ease of handling, and inexpensive film it uses have contributed to its popularity. Today the digital camera, with its ability to hold hundreds of high-quality images, provide immediate review, and quickly transmit files, dominates the field. While Greenfield started as a conventional film-based photographer, she now mostly records her subjects with Canon digital cameras. Although many documentary photographers use black-and-white film, Greenfield works in color. Her choice allows her to capture the mood, vitality, and often the complexity of her subjects' experiences, which together build to place her subjects in a contemporary world.

Finding Her Way into Photography

Greenfield did not intend to be a photographer.[178] At age twenty-one, after graduating from Harvard with a photography degree from the Visual Environmental Studies program, she expected to complete one documentary photography project for her senior thesis then move on to other interests in life. For her thesis, she lived with family friends in France for three months in 1987 and set out to photograph old French aristocratic families, many of whom were no longer as financially well-off as their lineage had been. She started with the question, "How can you be in an elite class without money?" She was prompted to investigate where aristocracy begets exclusivity and notoriety because, she explained, "coming from Los Angeles, elitism without money seemed impossible."[179] The black-and-white photographs, including one of hunt masters at the lunch table, families struggling to hold onto their land, and scenes inside private parties, garnered Greenfield a competitive internship at National Geographic in Washington, D.C., upon graduation.

While at National Geographic, Greenfield realized the photographer could be the storyteller, more than merely an illustrator of other people's ideas. Greenfield pitched a proposal to the editors in which she would photograph a remote Mayan village in Chiapas, Mexico, that had not been photographed. Greenfield's mother, Patricia Marks Greenfield, would write corresponding text, drawing on her unique relationships and contacts as a Harvard professor of psychology who conducted and maintained research with one Mayan family for twenty years. As an inexperienced photojournalist, Greenfield was technically challenged, and as someone outside the Mayan culture, she was frustrated by what she called "only documenting the surface and not getting to the heart of the matter."[180] Although she learned some of the Mayan language, her ability to fully understand what was being spoken, explained, discussed, shared, and perhaps even hidden inhibited the opportunity to build meaningful relationships. She had to work through the women of the community to gain access and permission to cover spaces and events. As an American, she felt the photographs were exotic, representing an outsider's view looking in, and did not bear her individual perspective.[181] Greenfield's reactions to her own work raised questions about cultural familiarity and fluency that would form the basis of her future projects, especially the idea that an insider with a nuanced understanding within her own community could navigate, communicate, and delve deeper than is possible for an outsider. Knowing how to garner access and having intimate knowledge of the dynamics that form a community is key.

Despite her patience and collaboration with National Geographic for three years, Greenfield's Chiapas photographs were never published by that organization. Eventually, in 2004, a scholarly press published the photographs with the text by her mother.[182] In the duration, Greenfield continued producing photographs. This new work was informed by her Mayan experience; the happenstance discovery of Bret Easton Ellis's novel *Less than Zero* (1985), about a Los Angeles high school where narcissism and amoral behavior are abundant[183]; and her original photography inspiration from street photographers such as Robert Frank and Garry Winogrand. Her formulation that teenagers live in a "culture of materialism and consumerism" in an environment that highly values celebrity, privilege, and wealth resolved into an extended visual study in and around her own former private high school. Her work explored the loss of innocence and the eagerness to be an adult. A grant from National Geographic to support her project in 1993 allowed her to generate the photography that became her first book, *Fast Forward: Growing Up in the Shadow of Hollywood*, released in 1997.[184]

Continuing to follow her interest in the intersections of popular culture, consumerism, materialism, identity, self-esteem, and body image, Greenfield produced additional books and documentary films including *Girl Culture* and *Kids + Money*. *Girl Culture* emerged from *Fast Forward* when Greenfield began to see that women have specific relationships with one another, themselves, and the material world that sometimes result in extraordinary behavior. Her moving work *Thin* was first an HBO documentary film then a book.[185] *Thin* delves into the world of severe eating disorders and the psychological and emotional struggles that accompany it.

Bringing the Struggle to the Surface

As an engaged documentary photographer, Greenfield's goal is to bring truthful photographs with compelling words to the attention of others. "A lot of the pictures are of moments we can all relate to. The hope is that they raise questions about our values, our insecurities, what we spend time doing," and encourage girls to "feed themselves intellectually, spiritually and emotionally."[186] As a storyteller, she achieves this through multiple technical approaches, but mostly by allowing each subject to represent her own story and reveal individual connections to the broader American culture.

Trudy Wilner Stack, the curator from 1995 to 2002 at the Center for Creative Photography at the University of Arizona,

Tucson, has worked closely with Greenfield on a number of projects including the traveling exhibition for *Thin*. She expressed the complexity of Greenfield's work during a lecture in January 2010: "Her pictorial insight into and embodiment of the issues is at once as a spinner of the web, its victim, and as witness to the silken seduction and entrapment. Without Greenfield's versatile and complex cultural engagement, *Girl Culture* and then *Thin*, could never stand as such profound and disturbing testimony."[187] If Greenfield were not an inside observer, her work would lack the very nuance and subtlety that give it an emotional edge.

Greenfield finds individuals who are articulate and thoughtful about their particular issues in response to her questions; she sees them as her "truth tellers."[188] The women's openness is dependent on Greenfield's skills of building trust and respect. Erin (p. 126), for example, who allowed a painful moment in her life to be photographed, revealed, "I hate being weighed. . . . I do the blind weights where I turn backward. . . . When I was twelve, I started developing. No one ever taught me how to deal with the attention I would get with that body, so when I started getting it, it scared me. I was going through a lot of sexual abuse. Plus I had a chaotic house and a controlling Dad. [My body] was the one thing in my life that was mine, and nobody could take it away."[189] The frankness of Erin's words and Greenfield's revealing images are a potent combination. This image, created during *Girl Culture*, was inspiration for the project *Thin*.

In *Thin*, Brittany (p. 127) discusses her desire to be thin and what she did to be the "perfect" anorexic. She explores what she thinks it means to be thin and openly discusses how she and her mother both have eating disorders. Greenfield's image, taken after an art therapy session, visualizes the inner dialogue Brittany has about her weight. It reflects a discrepancy between reality and self-perception. The photograph is complicated by Brittany's gaze at the viewer, which dares us to judge, console, or challenge her. Standing with her arms crossed, ready to protect herself, Brittany, not the viewer, offers the harshest judgment.

Greenfield's technical skills in photographic film and digital formats in addition to her sense of composition help make difficult subject matter approachable. *Boston Globe* reporter Mark Feeney described a gallery of Greenfield's photographs: "The bright colors and crisp focus make them seem all the sadder. They're like postcards from a vacation in hell. 'Having a great time! Wish we weren't here!'"[190] Feeney's comment speaks to two aspects of Greenfield's work, namely, color and the discomforting expressions of the women. In *On the Line: The New Color Photojournalism* (1986),

Adam Weinberg explains that photographs of the late 1970s and early 1980s, like Susan Meiselas and Mary Ellen Mark, whom he wrote about, "successfully play art against journalism, trying to reap the most from each. . . . Aesthetics are fused with reportage, creating tension within the image."[191] Greenfield has the good judgment to use color either modestly or to great effect. In a photograph like that of Lily (p. 128), for example, the color suggests the dizzying external influences and messages that surround girls and women. If such an image were black and white, the girl would become abstracted from reality and the reference to the contemporary era would be diminished.

The gentler image of Amelia (p. 129) reflects the tenderness and vulnerability that her heavy body is perhaps hiding or protecting. It is ironic that at a weight-loss camp she is wearing a shirt with the word "sugar" on it, celebrating one of the controlled substances there. The old-fashioned nursery rhyme "Girls are made of sugar and spice and everything nice" receives sarcastic treatment when "sugar" is written in spangled hearts. It is also a term of endearment that can reinforce the notion that girls are to be nice, a social subtext that places pressure on young women to behave a certain way and can cause internal conflict if they do not live up to that ideal. When Greenfield returned at the end of camp to photograph the girls again, Amelia had been sent home. It turned out she was a "cutter," like former model Shantell (p. 130).

At first glance, Shantell's portrait impresses us with the glamour of a magazine shot. The pose, the partial nudity, the pale skin, the dark eyes, and the full lips all suggest the image might be a fashion advertisement for blue jeans. But on closer inspection, one quickly realizes that her body is covered in slit-like scars. Striking a pose and engaging the viewer with direct eye contact, Shantell creates a conflicting moment when the observer realizes it is not the pre-imagined sexy advertising image, but rather a photograph revealing someone who has suffered in the hands of the very industry that shaped the viewer's expectation. The photograph points to the impact consumers can have on members of the fashion industry. When the industry presents a waifish ideal of beauty that consumers buy into, a demand is created and pressure is asserted on models to sustain the unrealistic vision. Shantell's cutting, as she herself said, "damaged the goods."

Cutting is a subversive act, a misdirected release of psychological tension with intention of creating damage. Plastic surgery aims to improve. Greenfield's portrait within a portrait of eighteen-year-old Lindsey's rhinoplasty (p. 131) is an example of the lengths to which some women go to improve their self-confidence. Lindsey's act is commonplace within her community of Calabasas, California, near Malibu. Her surgery to improve her self-esteem may seem less extreme when compared to what many others are willing to undergo, such as toe-shortening surgery in order to wear a particular designer's shoes comfortably.[192] Greenfield's photograph of Lindsey poses questions about when surgically altering one's shape is acceptable and when it is extreme.

Over and over again, viewers and readers find ways of personally relating to Greenfield's subjects, wondering how they are implicated by participation in a material, consumer-driven culture and what actions might redeem or prevent such traumas. Not only does she present her concerns via a documentary format, but in fashion magazines as well.

In "Revelations," a photo spread in the March 2003 *Elle* about boudoir fashion, Greenfield addresses the impact of sporting lingerie as outerwear. Her photograph of a young woman in a bra and fancy skirt on a playground with children around addresses an early introduction to sexuality. In another photograph a woman whose head is cropped just above her mouth is ascending an exterior staircase in a lacy camisole; she appears to be followed by an attractive, suited man and clearly speaks to the male gaze that objectifies women. Greenfield's ability to produce a glamorous critique of the very industry that often employs her is rather clever and demonstrates her nuanced talent for navigating among interconnected circles, seen in the complicated relationship between fashion, media, and our inner dialogues.

Greenfield's Web site is a constantly growing encyclopedia of her many professional projects and records a history that does not always distinguish clearly between editorial, advertising, and personal work. The content is produced through a sliding scale of variables based on her audience, clients, and final products and always infused with her frank and intellectual approach of placing her subject in a contemporary moment that often asks the viewer to question the role of materialism, consumerism, and well-balanced emotional and mental health. Greenfield's work allows the viewer to find where he or she sits in response to the concerns she presents in books, Web publications, films, or magazines.

Like Horenstein (chapter 8), Greenfield has a career that is largely self-defined. As the digital world continues to evolve, Greenfield's career will be one to watch to see how publication,

management, and artistic opportunities and controls play out over the long run. In the meantime, she will continue to create a thought-provoking portrait of America through individuals and groups that are part of the dynamic culture of consumerism.

Erin, 24, Being Blind Weighed
Lauren Greenfield, 2001
Cibachrome, 16 × 20 in.
Catalog number 2011.0034.04

This still image was made during Greenfield's
photographic investigations for *Girl Culture* (2002).
It spurred the photographer's interest in women's
eating disorders, which led her to filmmaking and her
HBO documentary *Thin* (2006).

Brittany, 15, Body Line Drawing
Lauren Greenfield, 2004
C-print, 16 × 20 in.
Catalog number 2011.0032.06

Greenfield is adept at using color to place her subjects
in a specific moment in time and place.

Lily, 5, Shops
Lauren Greenfield, 2001
Cibachrome, 16 × 20 in.
Catalog number 2011.0034.06

At five years old, Lily was already saying,
"If I don't dress well, I feel geeky.
And if I feel nice, I feel like people like me."

Amelia, 15, Weight-Loss Camp
Lauren Greenfield, 2001
Cibachrome, 16 × 20 in.
Catalog number 2011.0034.05

Although mostly focused on girls and women averse
to food, Greenfield found many similarities related to
self-image, abuse, and social pressures among
those who undereat and those who overeat.

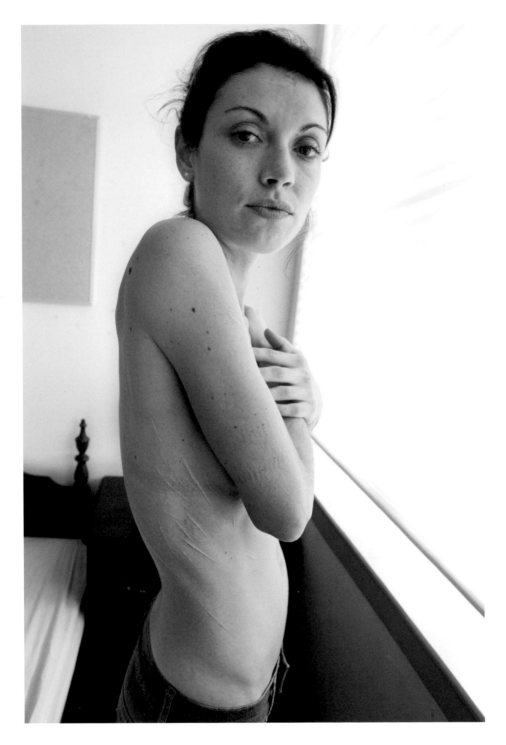

Shantell, 28, Model
Lauren Greenfield, 2004
C-print, 16 × 20 in.
Catalog number 2011.0032.04

As this image shows, those who participate in making
the fashion media that asserts messages to women are
not immune from its harmful effects.

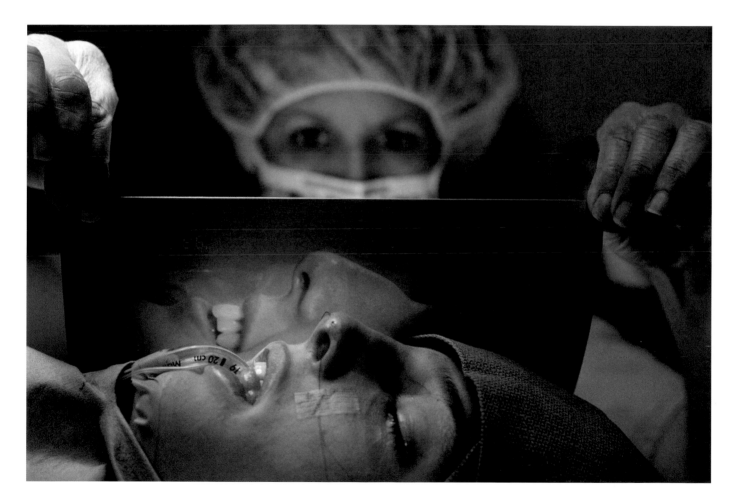

Lindsey, 18, Nose Job
Lauren Greenfield, 1993
Cibachrome, 16 × 20 in.
Catalog number 2011.0032.03

This simultaneous before-and-after portrait is at the
crux of Lindsey's improved self-image. She had been
self-conscious about her nose since she was twelve.

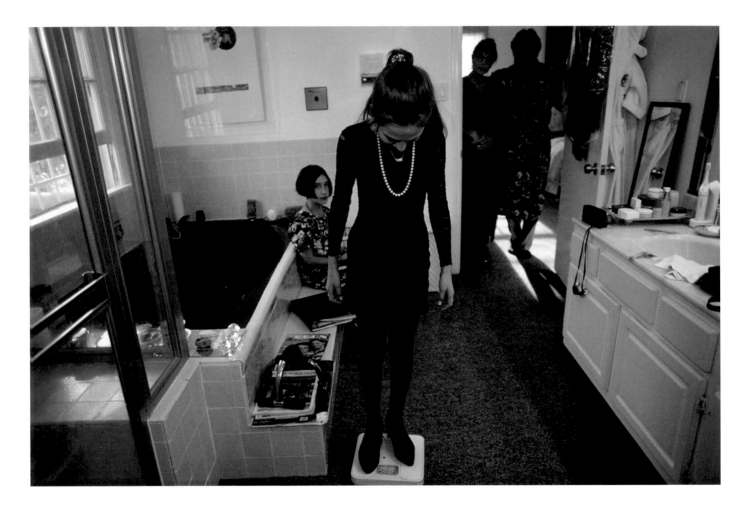

Ashleigh, 13, Weighing Herself
Lauren Greenfield, 1993
Cibachrome, 16 × 20 in.
Catalog number 2011.0034.02

This photograph reveals that many sufferers of eating
disorders are influenced by the role parents play in their
children's sense of self-worth and self-confidence.
Ashleigh's parents, in the background, watch as she
weighs herself, while her friend looks on with confusion.

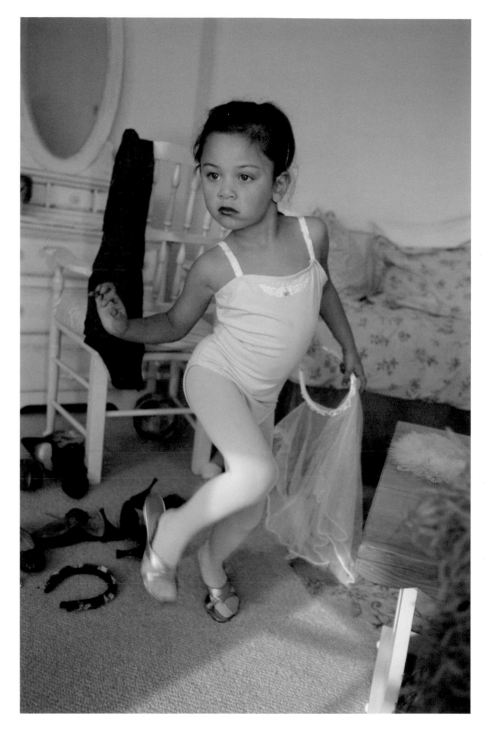

Allegra, 4, Playing Dress Up
Lauren Greenfield, 1999
C-print, 16 × 20 in.
Catalog number 2011.0034.03

Allegra's shoes, lipstick, and pose beg the question,
where is the line between learning through emulation and
acquiring inappropriate behavior?

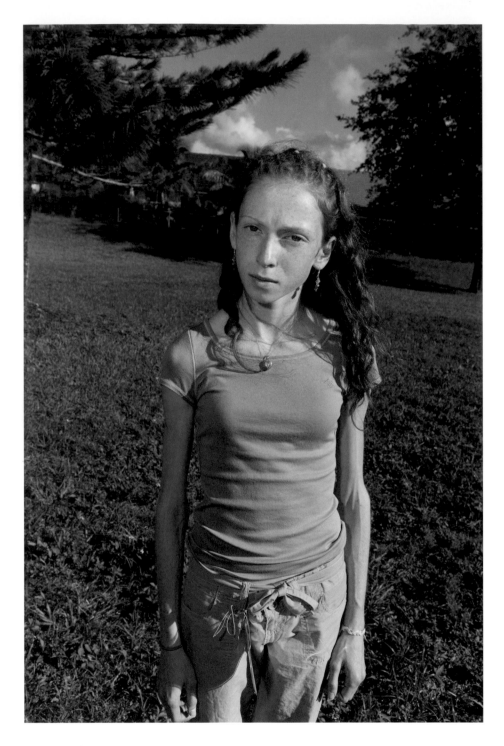

Aiva, 16, Before
Lauren Greenfield, 2005
C-print, 16 × 20 in.
Catalog number 2011.0032.01

Aiva entered treatment at seventy-seven pounds.
Ten weeks later (opposite) she looks physically healthier,
but her eyes convey a different message.

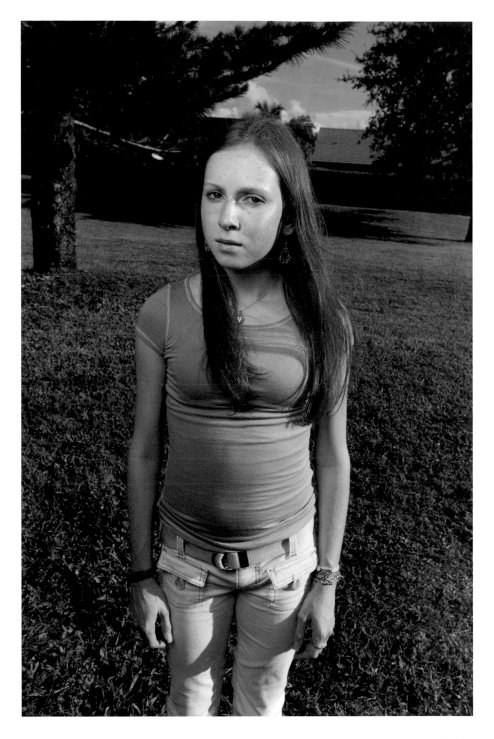

Aiva, 16, After
Lauren Greenfield, 2005
C-print, 16 × 20 in.
Catalog number 2011.0032.02

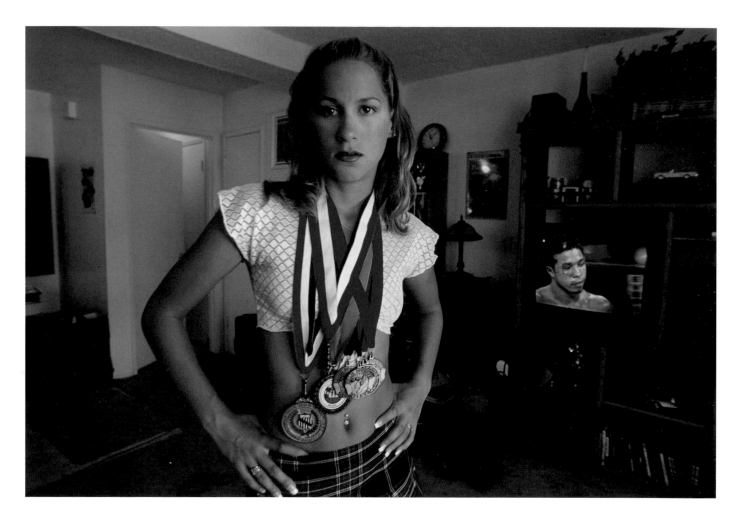

Leilani, 21, Exotic Dancer and Track Athlete
Lauren Greenfield, 2001
C-print, 16 × 20 in.
Catalog number 2011.0087.01

Leilani's achievement as a track star is paired with her
"school girl" costume she wears as a dancer to earn
tuition. This photograph presents the complexities of social
constructions associated with women's bodies, sexuality,
and power.

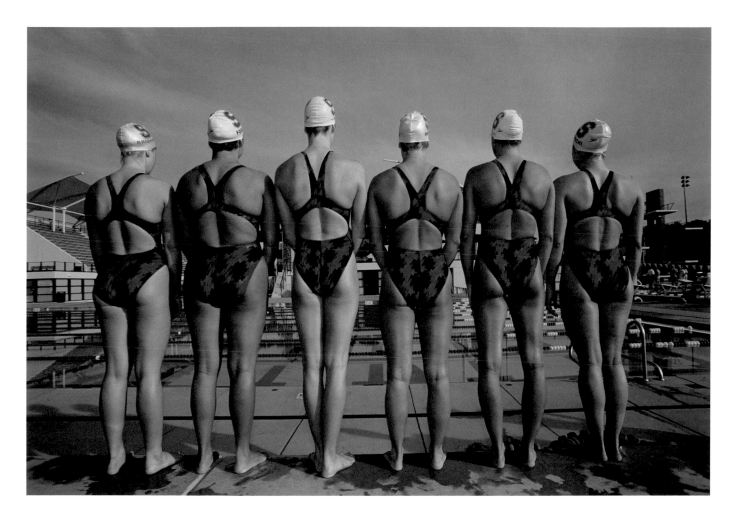

Stanford Women's Swim Team
Lauren Greenfield, 2001
Cibachrome, 16 × 20 in.
Catalog number 2011.0032.05

Greenfield also photographs women who are comfortable
in their own skin. "There's a little bit of Wonder Woman
in everyone," says swim-team member Jessica.

ROBERT WEINGARTEN

(b. 1941)

Portraits Unbound

Photographer Robert Weingarten quickly adapted to digital technology then took the visual capabilities of digital imaging to a new level. Weingarten worked predominately in black-and-white darkroom photography since his childhood, but began moving toward digital imaging in 1997. Until that time he had focused mostly on landscapes and the natural world. In a body of work originally called *Portraits Without People* and now known as *Portrait Unbound*, Weingarten created visually and intellectually layered portraits composed of multiple photographs. The *Portrait Unbound* pictures present notable cultural icons through combinations of images that are based on the sitters' suggestions in response to the question "What makes you who you are?" The series draws on the idea that traditional renderings are but momentary recordings of physical likenesses and inadequately address true identity. Weingarten's compositions bring together many facets of the sitters' lives but exclude the subjects' physical presence. His works explore the boundaries between portraiture and biography. The Photographic History Collection holds a range of Weingarten's work, which reflects the trajectory of his path to digital imaging, and the entire *Portrait Unbound* series, from which are drawn the images in this volume.

The Onset of Digital Imaging

Just as photographers in the mid-nineteenth century were inspired and challenged by the possibilities that new photographic

Buzz Aldrin
Robert Weingarten, 2007
Digital image, 44 × 60 in.
Catalog number 2007.0170.02

Walking on the moon and serving on a Navy icebreaker in Antarctica are two of the life experiences that shaped Aldrin.

processes presented, those at the turn of the twenty-first century using digital technology to reinvent their art find themselves faced with new philosophical and ethical concerns. Today, as in the past, some artists quickly assume new processes, some adapt at their own pace, and others abandon their cameras and studios altogether. In the eighth edition, published in 1863, of his famous 1856 photography manual, Nathan G. Burgess wrote that the daguerreotypists who were not able to transition to new photographic processes could not recognize the aesthetic and technological differences between the single, silver-plated, almost always cased daguerreotype and the glass-plate negative capable of making multiple prints on varied papers.[193]

Like Nickolas Muray (chapter 6), Weingarten is open to new tools and methods of image making. When digital photography first arrived onto the public scene in the mid-1980s, he could economically and artistically afford to investigate the differences among scanned film, conventional color printing, digital photography, and digital output. For others, embracing new technology, letting go of the existing paradigm of photography, and exploring new possibilities was not as comfortable.

Digital photography was first used mostly by photojournalists. News agencies invested in the fifty-thousand-dollar cameras because the ability to get the first pictures of news from around the world and run them on the front page meant selling more papers. Adobe's Photoshop 1.0 was released in 1990 for the Macintosh personal computer, which had been on the consumer market since 1984.[194] The real excitement, however, came in the late 1990s with version 3.0's introduction of the all-important "layer," which provides subtle and overt manipulation capabilities. At the same time, cameras were coming down in price and increasing in memory, availability, and quality. The widespread introduction of image-editing software gave both average and professional consumers a control over their images quite unlike before. After an initial monetary investment, photographers could endlessly combine photographs with other images or text,

apply filters for a variety of artistic effects, change colors, remove small or entire elements, and so on. The extensive accessibility of the technology for making these choices has heightened the public's awareness about the photograph's malleability.

The question of manipulation versus "reality" has always generated dialogue in photography. In the 1850s French photographer Gustave Le Gray and others used a second negative to include clouds in landscape images when the photographic materials could not simultaneously record all wavelengths of light. Oscar Gustave Rejlander's *Two Ways of Life* (1858) and Henry Peach Robinson's *Fading Away* (1860) were criticized for creating photographic scenes that did not occur as a singular moment in front of the camera and gave rise to the viewer's fear of being tricked or manipulated.[195]

Fred Ritchin insightfully dealt with digital imaging in his book *In Our Own Image: The Coming Revolution in Photography* (1990). Although acknowledging in his preface the "many new and fruitful avenues of exploration that will inevitably emerge from the marriage of computer and photography," he also expressed anxiety about the effect digital technology would have on the photographic representation of reality and personal identity.[196] Of particular concern to Ritchin was the question of whether viewers would be able to recognize when an image had been altered, for either benign or manipulative purposes. Ritchin cautions the reader that a new kind of image making will emerge that is both inspiring for its flexibility and accessibility and disturbing because it may not be easy to determine when the image is maliciously manipulated.

At the same time that image-management software first appeared on the market, artists began developing new, high-quality printing techniques for their work. In 1990 a culmination of digital explorations by photographer and musician Graham Nash and fellow photographer and road manager R. Mac Holbert bloomed into Nash Editions, a digital studio for fine art photographers. In late 1989 Nash purchased an IRIS 3047 printer for $126,000 (the cost of a house at the time) to print forty photographs in an edition of twenty-five for an exhibition of his work at the Parco Gallery in Tokyo. Within half an hour of their acquisition, Holbert and Nash voided the warranty on the printer and began making it do something it was not designed to do—print in black and white on archival paper. The printer is now part of the National Museum of American History collections, as is Nash's first print from the modified machine (see Acknowledgments, p. 150). Over the course of the next decade Holbert became a master digital printer by riding out and staying on the

steep learning curve of the ever-evolving and refined iterations of scanning methods, color-calibration tools, Photoshop releases, and other software and hardware revolutions.[197] His extraordinary energy, open-mindedness, and willingness to learn are signatures of early innovators in the digital era. Weingarten would eventually draw on Holbert's master skills to learn the new technology, transcending from student to colleague.

The Self-Taught Photographer

Weingarten committed himself to photography after retiring at age fifty-five from a career in international finance and publishing. Throughout his life, starting as a young boy in New York City, Weingarten trained himself in photography, technically and aesthetically. He enriched his work by reading voraciously, attending museum exhibitions, and seeking out photographers such as Englishman Charles Waite, with whom he studied by working side-by-side while on location in England. In 1997 Weingarten began the process of applying to the Royal Photographic Society of Great Britain, and by 2001, after a variety of portfolio reviews, he was admitted as a Fellow, marking his high level of artistic and technical proficiency.[198]

Weingarten, now a California-based photographer, honed his photographic skills creating landscapes of places like Tuscany, Provence, and the Palouse region of the northwestern United States, where beautiful light, gentle nature, and a soft hand of man coexist. Inspired by impressionist Claude Monet's studies of light, his landscapes hold hints of the emotional resonance and color palette of painter Edward Hopper and the composition of abstract painter Richard Diebenkorn.[199] Dissatisfied with the conventional color prints of his landscapes, Weingarten in 1997 sought out Holbert at Nash Editions to print his landscapes the way he envisioned them in regard to color and the surface of the papers.

Between 2001 and 2004, Weingarten photographed Amish communities in Pennsylvania, Indiana, Iowa, and Wisconsin, resulting in the series *Another America: A Testimonial to the Amish*. During this project he was surprised to find that the quality of his digital images met a standard on par or exceeding film, so he switched from film to digital cameras. Weingarten wanted to print the pictures with a look that would connect the contemporary Amish to their predecessors, so he employed Nash Editions to digitally duplicate the effect of platinum-palladium prints from an earlier era.[200] Working alongside Holbert, Weingarten realized that a new language and possibilities for photography were emerging, and he began studying to become fluent. In the process he

acquired his own image-management software, computers, and large Epson printers for his digital darkroom and studio.

From 2005 to 2007, Weingarten made a series of digital closeup examinations of the palettes—both the surfaces upon which paint resides waiting for application and the range of hues—of a variety of painters. *Palettes* became the first major body of digital work that he produced in his own studio. He enlarged the relatively unmanipulated microphotographs, covering approximately 2 × 3 inches of actual space, to 40 × 60 inches, achieving the look of abstract paintings. The technical skills that Weingarten developed during that time served him well during his next digital project, *Portrait Unbound*.

The Portrait Unbound

The photographs presented here, from Weingarten's *Portrait Unbound*, show a few of the results when the question of identity was posed to American icons from the last half of the twentieth and the beginning of the twenty-first century. Weingarten's photographs present a new, technically produced image of color composites that address the contemporary, complex visual experience encompassing video games, motion pictures, and a fast-paced culture filled with a plethora of photographic images. Wrapping this motif of a cacophony of images around the lives of his subjects results in a technological portrait that provides the historical moment in which these visual biographies are rendered.

Painters have represented their wealthy and powerful patrons for hundreds of years by using objects, colors, and expressions to convey overt meanings and symbolic messages. If the subject's face is excluded, can a sense of the person remain? Physical representation links an individual to a particular moment in time. Weingarten suggests that how we define and describe ourselves is not typically in physical terms of height, weight, or hair color, which change over time. He posits instead that what makes us who we are is an accumulation of life experiences.

The overt question Weingarten poses to his subjects for each portrait is, "What makes you who you are?" It is important to note that Weingarten's subjects transcend celebrity status—they are all American cultural icons whose contributions have altered our cultural and scientific lives. The individuals supply him with lists of ideas, experiences, and objects that are meaningful to them, and the results often combine the personal and the public. Weingarten then sets off to photograph the items. The process may sound simple, but the diverse and wide-ranging objects —whether landscapes, cityscapes, famous art, or material

in archives and private homes, sometimes even ephemera such as sounds—need to be researched and tracked down, with each component requiring a separate photo session. The process leads to the creation of an enormous pool of images to draw from to begin building rich layers on his electronic canvas.

With digital technology controlling opacity and density, Weingarten is free to layer color images in a way not previously possible in color photography. The scale of each image is based on artistic choice, and the objects reside on various picture planes rather than in an overall mathematical relationship that would occur within natural visual relationships. The result is that objects "float" in Weingarten's work to create a three-dimensional effect. The experience of viewing Weingarten's photographs, as large as 60 × 90 inches (thanks to newer printing technologies), can be equated to looking at objects and reflections in a storefront window. Like reflections from a variety of angles and sources, individual images immediately draw one's attention while others emerge from the background. The layers and skewed scales reinforce the idea that individuals are complex and that various parts of their lives come to the surface and have a large presence at certain moments.

Each print from *Portrait Unbound* typically has a single image that anchors the subject's history and relates to prominent items from the subject's list, coloring the metaphorical portrait. For Leonard Kleinrock (p. 148), a computer scientist whose work helped form the basis of the Internet, the main image is the wiring of the computer that sent the first machine-to-machine message and the logbook entry recording the feat on October 29, 1969. For four-star general and former secretary of state Colin Powell (p. 145), the significant symbols include names from the Vietnam Veterans Memorial in Washington, D.C., representing the war that shaped his ideas about international relations.

The central elements that anchor the overall image are sometimes perceived as foreground, other times as background. In contemporary painter Chuck Close's portrait (p. 146), Giotto's celestial frescoes on the ceiling of the Scrovegni Chapel in Padua, Italy, literally provides an overarching framework in which flowers from Sissinghurst Castle Gardens, Sussex, England, weave their way in and out of the ceiling. In the 1970s Close generated large-scale (7 × 9 feet) painted portraits of his friends that revealed a hyper-photographic accuracy. He created other portraits in a kind of protopixilation through his use of grids and thumbprints as data laid down in a painterly fashion, a treatment not so unlike Weingarten's works. Portraiture has figured prominently in Close's influences, especially Johannes Vermeer's *Girl*

with the Red Hat, c. 1665/1666 (National Gallery of Art, Washington, D.C.), his favorite painting, and Willem De Kooning's fractured *Woman, I*, 1950–1952 (The Museum of Modern Art, New York), his favorite made within his lifetime. Close's life was altered in 1988 when a spinal artery ruptured and left him with limited mobility; his IBOT wheelchair that climbs stairs has been an important object in his life. Bounty paper towels and black Sharpie pens, he says, are artists' greatest tools.

Sandra Day O'Connor (p. 147) gave Weingarten a challenge when she listed the sound of the windmills at her childhood home at the Lazy B Ranch in Arizona. O'Connor is most well known as the first female member of the Supreme Court; she served in that prestigious role from 1981 to 2006. The interior of the Supreme Court became the central image, framed by reminders of her rural western upbringing. The arid, brush landscape of the ranch can be seen behind all the images, a kind of underpinning. A pair of windmills bookmarks the red curtains and columns of the interior of the Court where the arch that marks the entrance to the Lazy B Ranch hovers, implying that one's former experiences frame the present. Through her justice's robe and white collar is the exterior of the Arizona State Capitol, where she started her judicial career. The blue-framed door is from her Phoenix home where she raised her family. The branding iron is from the ranch and was kept in her office, past and present coexisting and tangled together. Also from her Washington, D.C., office is the pillow with the saying, "Maybe in error, but never in doubt." Her legal and judicial history, the landscape that grounded her, and a humorous bit about her convictions begin to give viewers a hint about where she has been and who she had become. The image becomes a visual biography, a biographical portrait.

By allowing his subjects to define their list, which will become their biographical images, Weingarten provides them the last say on what experiences made them who they are. The impending historical value of Weingarten's images was hinted at when Dennis Hopper (p. 144) died in May 2010. The motorcycle from *Easy Rider*, the 1969 film that made him a household name, is recognizable. His passion for golf and cigars is evident. A director's chair with his name on it references his directing credits and offers up his name in case the viewer needs a little help identifying the subject. Hopper was also a photographer, and a camera is found floating. One of Hopper's best-known photographs, *Double Standard*, became the basis of a black-and-white mural in Los Angeles, an expression of his impact on that particular community. Perhaps the most interesting element of his portrait is the Andy Warhol painting of Mao

Tse-tung from 1972. Hopper was an avid collector of modern art, but notice that this Mao has orange grease-pencil notes on it: "Warning Shot" at the bottom center and "Bullet Hole" above Mao's left eye. It is one thing for reporters to write about Hopper's drug use, but to see the bullet holes in a priceless painting that were created when he, in a drug-induced rage, railed against communism and decided to shoot Mao brings Hopper's history sharply to life.

———

When a critical mass of subjects had been photographed and he was satisfied with his intellectual explorations—for which he had garnered exhibitions, publications, gallery sales, and the placement of work in museums—Weingarten ended the *Portrait Unbound* project. The desire to see the famous in photographs has existed since the medium was introduced, and our curiosity about celebrities has shaped the way those men and women are depicted (see also chapters 1 and 6). From Weingarten's portraits we learn of the sorts of life events that shape the internal and external worlds of significant individuals who are able to have an important impact on our world, and we can reflect on the ways that we may be the same or different. A brave viewer may turn inward to ponder aspects of his or her own history and the experiences that shape his or her life. Within the history of photography, Weingarten poses questions about how a portrait might convey information about the sitter by recording aspects of the subject's likeness, personality, or biography. His portraits also present one way in which digital technology brings a new visual experience to the metaphorical and literal layering of life events.

A viewer's ability to appreciate these multilayered, multiscaled, visually active images is dependent upon the viewer's willingness to slow down and look. It also requires a readiness to reframe one's own idea of what a photograph, portrait, and/or digital image should look like. In a lecture that Weingarten presented at the J. Paul Getty Museum at the Getty Center, he stated, "In art, Picasso said every act of creation is first an act of destruction."[201] Each process, each new art style, like the switch from the daguerreotype to the glass-plate negative or the change from realism to cubism, required both the producer and the audience to allow for new ways of forming and seeing images. Letting go, permanently or temporarily, of other forms provides a window to a new understanding. Weingarten's works are challenging and puzzling to some viewers, but they also reflect a moment in the broader culture and the building of a

visual language in a digital world. Through dialogue and public discourse the value and meaning of new technologies and styles eventually becomes standardized and common, until they, too, take their turn in the cycle of creative destruction.

Dennis Hopper
Robert Weingarten, 2006
Digital image, 44 × 60 in.
Catalog number 2007.0170.05

Three years before he died, Hopper actively contributed
to his list of what defined him. That effort enabled him to
shape his legacy through Weingarten's work.

Colin Powell
Robert Weingarten, 2008
Digital image, 44 × 60 in.
Catalog number 2009.0102.06

Individuals' lives are shaped by where they grew up.
Here, Brooklyn is the background for Powell's life as a
soldier and diplomat.

Chuck Close
Robert Weingarten, 2007
Digital image, 44 × 60 in.
Catalog number 2008.0179.02

Portraiture has featured prominently in the painter
Chuck Close's life; his visual biography incorporates
portraits by him and others.

Sandra Day O'Connor
Robert Weingarten, 2008
Digital image, 44 × 60 in.
Catalog number 2008.0179.03

Weingarten synthesizes and melds O'Connor's rural
Arizona upbringing with her role as the first female
Supreme Court justice.

Leonard Kleinrock
Robert Weingarten, 2008
Digital image, 44 × 60 in.
Catalog number 2009.0102.05

Kleinrock's work helped form the World Wide Web.
His Eagle Scout Award provided values, and M. C. Escher's
work reflects Kleinrock's systematic but complicated
thinking.

Joyce Carol Oates
Robert Weingarten, 2011
Pigment print, 44 × 66 in.
Catalog number 2011.0045.08

The final print of the series is about Joyce Carol Oates,
a writer with more than fifty novels to her credit.
Interestingly, Oates's portrait contains no words,
but rather images that reference the personal places
and ideas that have shaped her work.

The Man That Jan Sees
Graham Nash, 1969/1989
Pigment print, 24½ × 18½ in.
Catalog number 2005.0202.01

The negative for this portrait of musician David Crosby was
made in 1969. In the late 1980s Nash and R. Mac Holbert
purchased an IRIS printer and got it to print black-and-white
archival photographs on watercolor paper. This is the first
successful print off the machine that was the backbone of
Nash Editions for over a decade.

ACKNOWLEDGMENTS

No book is ever the sole effort of the author but rather, the sum of those who labor with her. A special thank you goes to my research assistant, Ryan Lintelman, who was invaluable in keeping data straight, managing image files, hunting for history, and being a friend and all-around good guy. Monica Smith, a kind friend and colleague, proved to be a brilliant editor. I owe Paula Fleming a large debt of gratitude as a mentor and researcher extraordinaire. My Smithsonian Books editor Christina Wiginton, a collaborator who taught me a tremendous amount, was brilliant at heightening readability, organization, and design.

I am honored to have worked with photographers John Paul-Caponigro, Regina DeLuise, Lauren Greenfield, R. Mac Holbert, Henry Horenstein, Graham Nash, Bruce McKaig, Susana Raab, Charles Rushton, Robert Weingarten, and Jerry Uelsmann. I thank them for letting me tell their stories and allowing me to share an honest and thoughtful dialogue that creates a balance between my perceptions and interpretations and their intentions.

This book came to fruition because of my bright, kind, calm, and competent colleagues with can-do attitudes: Ginger Strader at Smithsonian Institution Scholarly Press, whose sharp eyes and penchant for detail sanded off the rough edges to give the book its final form, and Carolyn Gleason at Smithsonian Books. Carrie Hunt at HK Creative, Inc., is behind the elegant book design that made disparate visual objects into a seamless presentation.

To the readers who commented on the text—J. Ross Baughman, Donald Beattie, James Bryan, Sarah Kate Gillespie, Marvin Heiferman, Edward Robinson, Will Stapp, and Trudy Wilner Stack—thank you for your thoughtful contributions. Any errors are mine, not theirs.

Thank you to Curator of Photographs Anne E. Peterson at the DeGolyer Library, Southern Methodist University, and Lawrence T. Jones III for helping ferret out information on David P. Barr and Charles J. Wright. Thank you to Cathy Fitch for sharing genealogical research on David P. Barr and Charles J. Wright. Beverly Stimson and Warren Thomas have also generously shared George McNeel's genealogy; it has led to projects none of us could have anticipated.

The beautiful reproductions in this book began with the brilliant work of Smithsonian Photographic Services photographer Hugh Talman. David Sterling helped ensure the photographs presented here are as close to the originals as we could get.

Thank you to my many National Museum of American History colleagues and supervisors who supported and encouraged me, especially David Allison, Joan Boudreau, Kathryn Campbell, Russell Cashdollar, Michelle Delaney, Petrina Foti, Eric Jentsch, Peggy Kidwell, Stacey Kluck, Katherine Ott, Vanessa Pares, Lauren Telchin-Katz, Deborah Warner, Helena Wright, and director of the Museum, Dr. Brent Glass. Thank you to the Collections Committee, which has helped support and bring photographic materials to the Photographic History Collection over the years. Joan Mentzer, whose editing has made my writing smoother and clearer, has been a pleasure to work with, as always.

The Smithsonian Institution Library is one of the best in the world, rich in materials made accessible by an excellent staff. I appreciate all the assistance given to me throughout the Smithsonian library system.

Many interns have helped shaped records and care for collections in the Photographic History Collection. I especially thank them for committing their time and emerging scholarship to the benefit of all who use the Collection. Andrea Hackman and Carolyn Ureña were a special help.

Thank you to my friends and family who cheer me on, making work and life ever so nice: Aunt B and Uncle Steve Arnold, the Bergin family, Tracey Enright, the Garrison-Cancino family, Aunt Sandy and Uncle Sonny Hale, Aunt Rena Jacobson, the Moore-Dixon family, Jack and Carolyn Perich, Christine Powers, Helen Riggs, Mitchell Story, my sister Kathleen Thomas, Uncle Randy and Beverly Thomas, Aunt Ramona Thomas, Ray Thomas, Grandma Thelma Whitley, Uncle Mike and Aunt Tricia Whitley, Uncle Ronnie and Aunt Linda Whitley, and, last but not least, my husband Scott and children Maeve and Thomas for their laughter, patience, hugs, and kisses.

NOTES

George K. Warren

1. Mark Osterman, "Introduction to Photographic Equipment, Processes, and Definitions of the 19th Century," in *The Focal Encyclopedia of Photography: Digital Imaging, Theory, and Applications, History, and Science*, 3rd ed., ed. Michael R. Peres (London: Focal Press, 1993), 114–115.

2. *Photographic Art Journal* 3 (February 1852): 130.

3. Mary Panzer, "The George Kendall Warren Photography Collection: National Museum of American History," *History of Photography* 24, no. 1 (Spring 2000): 25; cites "reviews, cited in 'George K. Warren, Patricia H. Rodgers, Charles M. Sullivan and the staff of the Cambridge Historical Commission. *A Photographic History of Cambridge* (Cambridge: MIT Press, c.1984) 135ff."

4. Beecher to G. K. Warren, July 23, 1873, catalog number 2005.0231.248. These and assorted other letters to Warren are bound in a volume held in the Photographic History Collection, National Museum of American History (hereafter cited as PHC). All letters to Warren cited below are in this volume.

5. Phineas Taylor Barnum, *The Life of P. T. Barnum* (Buffalo: The Courier Company Printers, 1886). n.p. The engraving in the book, based on the PHC portrait, indicates he was "At the Age of 75" when the photograph was made.

6. George Gilbert to G. K. Warren, February 24, 1860, and March 12, 1860 (PHC).

7. University of Michigan, Chronicle 1, no. 1 (September 25, 1869): 1870. There are two examples of Warren's University of Michigan albums. One at William L. Clements Library, University of Michigan, Ann Arbor, and another at the Bentley Historical Library, University of Michigan, Ann Arbor.

8. Advertisement, *Yale Literary Magazine* 21, no. 1 (October 1861): 43.

9. "Class Pictures," *Yale Literary Magazine* 34, no 1. (October 1868): 93.

10. "Editor's Table," *Harvard Magazine* 8 (April 1862): 310.

11. Beardslee to G. K. Warren, November 3, 1859 (PHC).

12. G. K. Warren to parents, mid-November 1860 (PHC).

13. J. W. Beardslee to G. K. Warren, November 29, 1859 (PHC).

14. J. W. Beardslee to G. K. Warren, December 12, 1859 (PHC).

15. Williams College to G. K. Warren, April 1, 1859 (PHC).

16. "R" to G. K. Warren, March 8, 1859 (PHC).

17. "Editor's Table," *Harvard Magazine*, 310.

18. Josiah Collins Plumpelly to G. K. Warren, January 21, 1860 (PHC).

19. *Rutgers College Class of '60*, yearbook owned by George Washington McNeel, catalog number 2005.0149.01 (PHC).

20. Beverly Stimson, email message to author, February 2, 2010.

21. *Rutgers College Class of '60*, n.p.

22. "Rutgers College," *New York Times*, June 23, 1860, 3.

23. Beverly Stimson, email message to author, February 2, 2010.

24. Three annotated cartes de viste by Warren, catalog numbers 1995.0231.028, 1995.0231.029, and 1995.0231.030 (PHC).

25. Panzer, "The George Kendall Warren Photography Collection," 29.

Julia Margaret Cameron

26. Pam Roberts, "Julia Margaret Cameron: A Triumph over Criticism," in T*he Portrait in Photography*, ed. Graham Clarke (London: Reaktion Books Ltd., 1992), 49.

27. Julia Margaret Cameron, "Annals of My Glass House," Photographic Journal LI (n.s.) (July 1927), 293–230. Vicki Goldberg, ed., *Photography in Print: Writings from 1816 to the Present* (Albuquerque: University of New Mexico Press, 1981), 183.

28. Julian Cox and Colin Ford, *Julia Margaret Cameron: The Complete Photographs* (Los Angeles: Getty Publications, 2003), 48.

29. Charles Hay Cameron, Two Essays: *On the Sublime and Beautiful, and on Dueling* (London: Ibotson and Palmer, 1835), 1.

30. Roberts, "Julia Margaret Cameron," 60.

31. Ibid., 70.

32. Julia Margaret Cameron to Miss Osborne, June 20, 1875; Cox and Ford, *Julia Margaret Cameron*, 4.

33. Cox and Ford, *Julia Margaret Cameron*, 499, 500.

34. Mike Weaver, *Julia Margaret Cameron (1815–1879)* (Boston: Little, Brown and Company, 1984), 7.

35. Weaver, *Julia Margaret Cameron (1815–1879)*, 14–15.

36. Cox and Ford, *Julia Margaret Cameron*, 50.

37. Letter from Julia Margaret Cameron to Sir John Herschel, December 31, 1864. Heinz Archive and Library, National Portrait Gallery, London, catalog number NPG P201 (1d). Quoted in Helmut Gernsheim, *Julia Margaret Cameron: Her Life and Photographic Works* (New York: Aperture, 1975), 14. The whole of this letter can be found online at the National Portrait Gallery, London.

38. Weaver, *Julia Margaret Cameron (1815–1879)*, 22–24.

39. Cox and Ford, *Julia Margaret Cameron*, 514.

40. Ibid., 514.

41. Cameron, "Annals of My Glass House," 186.

42. Weaver, *Julia Margaret Cameron (1815–1879)*, 24.

43. Ibid., 61.

44. Stopford Augustus Brook, *The Poetry of Robert Browning* (New York: Thomas Y. Crowell, 1902), 365.

45. Weaver, *Julia Margaret Cameron (1815–1879)*, 23.

46. Barbara Michaels, *Gertrude Käsebier: The Photographer and Her Photographs* (New York: Harry Abrams, 1992), 17.

47. Roberts, "Julia Margaret Cameron," 63.

Barr & Wright Studio

48. David Haynes, *Catching Shadows: A Directory of Nineteenth-Century Texas Photographers* (Austin: Texas State Historical Association, 1993), 6.

49. Advertisement, *Anthony's Photographic Bulletin* 4 (1873): n.p.

50. Jeff Giambrone, "To Catch the Shadow: Photographers in Occupied Vicksburg," *Military Images* (January/February 2002), http://findarticles.com/p/articles/mi_qa3905/is_200201/ai_n9074119/ (accessed May 5, 2010).

51. http://boards.ancestry.com/localities.northam.usa.states.texas.counties.harris/2216.2/mb.ashx.

52. Haynes, *Catching Shadows*, 6.

53. Lawrence T. Jones III Texas Photography Collection, Southern Methodist University, Central University Libraries, DeGolyer Library, Dallas, Tex., http://digitalcollections.smu.edu/all/cul/jtx/.

54. Nathan G. Burgess, *The Photograph Manual: A Practical Treatise Containing the Cartes de Visite Process, and the Method of Taking Stereoscopic Pictures, Including the Albumen Process, the Dry Collodion Process, the Tannin Process, the Various Alkaline Toning Baths, etc., etc.* (New York: D. Appleton & Co., 1863), 224, 228.

55. Lawerence Jones to Shannon Perich via Anne Peterson, July 1, 2010.

56. Burgess, *The Photograph Manual*, 171–172.

57. John L. Gihon, "Post-Mortem Photography," *Photo Mosaics* (1871): 32–34.

58. Ibid., 34–35.

59. U.S. Federal Census Records, 1891, San Antonio Directory, 1900, 1910, and 1920.

Gertrude Käsebier

60. Accession numbers 287543, 306580, and 187180 comprise the majority of the Gertrude Käsebier collection (PHC).

61. Michelle Delaney, *Buffalo Bill's Wild West Warriors: A Photographic History by Gertrude Käsebier* (Washington, D.C.: National Museum of American History, Smithsonian Institution, and HarperCollins, 2007).

62. Barbara Michaels, *Gertrude Käsebier: The Photographer and Her Photographs* (New York: Harry Abrams, 1992), 17–18.

63. Ibid., 19.

64. Ibid., 20.

65. Ibid., 22.

66. Ibid., 24.

67. Lily Norton, "Department of Commerce-Business Principles for Women," *Pratt Institute Monthly* 11, no. 8 (April 1894): 261.

68. Michaels, *Gertrude Käsebier*, 29.

69. Miss M. E. Sperry, "Women and Photography," The Pacific Coast Photographer 3 (October 1894): 153–154, in *Camera Fiends and Kodak Girls II: Sixty Selections By and About Women Photography, 1855–1965*, ed. Peter E. Palmquist (New York: Midmarch Arts Press, 1995), 71–74.

70. Michaels, *Gertrude Käsebier*, 29.

71. Bronwyn A. E. Griffith, ed., *Ambassadors of Progress: American Women Photographers in Paris, 1900–1901* (Giverney, France: Musée d'Art Américain Giverney in association with the Library of Congress, 2001).

72. "Minneapolis Camera Club," *American Amateur Photographer* 12, no. 1 (January 1900): 42.

73. *The Manger* by Gertrude Käsebier, catalog number 4668.02 (PHC), depicts a woman wearing a diaphanous veil and gown cradling a baby in her arms. The two appear to be inside a barn, with sunlight streaming in through a window on the upper right.

74. Charles Henry Caffin, Photography as a Fine Art: *The Achievements and Possibilities of Photographic Art in America* (New York: Double, Page & Company, 1901), 72.

75. Ibid.

76. Michaels, *Gertrude Käsebier*, 103.

77. Michaels, *Gertrude Käsebier*, 106.

78. Library of Congress, call number LC-K2- 36-A [P&P].

79. Ronald G. Pisano, *William Merritt Chase: Portraits in Oil* (New Haven: Yale University Press, 2006), 66.

80. Michaels, *Gertrude Käsebier*, 118–120.

81. Bennard B. Perlman, *Robert Henri: His Life and Art* (New York: Dover Publications, 1991), 78.

82. Rose Cecil O'Neill, *The Story of Rose O'Neill: An Autobiography*, ed. Miriam Formanek-Brunell (Columbia: University of Missouri Press, 1997), 95.

83. Delaney, *Buffalo Bill's Wild West Warriors*, 13.

84. Ibid., 94.

85. *The Red Man* by Gertude Käsebier, catalog number 2007.0200.01 (PHC).

Dorothea Lange

86. *Migrant Mother* by Dorothea Lange, catalog number 1983.0069.07 (PHC). Arthur Rothstein donated a group of ten photographs by Lange, Ben Shan, Walker Evans, and himself. The photographs were printed by Berkey K & L Custom Services, Inc., New York City, under Rothstein's supervision, presumably in the early 1980s.

87. Robert Taft, *Photography and the American Scene: A Social History, 1839–1889* (New York: Macmillan, 1938).

88. Ibid., 450.

89. Ibid.

90. Jacob Riis, *How the Other Half Lives: Studies among the Tenements of New York* (New York: Charles Scribner's Sons, 1890).

91. Linda Gordon, *Dorothea Lange: A Life Beyond Limits* (New York: W. W. Norton and Company, 2009), 10–14, 41.

92. Ibid., 21–31.

93. Ibid., 29.

94. Ibid., 9, 28.

95. Ibid., 32–34.

96. Ibid., 35–36.

97. Ibid., 41, 44.

98. Ibid., 44.

99. Ibid., 63.

100. Pierre Borhan, *Dorothea Lange: The Heart and Mind of a Photographer* (Boston: Bullfinch Press, Little, Brown and Company, 2002), 8.

101. Dorothea Lange, Oral History interview by Richard Doud, May 22, 1964. The Archives of American Art has a number of interviews with Roy Styker and his photography staff available at http://www.aaa.si.edu/collections/interviews/oral-history-interview-dorothea-lange-11757.

102. The Library of Congress provides an explanation and illustration of the quick photo session at http://www.loc.gov/rr/print/list/128_migm.html.

103. Gordon, *Dorothea Lange*, 237.

104. Robert Hariman and John Louis Lucaites, *No Caption Needed: Iconic Photographs, Public Culture, and Liberal Democracy* (Chicago: University of Chicago Press, 2007), 49–92.

105. Gordon, *Dorothea Lange*, 238.

106. Edward Steichen, *The Family of Man: The 30th Anniversary Edition of the Classic Book of Photography* (New York: Simon & Schuster, 1983 [orig. 1955]). There were several versions of the 1955 Museum of Modern Art exhibition that traveled the world. There is one on permanent exhibition in Luxembourg, Belgium (http://www.luxembourg.co.uk/clervaux.html#family).

107. Gordon, *Dorothea Lange*, 358.

108. Roy Emerson Stryker and Nancy Wook, *In This Proud Land: America 1935–1943 as Seen in the FSA Photographs* (Greenwich: New York Graphic Society Ltd., 1973), 19.

109. Gordon, *Dorothea Lange*, 241.

110. Kiku Adatto, *Picture Perfect: Life in the Age of the Photo Op* (Princeton: Princeton University Press, 2008), 247.

111. Bill Ganzel, *Dust Bowl Descent* (Lincoln: University of Nebraska Press, 1984), 30–31.

112. Carolyn Jones, "Daughter of 'Migrant Mother' Proud of Story," *San Francisco Chronicle*, August 23, 2009, http://articles.sfgate.com/2009-08-23/news/17178626_1_images-farm-children (accessed March 8, 2011).

113. Gordon, *Dorothea Lange*, 298.

114. "The Migrant Worker," American Art on Postage Stamps: Telling the Story of a Nation, Smithsonian National Postal Museum, http://arago.si.edu/flash/?s1=5lsq=Celebrate%20the%20Centurylsf=0.

115. Miles Orvell, *American Photography, Oxford History of Art* (New York: Oxford University Press, 2003).

116. Hariman and Lucaites, *No Caption Needed*, 65.

Nickolas Muray

117. Accession numbers 258415, 287542, and 1982.0545. These three accessions comprise the collection of more than fifty photographs by Muray.

118. http://photography.nationalgeographic.com/photography/photographers/first-natural-color-photo.html.

119. Patricia Johnston, *Real Fantasies: Edward Steichen's Advertising Photography* (Berkeley: University of California Press, 1997), 83–85, 121, 240.

120. Saloman Grimberg, *I Will Never Forget You . . . Frida Kahlo and Nickolas Muray Unpublished Photographs and Love Letters* (Munich: Schirmer/Mosel, 2004), 10.

121. Ibid., 109.

122. Ibid., 11.

123. Nickolas Muray, *Celebrity Portraits of the Twenties and Thirties: 135 Photographs* (New York: Dover, 1978), n.p.

124. Gabrielle H. Cody and Evert Sprinchorn, eds., *The Columbia Encyclopedia of Modern Drama*, Volume 2 (New York: Columbia University Press, 2007), 1230.

125. Grimberg, *I Will Never Forget You . . . Frida Kahlo and Nickolas Muray*, 109.

126. George Amberg, *Ballet in America—The Emergence of an American Art* (New York: Da Capo Press, 1983), 27.

127. Paul Gallico, "The Revealing Eye: Personalities of the 1920s," in *Photographs by Nickolas Muray and Words by Paul Gallico* (New York: Atheneum, 1967).

128. Muray, *Celebrity Portraits of the Twenties and Thirties*, n.p.

129. Gallico, "The Revealing Eye," 14.

130. Muray, *Celebrity Portraits of the Twenties and Thirties*, n.p.

131. "Leading Color Photographers of U.S. Display Their Art in New York Show," *Christian Science Monitor* (1908–current file), May 21, 1938, 1.

132. Grimberg, *I Will Never Forget You . . . Frida Kahlo and Nickolas Muray*, 15.

133. Accession numbers 71:0034 (prints) and 71:0046 (negatives), George Eastman House, Rochester, N.Y. George Eastman House has 370 Muray photographs online at http://geh.org/fm/muray/murcol_idx00001.html.

134. Grimberg, *I Will Never Forget You . . . Frida Kahlo and Nickolas Muray*, 9–41.

135. Kerry Segrave, *Endorsements in Advertising: A Social History* (Jefferson, N.C.: McFarland, 2005), 3.

136. Ibid., 67.

137. Ibid., 85.

138. "Adverting: A Man of Distinction," *Time*, April 10, 1950, http://www.time.com/time/magazine/article/0,9171,856623,00.html.

139. Quoted in Anthony Slide, *Inside the Hollywood Fan Magazine: A History of Star Makers, Fabricators, and Gossip Mongers* (Jackson: University of Mississippi, 2010), 80.

140. Muray, *Celebrity Portraits of the Twenties and Thirties*, n.p.

Richard Avedon

141. *A Special Exhibition of Photographs by Richard Avedon*, exhibition at the Smithsonian's Arts and Industries Building, Washington, D.C., November 1–December 17, 1962.

142. James Baldwin (text) and Richard Avedon (photos), *Nothing Personal* (New York: Atheneum, 1964).

143. Penelope Rowlands, *A Dash of Daring: Carmel Snow and Her Life in Fashion, Art, and Letters* (New York: Atria Books, 2005), 331.

144. Harold Rosenberg, "A Meditation on Likeness," in Richard Avedon, *Portraits* (New York: Farrar, Straus, and Giroux, 1976), 177–186.

145. "New Focus on Familiar Faces," *Life*, 47, no. 15 (October 12, 1959): 136.

146. Andy Grundberg, *Brodovitch: Masters of American Design* (New York: Harry Abrams, 1989), 137.

147. Langston Hughes, *Autobiography: The Collected Works of Langston Hughes*, Vol. 14, ed. Arnold Rampersad (Columbia: University of Missouri Press, 2002), 14–307.

148. Baldwin and Avedon, *Nothing Personal*, 2–4.

149. Ibid., 5.

150. Claudia Cassidy, "The Superb Clown Crowns Felicty of 'Godot's' Performance," *Chicago Daily Tribune*, May 20, 1956, F7.

151. "New Focus on Familiar Faces," 136.

152. Dan Sullivan, "'Cowardly Lion' a Theatrical Biography of Bert Lahr," *Los Angeles Times*, December 7, 1969, C40.

153. *The New Yorker*, November 1, 2004, 60–91.

154. Andy Grundberg, "Richard Avedon, the Eye of Fashion, Dies at 81," *New York Times*, October 1, 2004.

Henry Horenstein

155. http://aesthetic.gregcookland.com/2007/07/henry-horenstein.html.

156. Virginia A. Heckert and Anne Lacoste, *Irving Penn: Small Trades* (Los Angeles: J. Paul Getty Museum, 2009).

157. Beaumont Newhall, "Preface," in August Sander, *Photographs of an Epoch, 1904–1959: Man of the Twentieth Century, Rhineland Landscapes, Nature Studies, Architectural and Industrial Photographs, Images of Sardinia* (Millerton, N.Y.: Aperture, 1980), 8, 40.

158. http://www.loc.gov/pictures/collection/fsa.

159. http://www.blip.tv/file/1934154, minute 2:05.

160. E. P. Thompson, *The Making of the English Working Class* (New York: Pantheon Books, 1963).

161. Henry Horenstein, email message to author, September 16, 2010.

162. Henry Horenstein, email message to author, February 20, 2011.

163. http://www.blip.tv/file/1934154, no time marker.

164. Henry Horenstein with drawings by Claire Nivola, *Black and White Photography: A Basic Manual* (Boston: Little, Brown, 1974); Henry Horenstein with photos by the author and drawings by Henry Isaacs, Beyond Basic Photography: A Technical Manual (Boston: Little, Brown, 1977).

165. Horenstein, Beyond Basic Photography, 118.

166. Henry Horenstein (photographer), Tom and Ray Magliozzi (Introduction), and Shannon Perich (Afterword), *Close Relations* (New York: Powerhouse Books, 2006), 93.

167. Henry Horenstein, "Photographer's Notes," in *Humans* (Heidelberg: Kehrer, 2004), 93.

168. Artist Statement, www.horenstein.com, 2010.

169. Margaret Brown Klapthor and Paul Dennis Brown, *The History of Charles County, Maryland, Written in Its Tercentenary Year of 1958* (Westminster, Md.: Heritage Books, 1995), 7.

170. Charles McGovern, "Afterword," in Henry Horenstein, *Honky Tonk: Portraits of Country Music, 1972–1981* (San Francisco: Chronicle Books, 2003), 141.

171. Horenstein, *Humans*, 93.

172. http://www.nytimes.com/2008/05/18/nyregion/thecity/18burl.html.

173. http://photo.net/photographer-interviews/henry-horenstein.

Lauren Greenfield

174. See notes 184 and 185 below for full citations of these books.

175. Ken Light, *Witness of Our Time: Working Lives of Documentary Photographers* (Washington, D.C.: Smithsonian Books, 2000), 5.

176. Brett Abbott, "Engaged Observers in Context," in *Engaged Observers: Documentary Photography since the Sixties* (Los Angeles: J. Paul Getty Museum, 2010).

177. Jean Lacouture, "The Founders," in William Manchester, *In Our Time: The World as Seen by Magnum Photographers* (New York: American Federation of Arts in association with Norton, 1989), 48.

178. Peter Howe, "Forged by Fire," *The Digital Journalist*, 2001, http://digitaljournalist.org/issue0111/seven_intro.htm.

179. Lauren Greenfield interviewed by Alex Chadwick, *VII Seminar Part 1*, recorded interview, April 9, 2006, no timing marker available, http://www.laurengreenfield.com/index.php?p=IZRBKHV6.

180. Ibid.

181. Ibid.

182. Patricia Marks Greenfield (text) and Lauren Greenfield (photographs),

Weaving Generations Together: Evolving Creativity in the Maya of Chiapas (Santa Fe, N.M.: School of American Research Press, 2004).

183. Bret Easton Ellis, *Less Than Zero* (New York: Simon & Schuster, 1985).

184. Lauren Greenfield, *Fast Forward: Growing Up in the Shadow of Hollywood*, ed. Leah Painter Roberts (New York: Alfred A. Knopf/Melcher Media, 1997).

185. Lauren Greenfield, *Girl Culture* (San Francisco: Chronicle Books, 2002); Lauren Greenfield, *Thin* (San Francisco: Chronicle Books, 2006).

186. Anne-Gerard Flynn, "Photographer Lauren Greenfield to Speak on Body Image Exhibits," masslive.com, March 1, 2009, http://www.masslive.com/entertainment/index.ssf/2009/03/documentary_photographer_laure.html.

187. Trudy Wilner Stack, "Lauren Greenfield's THIN Line," a lecture by Trudy Wilner Stack at the University of Missouri–St. Louis, Center for the Humanities, January 25 and 28, 2010. Earlier versions of this lecture were presented at the Minnesota Center for Photography and the College Art Association Annual Conference.

188. Lauren Greenfield interviewed by James Rocchi, "Cenimatical," Sundance Film Festival, 2008, http://www.laurengreenfield.com/index.php?p=IZRBKHV6.

189. Greenfield, *Girl Culture*, 102.

190. http://www.boston.com/community/photos/raw/articles/2009/03/22/a_clear_lens_on_distorted_values/?page=2.

191. Adam D. Weinberg, On the Line: *The New Color Photojournalism* (Minneapolis: Walker Art Center, 1986), 23.

192. http://lens.blogs.nytimes.com/2010/03/31/showcase-145/.

Robert Weingarten

193. Nathan G. Burgess, *The Photograph Manual: A Practical Treatise Containing the Cartes de Visite Process, and the Method of Taking Stereoscopic Pictures, Including the Albumen Process, the Dry Collodion Process, the Tannin Process, the Various Alkaline Toning Baths, etc., etc.* (New York: D. Appleton & Co., 1863), 6.

194. http://creativebits.org/the_first_version_of_photoshop, June 27, 2006.

195. Oscar Gustave Rejlander, *The Two Ways of Life* (1857) and Henry Peach Robinson, Fading Away (1858). Both English photographers used combination printing to create images formed from their imaginations and created controversy about photographic veracity and creativity. Rejlander's photograph can be seen at http://www.rleggat.com/photohistory/history/rejlande.htm. Robinson's can be seen at http://www.nationalmediamuseum.org.uk.

196. Fred Ritchen, *In Our Own Image: The Coming Revolution in Photography; How Computer Technology Is Changing Our View of the World* (New York: Aperture, 1990), xi.

197. Garrett White, ed., *Nash Editions: Photography and the Art of Digital Printing* (Berkeley, Calif.: New Riders Press, 2007).

198. Robert Sobieszek, "Introduction," in Robert Weingarten, *Another America: A Testimonial to the Amish* (Göttingen: Steidl, 2004).

199. http://robertweingarten.com/landscapes.html.

200. Sobieszek, "Introduction," *Another America*, 12.

201. Robert Weingarten, "My Journey from Film Fidelity to Digital Metaphor," lecture presented at the Getty Center, J. Paul Getty Museum, Los Angeles, Calif., September 16, 2010.

INDEX